Willem de Kooning

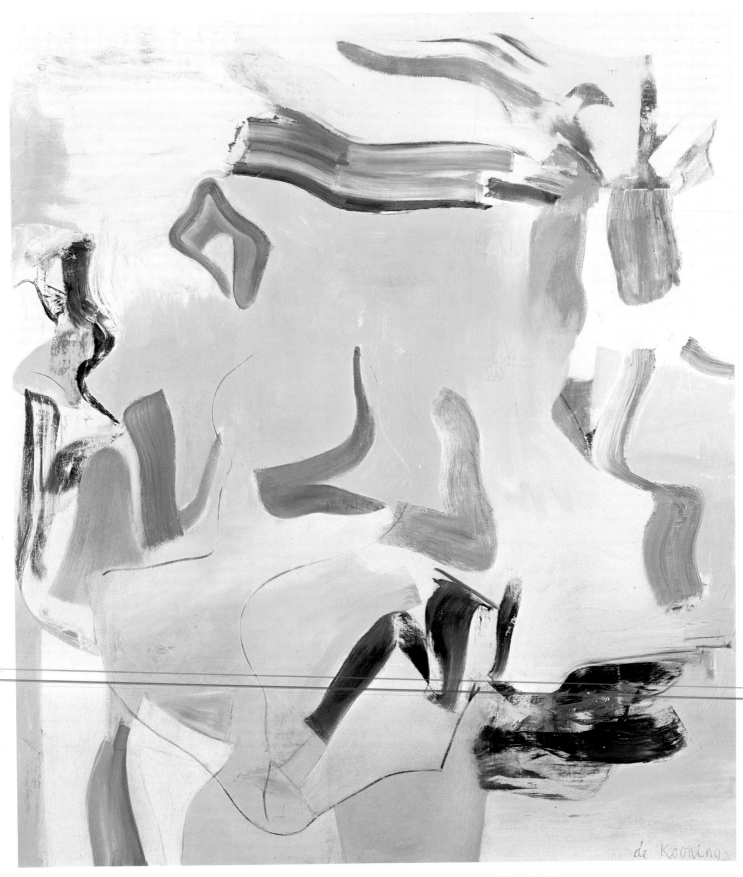

Untitled III, 1981
Oil on canvas, 88 × 77 in.
Hirshhorn Museum and Sculpture Garden,
Smithsonian Institution, Washington, D.C.

MODERN MASTERS SERIES

Willem de Kooning

Harry F. Gaugh

ABBEVILLE PRESS · NEW YORK

Willem de Kooning is volume two in the Modern Masters series.

For my students

Art director: Howard Morris
Designer: Gerald Pryor
Editor: Nancy Grubb
Production manager: Dana Cole
Picture researcher: Christopher Sweet
Chronology, Exhibitions, Public Collections, and Selected Bibliography
compiled by Anna Brooke.

FRONT COVER:
Woman V, 1952–53
Plate 1 (detail)

BACK COVER:
Untitled III, 1982
Plate 102

END PAPERS:
Willem de Kooning, 1982
Photographs by Linda McCartney

Marginal numbers in the text refer to works illustrated in this volume.

Library of Congress Cataloging in Publication Data

Gaugh, Harry.
 Willem de Kooning.
 (Modern masters series)
 Bibliography: p.
 Includes index.
 1. De Kooning, Willem, 1904– . 1. De Kooning,
Willem, 1904– . 11. Title. 111. Series.
N6537.D43G38 1983 759.13 83-2787
ISBN 0-89659-332-0
ISBN 0-89659-333-9 (pbk.) ISSN 0738-0429

First edition

Contents

Introduction 7

1. Early Work 11

2. Black and White Abstractions 25

3. The Women 41

4. The Landscapes 55

5. Women, Men, and Landscapes 77

6. Sculpture and Late Paintings 95

Artist's Statements 115

Notes on Technique 119

Chronology 123

Exhibitions 126

Public Collections 129

Selected Bibliography 130

Index 135

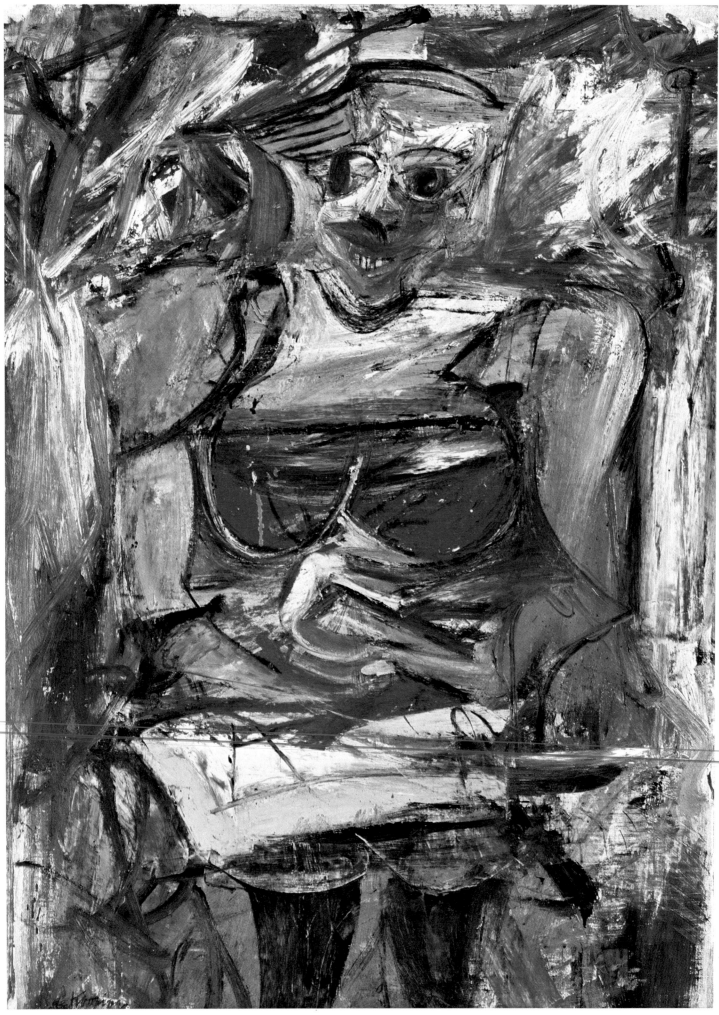

Introduction

Willem de Kooning is always pushing us around, making us change our minds just when we think we finally have his art figured out. As the most venerated, yet still misunderstood and upbraided exponent of Abstract Expressionism, he continues to put stringent demands on himself as an artist and on his audience, not merely as viewers, but as participants in his creative act. In a 1958 interview with Thomas B. Hess, the highly perceptive critic, editor, and champion of de Kooning's work, the artist remarked: "I was reading Kierkegaard and I came across the phrase 'To be purified is to will one thing.' It made me sick."[1] Constantly seeking visual predicaments, de Kooning complicates them still further, thereby affirming as an ethical decision the refusal to accept any one approach as the only possible solution—even for his own art.

Born in Holland in 1904—his surname in Dutch literally means "the king"[2]—de Kooning had an early education that was both practical and academic, a duality that has characterized his career ever since. As a teenager he was apprenticed to a commercial art and decorating firm, yet he also spent eight years at the Rotterdam Academy of Fine Arts and Techniques. By the time he sailed for the United States in 1926, he had matured as a skilled craftsman and was developing as an eclectic intellectual.

Expecting to find no art in America, he came here "feeling that this was where an individual could get places and become well off, if he worked hard; while art, naturally, was in Europe."[3] Working first as a house painter in Hoboken, New Jersey, he soon learned that America had artists too. "There was Greenwich Village; there was a whole tradition in painting and in poetry."[4] Indigenous to that tradition was artists' poverty. Even though he worked for the Federal Arts Project in 1935 and won a commission to design a mural for the Hall of Pharmacy at the 1939 World's Fair,[5] poverty was a persistent threat. Among other odd jobs, he designed window displays for A. S. Beck Shoe Stores. (At one point he came up with a "Stepping in Style" theme, incorporating a series of steps.) He also painted features and clothing on flat, planklike mannequins, finishing them quite rapidly—a dozen or two in a day.[6] An early friend, the photographer Rudolph Burckhardt, recalls that de

1. *Woman V*, 1952–53
Oil and charcoal on canvas, 60⅞ × 44¾ in.
Australian National Gallery, Canberra

Kooning turned down a $100-per-week commercial art job in Philadelphia. "He said he'd rather be poor in New York than rich in Philadelphia." Burckhardt also remembers de Kooning's refusing to open the door to his loft at 147 West Twenty-first Street in the mid-1930s. "To get in, you had to shout through the door so that Bill would know it wasn't the landlord." When asked how things were going in those late Depression years, de Kooning's reply was an oft-repeated, "I'm struggling."[7]

Indeed, not until the mid-1950s did de Kooning's financial situation improve through the sale of his art. No one was clamoring to buy the Women in the infamous 1953 show at the Sidney Janis Gallery; twenty-one years later, the National Gallery of Australia paid $850,000 for *Woman V.*[8] De Kooning's commercial success is most significant because it enables him to devote himself to art without the once time-consuming problem of making ends meet. "It's terrific. . . . I enjoy my life so much now because I can stay here [in The Springs, near East Hampton]. I can paint all the time. I don't have to do anything else."[9] And, indeed, making art has become his predominant activity—he paints every day. "The studio is his universe now."[10]

De Kooning's knowledge of artists and writers is extensive. For him, Michelangelo is "a force of nature," while El Greco remains perhaps the most modern of all old masters. De Kooning has read Dostoevski, Marcel Proust, Henry James, Mark Twain, and William Faulkner, who at one time was a "real passion" in his life. From time to time he rereads his philosophical mentor, Ludwig Wittgenstein, who has become for de Kooning a kind of "security blanket."[11] De Kooning's self-effacing erudition won him respect from other first-generation Abstract Expressionists in the 1940s and '50s. His range of interests and ability to articulate his ideas distinguished him from Jackson Pollock, for example, who was once described by a fellow painter, John Ferren, as the ultimate "Ugh artist."[12]

The de Kooning-Pollock relationship is affectionately summarized in de Kooning's reminiscence: "He was *it*. A couple times he told me, 'You know more, but I feel more.' I was jealous of him—his talent. But he was a remarkable person. He'd do things that were so terrific."[13] In reference to the battle for abstract art fought by New York artists shortly after World War II, de Kooning's famous comment, "Jackson Pollock broke the ice," expressed the abrupt, intense, and irrevocable nature of Pollock's achievement.[14] However, considering his own work during the last thirty years, de Kooning seems only to have paused momentarily, recognized Pollock's apocalyptic breakthrough, and then resumed working in his independent, yet inclusive way. He has sworn allegiance to neither figural imagery nor abstraction, but has extended and at times fused both modes.

Meyer Schapiro likens de Kooning to a mathematician, working in a highly intuitive way with very strong personal reactions. Rejecting a "proof," or style, he poses a new problem and starts all over again. Yet, Schapiro adds, "de Kooning has the simplicity of a craftsman. He respects skill. For that reason, he's always admired commercial artists, those who are *not* original."[15] This attitude is

* Marginal numbers refer to works illustrated in this volume.

related to de Kooning's ongoing desire to master totally whatever medium he works in: oil, enamel, pencil, pastel, charcoal, and, between 1969 and 1974, clay, which he modeled into pieces that were subsequently cast in bronze or polyester resin. No other Abstract Expressionist has wrestled so frequently and strenuously with so many distinct painting and drawing techniques.[16] De Kooning has sometimes taken them on all at once—as in the figure/landscapes of the late 1960s—not simply to show off his skills, but to amplify the content of his art. And its meaning, its nonformal content, is as extensive as his techniques: ambivalent, somber, frightening, yet at other times joyous, playful, witty, ribald.

De Kooning's influence, direct and indirect, has been enormous. Major art of the last forty years cannot be even superficially surveyed without focusing on his monumental series. *Woman I* is as much a symbol of mid-twentieth-century America as Edouard Manet's *Olympia* was a scandalous Venus in 1865 Paris or Marcel Duchamp's *Nude Descending a Staircase* a puzzle hopelessly gone to pieces at the 1913 Armory Show. But de Kooning's other *Women*, as well as his black and white abstractions, his "abstract landscapes" of 1957–63, and his recent sensual abstractions casually yet specifically reflecting the East Hampton environment also qualify as conspicuous landmarks in the history of twentieth-century art. To be sure, not every work in these series is a masterpiece, but de Kooning's ability to achieve high quality is prodigious. As artists of his generation had to contend with the promethean Picasso, today's artists have to work their way around de Kooning, or consciously turn their backs on him and walk away.[17] Avowing de Kooning as a paradigm of freedom and dedication for all contemporary artists, regardless of personal style or cause, Jim Dine may say it best: "I love de Kooning most as a fact that he exists for all of us, as our most profound painter, I think."[18]

33

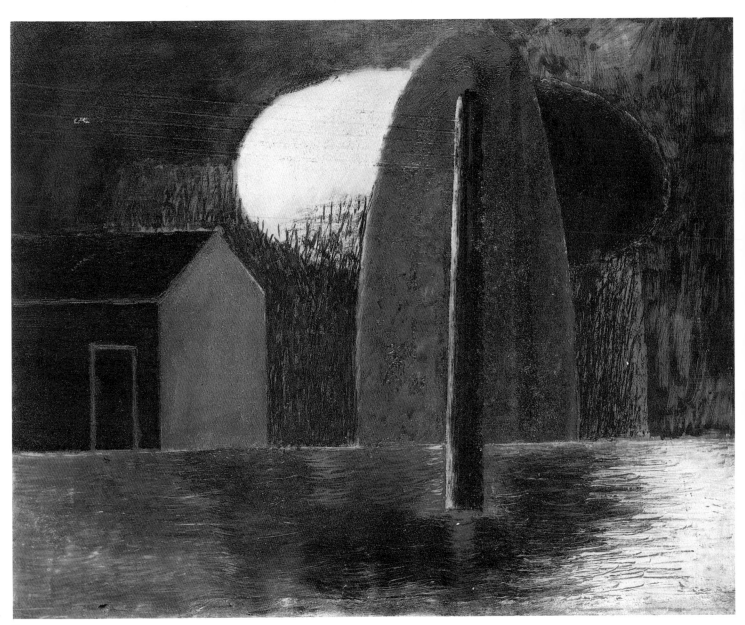

2

1 Early Work

While the bulk of de Kooning's art, particularly that of mid-career such as the Women (1950–55), is well known for its insolent imagery and volatile brushstrokes, his earliest work is remarkably placid. Most familiar is the charcoal drawing, *Dish with Jugs* (c. 1921), done when he was a seventeen-year-old student in Rotterdam. It points up his early mastery of modeling in light and shade to instill an illusion of volume. And although this work is merely an academic exercise, its four-part composition and deliberate asymmetry may foreshadow his pictorial concerns of the late 1940s and '50s.

In contrast, *The Farmhouse*, dating from 1932, represents a little-known side of de Kooning's art. Shapes are reduced to geometric elements: a red pentagon with unequal sides for the end of the barn; an oval, half-white and half-black, suggesting a cloud but also standing for the moon and its two faces. Between the white and black is another oval: green, flat on the bottom. In front stands a pole edged in white but otherwise all black—as if reflecting directly the white and black masses in the sky. De Kooning pushes everything in this surreptitious landscape back to the horizon—everything, that is, but the pole. Two planes define the space, that on the horizon and the picture plane itself. Forms spread flatly across the distant plane, a characteristic that will be pulled up front in his black and white abstractions (1946–49). Nothing recedes toward the horizon because all forms, except the pole, are already there. While tapering slightly, the pole does not recede in depth but functions in the opposite way, stabilizing the composition and drawing background shapes close to the picture plane.

From the 1930s through the early '40s, de Kooning's closest artist friend was Arshile Gorky. They had known each other since the late 1920s or early '30s, although reports vary on how they met.[19] De Kooning has recalled how, after talking with Gorky a few times on the street, he brought him to his studio and showed him some drawings. Gorky looked at them and said, "Aha, so you have some ideas of your own." Somehow, de Kooning remembers, "That didn't seem so good."[20] Hess has described the Gorky/de Kooning artistic relationship at the time as "sometimes approaching the

2. *The Farmhouse*, 1932
Oil on canvas, 16 × 20 in.
Private collection

3

4

Picasso-Braque closeness. . . . but usually the works are a good deal further apart."[21] Reports that the two shared a studio are inaccurate:[22] de Kooning insists that he never had a studio with Gorky,[23] an affirmation of his need for a private place in which to produce art. Nevertheless, the artists did exchange ideas over several years. While their relationship was never broken off, it dwindled after 1944 when Gorky began to spend months at a time in Virginia or Connecticut.

De Kooning's *Elegy* (c. 1939), crucial for its abstract/figurative synthesis, is also important for its Gorky connections. Viewing *Elegy* beside a "typical" Gorky such as the oil version of *Nighttime, Enigma, and Nostalgia* (1934), points up how both artists flattened shapes and sought a tangential correspondence of form. The pink and blue fishlike shapes at center and right of de Kooning's picture echo each other; their lower edges continue the curve defined by the dark line. Such contiguity, tightened up, is visible in the white and black "palette" or "boomerang" shapes at upper left in the Gorky.

Unlike Gorky's *Nighttime* shapes, which are logical descendants of Synthetic Cubism, de Kooning's are biomorphic and their relationship is easier, less fitted together. They do not imply an abstracted still life but a mini-community of living things; their cellular connotations are enhanced by looping lines that suggest sensitive feelers and the motion of individual beings through liquid or air. The painting's mood rests in large part on the subtle balance of line, mass, soft-spoken color, implied momentum, and a cautious, uncrowded composition. De Kooning did not pursue this tendency toward gentility and understatement in his later art; it matured fully, however, in Gorky's "hybrid forms" of the 1940s.

During the late 1930s and early '40s de Kooning made a series

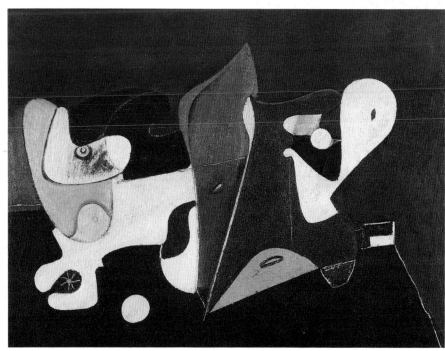

3. *Reclining Nude (Juliette Brauner)*,
1933–34
Pencil on paper, 10½ × 13 in.
Private collection

4. *Untitled*, c. 1934
Oil on canvas, 36 × 45⅛ in.
Private collection

5. Arshile Gorky
Nighttime, Enigma, and Nostalgia, 1934
Private collection

5

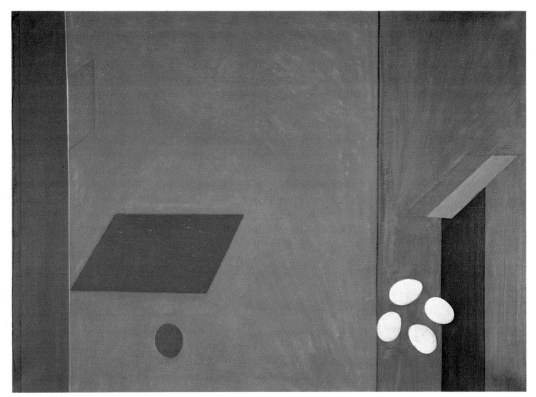

6

of apparitional paintings of men. Certainly less obstreperous than the later Women, the males are withdrawn, essentially passive, and raise questions about themselves and the direction of de Kooning's art. To begin with: who are they? Not fully self-portraits, at times they veer close to the artist's likeness only to pull away from it at second glance. According to Hess, "some of them look like . . . Edwin Denby,"[24] the poet and dance critic who met de Kooning in 1935. One is a portrait of Rudolph Burckhardt, who shared a loft with Denby at 145 West Twenty-first Street. De Kooning worked on the painting for months, defining in detail Burckhardt's suit, shoes, table, and photo-lamp, yet barely outlining his sitter's facial features. Eventually, he left the painting unfinished.[25] Since de Kooning lived next door, he would ask Burckhardt and Denby to pose from time to time. The sessions were very informal, and occasionally Denby would read aloud something he admired—a bit of Gertrude Stein, for instance.[26]

Other paintings of these ephemeral men are prolonged experiments in how to draw and paint difficult body parts: *Glazier* (c. 1940) emerged after hundreds of studies of a shoulder.[27] Reminiscent of Cézanne's rigorously explicative approach to a subject, de Kooning's attitude toward these men is structurally analytical yet psychologically elusive.

Another possibility exists as to the identity and meaning of de Kooning's enigmatic but awesome little painting, *Man* (c. 1939), which is a touchstone for the series. It was in the year 1937 that de Kooning met Elaine Fried, an art student, and they were married in 1943. In 1938 de Kooning began his first series of

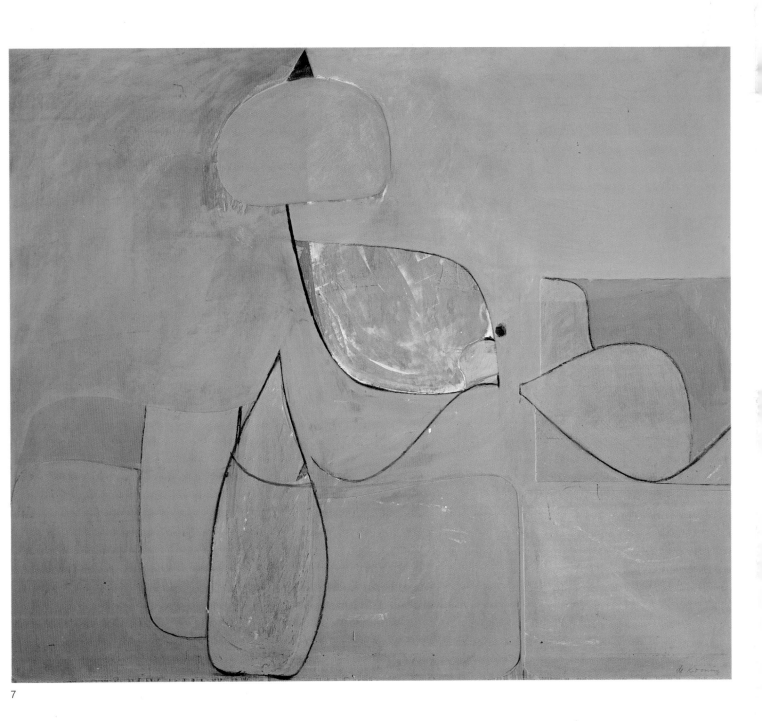

7

6. *Untitled*, c. 1931
Oil on canvas, 23⅞ × 33 in.
Collection of the artist

7. *Elegy*, c. 1939
Oil and charcoal on composition board,
40¼ × 47⅞ in.
Private collection

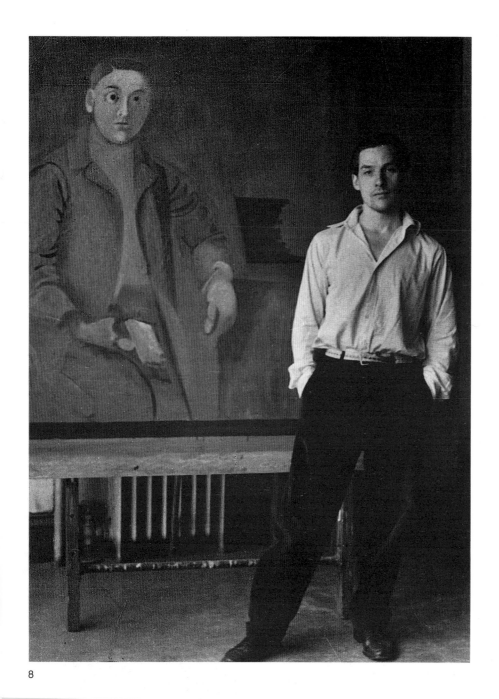

8

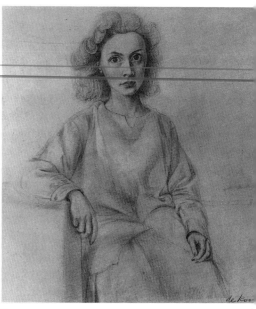

9

Women.[28] Painted during this same period, *Man* may be an andro-
gynous image of the artist—a quasi-self-portrait incorporating
Elaine as well. The big eyes and tightly held mouth bear partial
likeness to his famous pencil drawing of Elaine (c. 1940).[29] At the
same time, the hands of *Man* are remarkably similar to those of
Edwin Denby. To insist, however, on only one interpretation of this
evanescent painting would be mistaken. Multiple levels of
meaning—sometimes apparently contradictory—characterize de
Kooning's art. He once remarked that he'd like to paint like Ingres
and Soutine at the same time.[30] And in *Man*, as in much of his later
figural art, de Kooning sought to give an emotionally engaged sub-
ject an open-ended meaning. *Man's* facial expression is utterly spe-
cific, revealing his momentary awareness of the viewer, yet his

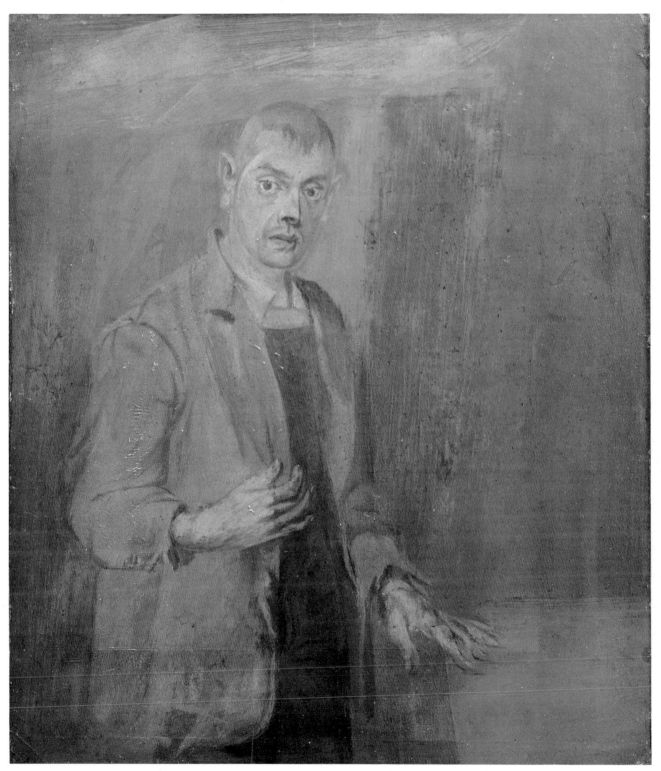

10

8. De Kooning in his studio, late 1930s
Photograph by Rudolph Burckhardt

9. *Elaine de Kooning*, c. 1940
Pencil on paper, 12¼ × 11⅞ in.
Courtesy Allan Stone Gallery, New York

10. *Man*, c. 1939
Oil on paper, mounted on composition board,
11¼ × 9¾ in.
Private collection

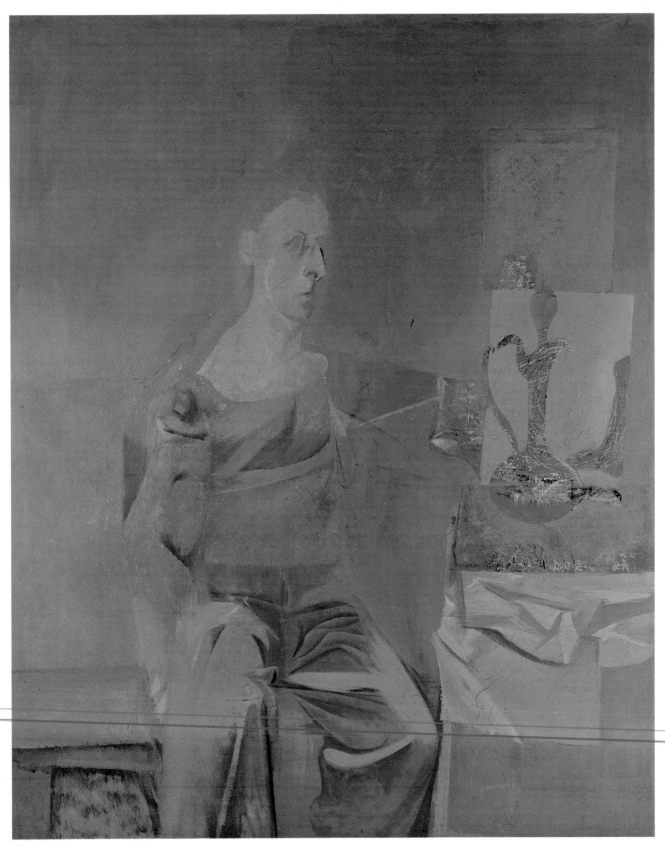

11

11. *Glazier*, c. 1940
Oil on canvas, 54 × 44 in.
Private collection

12. *Seated Figure (Classic Male)*, c. 1940
Oil and charcoal on plywood, 54⅜ × 36 in.
Sarah Campbell Blaffer Foundation, Houston

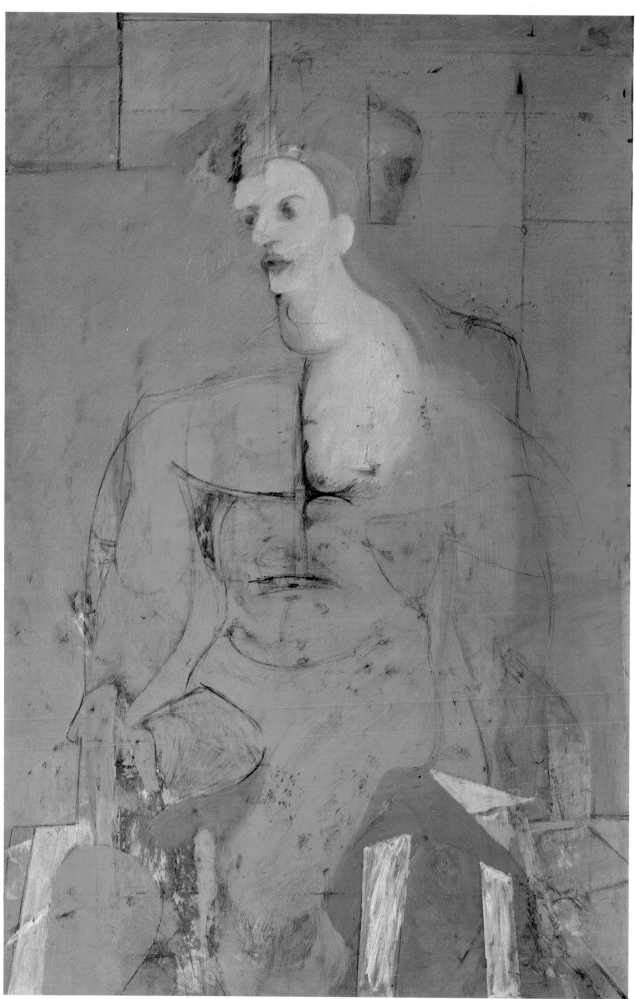

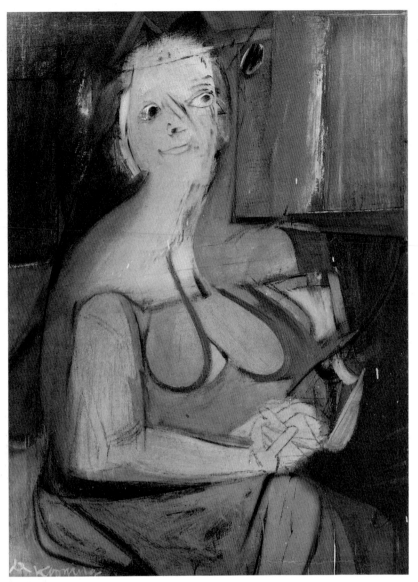

13

response, both psychological and physical, remains problematic.

Man may have barely squeezed by the artist's hypercritical instinct.[31] In light of the wide brushstrokes across the background, one senses that if de Kooning had looked at the painting much longer he would have wiped the man out forever. Perhaps the figure's defenseless mien, if not the amalgam of features from persons the artist cared about deeply, stayed his hand. The painting was de Kooning's first work to be shown in a New York gallery:[32] in January 1942 it was included in a group show organized by John Graham for McMillen, Inc., an interior design firm that exhibited art. Other artists represented were Matisse, Picasso, Georges Braque, Stuart Davis, Jackson Pollock, and Lee Krasner.[33]

Unlike other New York painters whose commitment to abstraction matured in strong, individualistic work after World War II—Gorky, Pollock, Rothko—de Kooning was never drawn to the fountainhead of Surrealism. His passing interest in the movement was more often in Surrealism recast by Gorky than in the original European variety. In fact, with the exception of his good friend

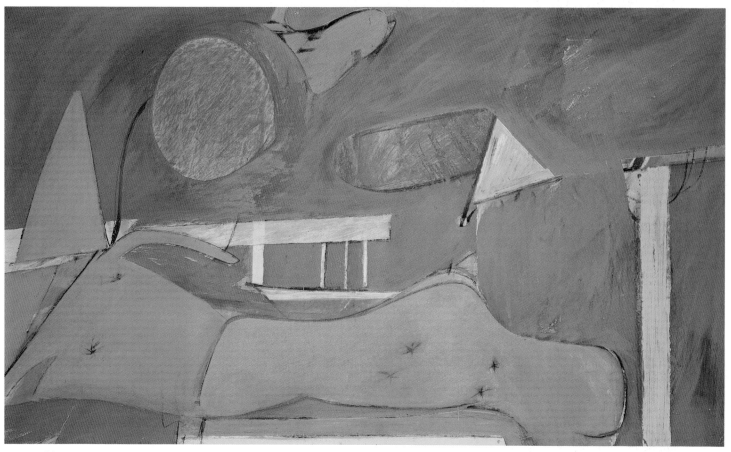

14

Franz Kline, de Kooning had less to do with Surrealism than any other leading member of the New York School. A few paintings from the late 1930s, filled with arrested biomorphic forms or slightly askew spheres, have the ingredients but lack the narrative context of Surrealism. Rather than probe the subconscious, de Kooning wanted to define abstract shapes within fixed precincts on a painting's flat surface, yet at the same time keep them all moving, turning, jostling one another.[34] The twin poles of such works (nearly always untitled) are perpetual motion and immutable stasis. Idiosyncratic elements with Surrealistic overtones appear at times in the early 1940s, but are characterized by spatial as well as thematic ambiguity.

One Surrealistic element of *Summer Couch* (1943) is its reclining figure, which takes on some of the features of a mattress, as well as acquiring a triangle for a head. Moreover, the triangle is not attached to the body by a neck, but instead touches the shoulder, that part of the body that had fascinated de Kooning in the Men series. While the figure reclines on (or turns into) a dilapidated bed, the rest of the scene is charged up by shapes of various colors, most of them seemingly pancake flat, that begin to move hither and yon, yet hesitate to veer into each other's territory. A funny pink form near the top builds up steam and prepares to zoom away. De Kooning's art is not usually regarded as humorous or lighthearted, but a

good share of it is, like *Summer Couch*, and the viewer should not overlook the artist's tongue-in-cheek joie de vivre. But while wit operates on one level, a tendency to perplex functions on another. Is this a mannequin, a pastiche of a mannequin, or a more sinister remodeling of the human body—with whalelike references from the waist down? De Kooning's strongest work pulls us in several directions at once, similar to a three-ring circus with a major act in each ring.

Another "Surrealistic" work, *Pink Angels* (c. 1945), refers only marginally to fun, unless one extends that to black comedy. The sharklike and serpentine forms crisscross back and forth, cutting into themselves and pulling diagonally against the frame. Their energy accelerates to such cataclysmic force that it yanks the bodies apart, hurling them into the tangle of lines and shallow yellow space. There is not enough room in the painting to hold these revved-up forms. John Ferren once described de Kooning's "whiplash line" as traveling at 94$^{1}/_{4}$ miles per hour.[35] The velocity of *Pink Angels* may exceed that. Few abstractions coming out of New York in the 1940s were packed with this much speed.

The painting's imagery partially derives from World War II, which ended the year *Pink Angels* was completed. Photographs of heaps of bodies, buried in mass graves after dying from starvation or in the gas chambers, appeared at this time. Equally horrifying were photographs and accounts of victims at Hiroshima and Nagasaki, some of whom vaporized into their surroundings, leaving "shadows" of their silhouettes on pavements near ground zero. Elements of such World War II imagery surface amid the self-destructive chaos of *Pink Angels*: from tangled parachutes to Kamakazi suicide squadrons, dive-bombers, submarines, and nuclear fission. The sharklike grin (which appears in other works from the late 1940s and 1950) reiterates the grit-your-teeth grimace painted on noses of Allied aircraft.[36] Both during and after the war, the de Koonings went to the movies regularly two or three times a week—after working in the studio, they would walk up to Forty-second Street for the late show. Elaine de Kooning remembers that newsreels filled with war images were nearly always part of the program.

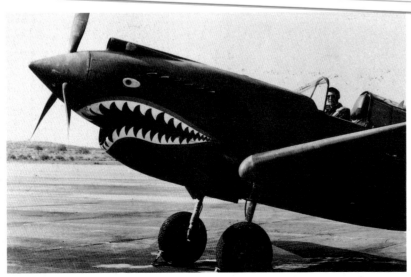

15. P-40 aircraft with tiger shark symbols

16. *Pink Angels*, c. 1945
Oil and charcoal on canvas, 52 × 40 in.
Weisman Family Collection, Beverly Hills, California

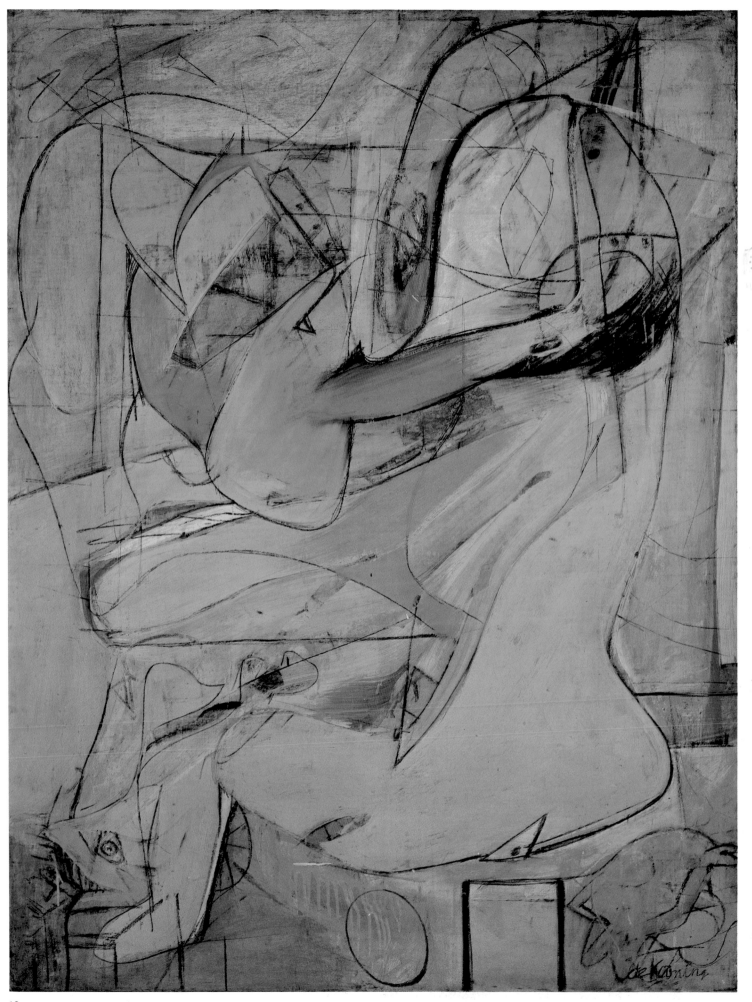

16

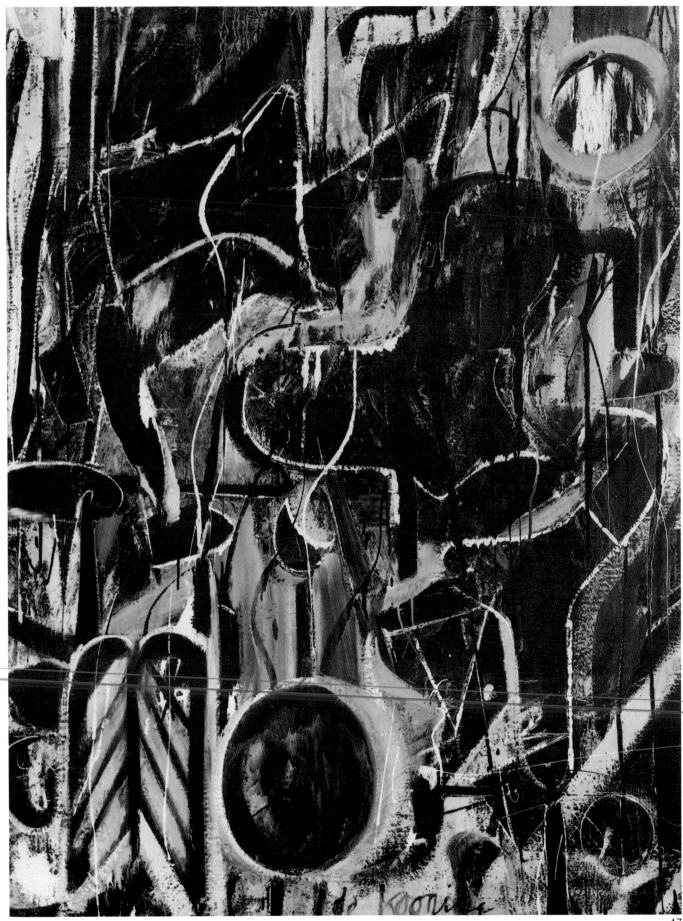

 # Black and White Abstractions

By 1946 de Kooning had begun a series of black and white paintings, which he would continue into 1949. During this period he had his first one-man show at the Charles Egan Gallery; it consisted largely of black and white works, although a few had passages of bright color.[37] Much discussion has focused on which New York artist began to paint black and white abstractions first: de Kooning, Pollock, Motherwell, or Kline. No one artist is likely to win the laurel of historical precedence, and in the long run it makes more sense to note that all these painters, and others, too—Gorky, Jack Tworkov, James Brooks—worked in black and white for varied reasons in the late 1940s and early '50s. It was not until Kline's first one-man show in 1950 (also at Egan), that an abstract artist was recognized as pushing black and white to their expressive limits. But unlike Kline's, de Kooning's paintings in his first one-man show were largely black works in which white didn't have much of a chance. In this respect, they were shape-infested forebears of Ad Reinhardt's "empty" all-black canvases of the 1940s and '60s.

De Kooning's black paintings are important to the history of Abstract Expressionism for their densely impacted forms, their mixed media, and their technique. Although a slight suggestion of depth survives in *Light in August* (c. 1946), the black shapes have been steamrollered against the paper. Thin streams of white and broader strokes of dirty beige snare the black shapes and keep them from moving off at various speeds. The painting offers an intriguing cache of shapes filled with many allusions, some symbolic (the black crescent near the center); some iconic (the twin gate or tablet form at lower left); some vaguely mechanical (the "plumbing" shape to the right); some geometric (the black ball and its open-centered counterpart at top right); and some with biomorphic overtones (the "boot" shape above the ball). The black paintings have an X-ray quality, not only because of their darkness, but because in some places we see into things, but never clearly. Rather, an inconstant backlighting or reflected light fuses silhouettes and shadows. The result is not negative space—a redundant misnomer in any case—but negative shape.

17. *Light in August*, c. 1946
Oil and enamel on paper, mounted on canvas, 55 × 41½ in.
Tehran Museum of Contemporary Art

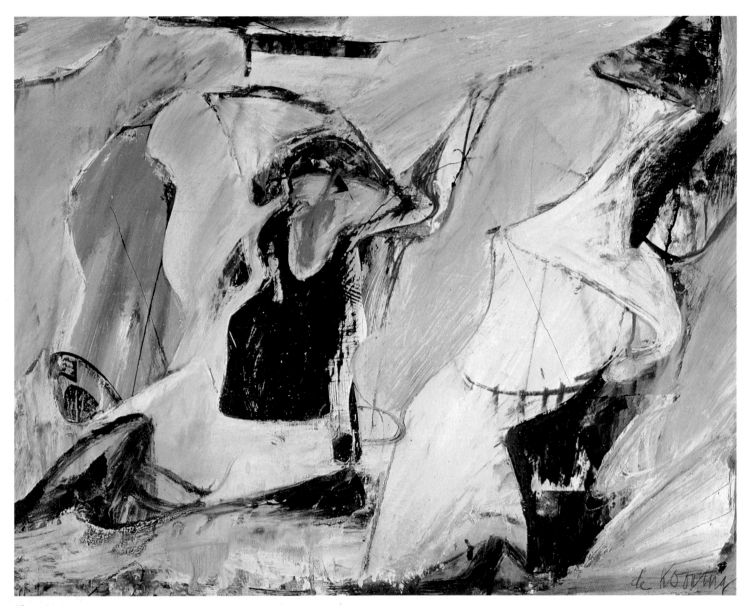

18

Visually, New York is a richly black city. On rainy nights, the oil-slick streets shine like patent leather. De Kooning loved walking in the city at night. Evoking such a midnight stroll, Edwin Denby has recalled de Kooning "pointing out to me on the pavement the dispersed compositions—spots and cracks and bits of wrappers and reflections of neon-light—neon signs were few then—and I remember the scale in the compositions was too big for me to see it."[38] Unexpected scenes would sometimes liven up these nocturnal wanderings. At five o'clock one morning in Chelsea, de Kooning and Denby were accompanying Burckhardt on a photo-making session when it was decided that de Kooning would pose as a drunken bum in a doorway. The role playing proved so convincing that a policeman happening by asked Denby and Burckhardt if they wouldn't like him to hustle off their annoying intruder.[39] Recognizing New York as a spontaneous succession of plots and improvisa-

18. *Untitled*, 1947
Oil on composition board, 22¾ × 29½ in.
Private collection

19. *Orestes*, 1947
Enamel on paper, mounted on plywood,
24⅛ × 36⅛ in.
Private collection

tions, de Kooning likened it to a Byzantine city,[40] an association rife with visual as well as social implications to be seen in the darkening light of his black and white abstractions.

As for medium, de Kooning's thick and sometimes shiny blacks are not tube paint but Sapolin and Ripolin, house-painting enamels. At times he toned them down by mixing in pumice, thus altering the paint's viscosity. Several works, such as *Light in August* and *Orestes* (1947), were created on paper and only later mounted on canvas, plywood, or composition board. Zinc white, the pigment in the painting, was also used to mount the paper on a more substantial surface.[41] Hess has written that de Kooning chose black and white "to achieve a higher degree of ambiguity—of forms dissolving into their opposites—than ever before." He adds that the artist was not forced to use commercial enamels because of any bohemian poverty. He somehow managed to get tube colors when he wanted them.[42] De Kooning's preference for these heavy blacks and whites was akin to his use of cryptic shapes and filled-up spaces. Not only would color change the mood of these paintings—and there are examples with embedded color where this happens—it would also offer a way out. Color would be like flipping to Dixieland in the midst of an *Inner Sanctum* radio mystery.[43]

19

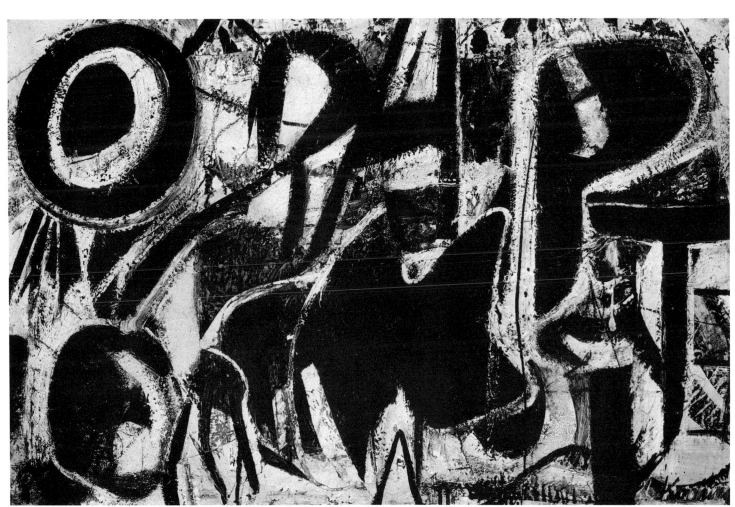

19

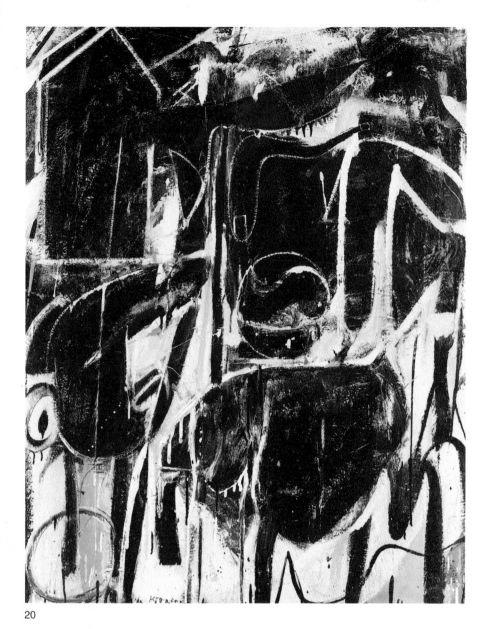

20

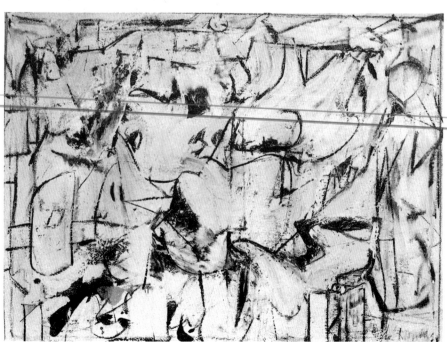

21

20. *Black Friday*, 1948
Enamel and oil on composition board,
48 × 38 in.
Mrs. H. Gates Lloyd, Haverford,
Pennsylvania
(partial gift to Princeton University)

21. *Town Square*, 1948
Oil and enamel on paper, mounted on
composition board, 17⅜ × 23¾ in.
Mr. and Mrs. Richard E. Lang, Medina,
Washington

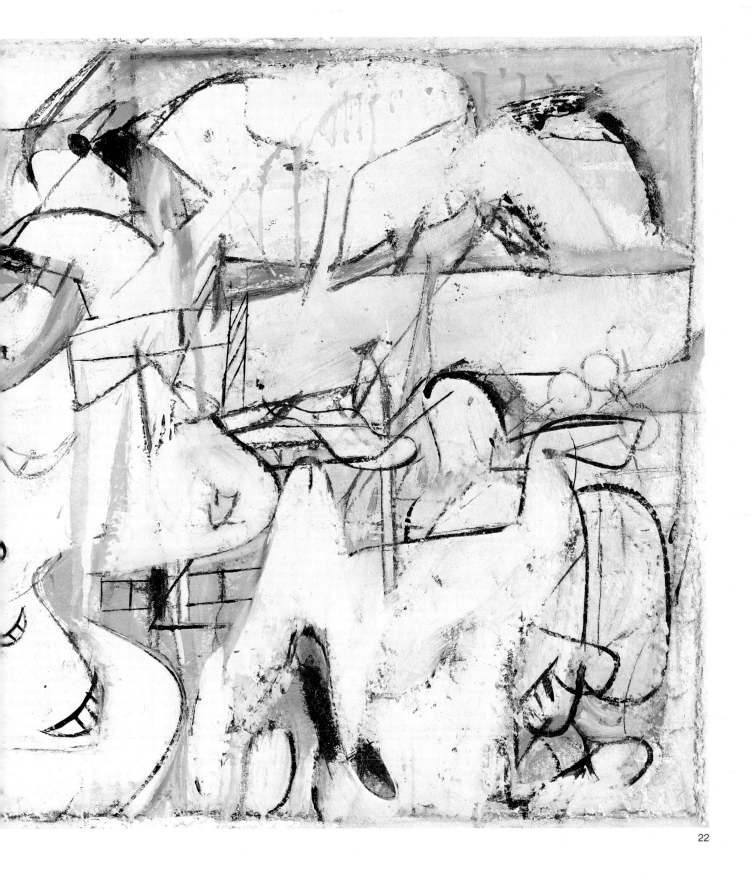

22

22. *Mailbox*, 1948
Oil, enamel, and charcoal on paper, mounted
on cardboard, 23¼ × 30 in.
Edmund Pillsbury, Fort Worth

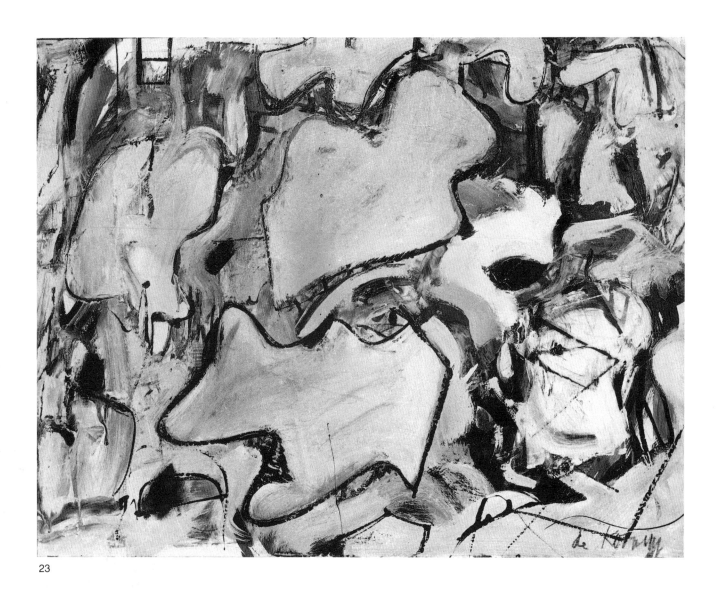

23

More clearly than *Light in August, Orestes* indicates de Kooning's practice of beginning a painting with letters.[44] Easily decipherable are *O, R, A, P, T,* and *E*. The shape at lower center can be read as a pumped-up *M*; to the right is an *I*. In the late 1930s de Kooning had also begun abstractions with letters, but painted over them, turning the letters into quasi-objects. Figural metamorphosis does not occur in *Orestes*, yet something equally exciting and even more inventive does: parts of letters expand and take possession of the space. De Kooning's interest in letters and their personalities was rooted in his awareness of how American lettering differed from European. In the 1930s he remarked to friends how much he admired the boldness of large-scale New York lettering, which covered entire walls, preferring this to smaller, more elegant European examples.[45]

The black paintings continued into 1949, but de Kooning was at the same time pushing toward a more open field by extending his use of white. In the black paintings, white is always subservient to black as *shape*. However, with *Town Square* and *Mailbox* (both 1948), white takes over, encroaches severely on the blacks, and be-

21, 22

23. *Attic Study*, 1949
Oil and enamel on buff paper, mounted on composition board, 18⅞ × 23⅞ in.
Private collection

24. Pablo Picasso
Head of a Warrior (study for *Guernica*), 1937
Pencil and gouache on paper, 11½ × 9¼ in.
Museo del Prado, Madrid

25. *Attic*, detail. See plate 26.

gins to assume shapes of its own, though the white forms never exhibit the separateness that assured the dominating presence of the blacks. *Town Square* is covered with graffitilike marks, some suggesting letters or the way children will print letters and sometimes get them turned around—the smudged *N* in the upper-left corner and, across the painting near the right edge, an *N* in reverse. Quite a few little squares, rectangles, or boxes are pushed to the periphery of the field, and herein lies one of the major distinctions between such white paintings and the black ones from the same time. Rather than loading the center with shapes, de Kooning sweeps them toward the edges. The composition does not seem likely to coalesce; forms head out and accumulate along the sides. In the black paintings, shapes as semiautonomous units were dismantled and piled up; de Kooning seemed to be rummaging through a junkyard at midnight. In the white paintings, he turned from his obsession with shape and began to stretch mass and space across the picture plane, scratching marks into the fluctuating, elastic surface.

The white paintings culminate in two highly complex works, *Attic* (1949) and *Excavation* (1950). While affirmations of de Koon-

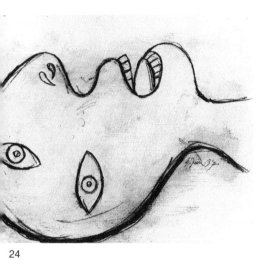

24

25

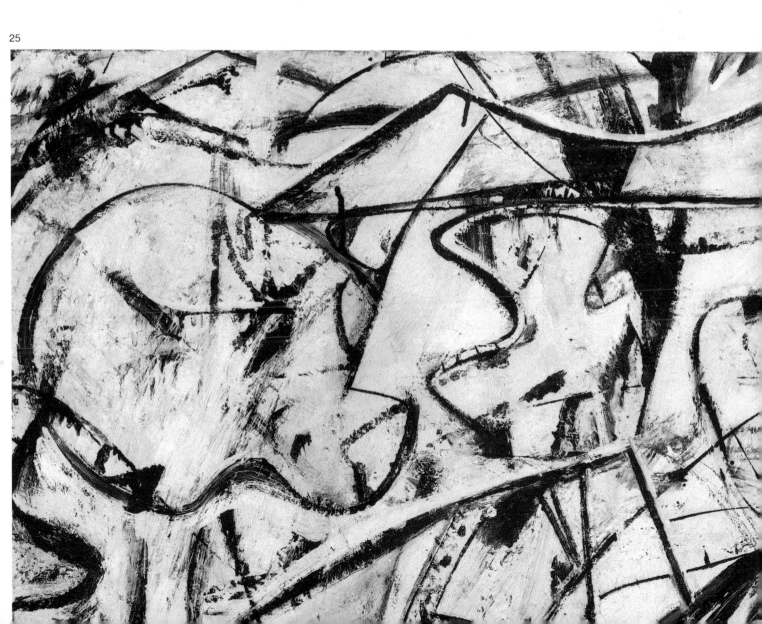

26, 27

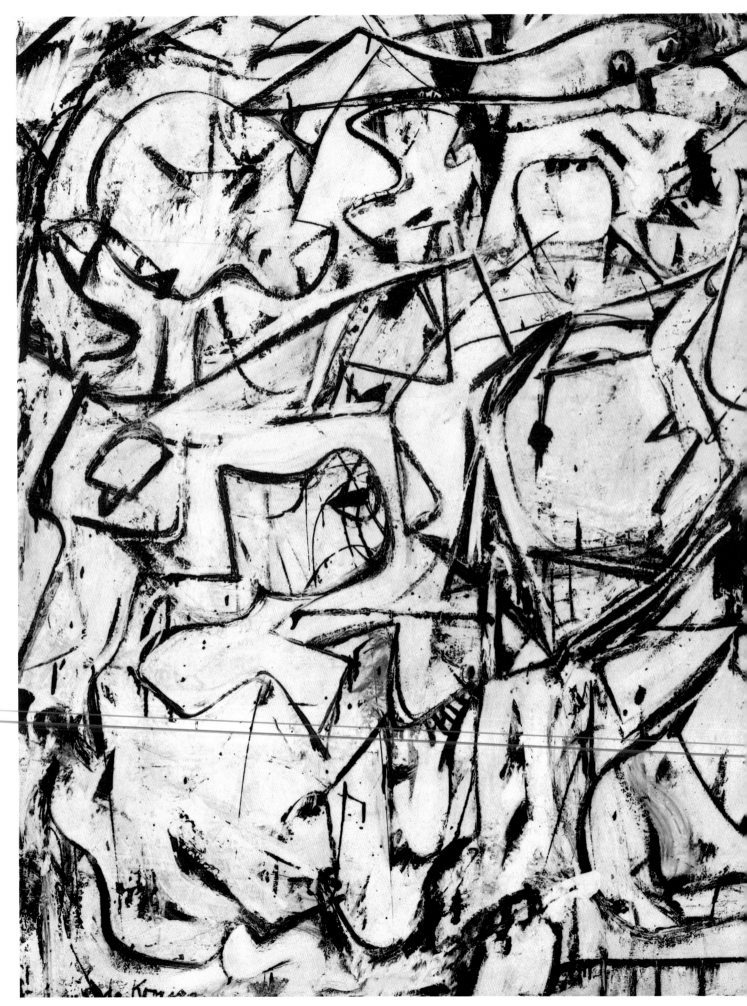

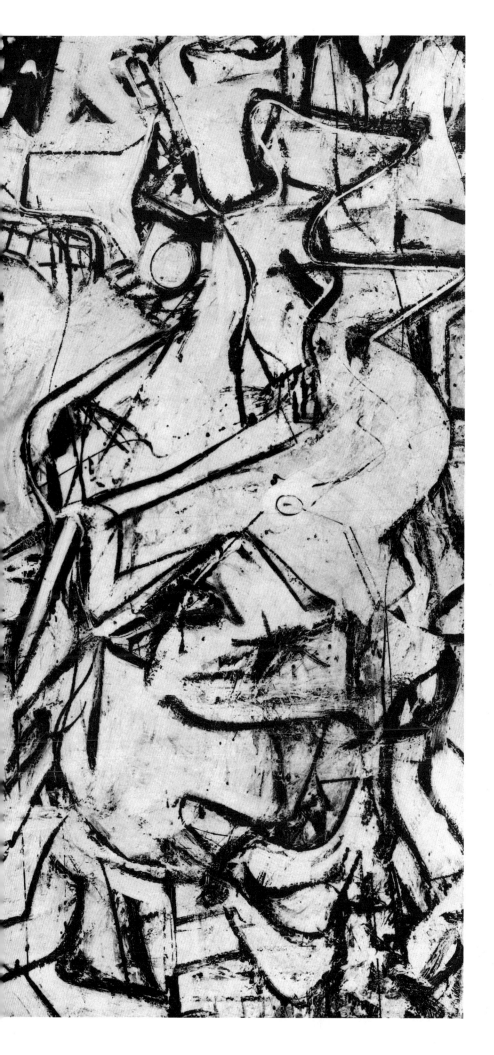

26. *Attic*, 1949
Oil, enamel, and newspaper transfer on
canvas, 61⅞ × 81 in.
Jointly owned by the Metropolitan Museum of
Art, New York, and Muriel Kallis Newman, in
honor of her son Glen David Steinberg
The Muriel Kallis Steinberg Newman
Collection, 1982

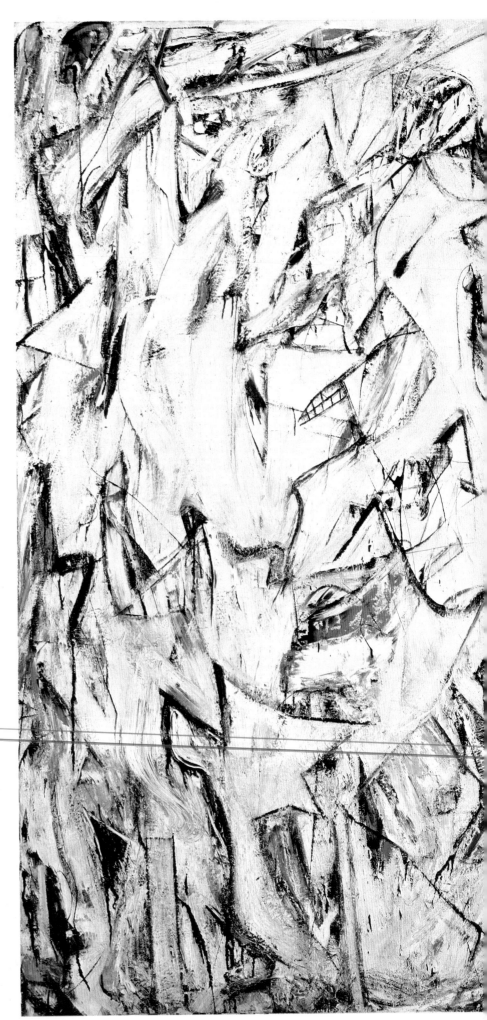

27. *Excavation*, 1950
Oil and enamel on canvas, 80⅛ × 100⅛ in.
The Art Institute of Chicago
Mr. and Mrs. Frank G. Logan Purchase Prize
Gift of Edgar Kaufman, Jr., and
Mr. and Mrs. Noah Goldowsky

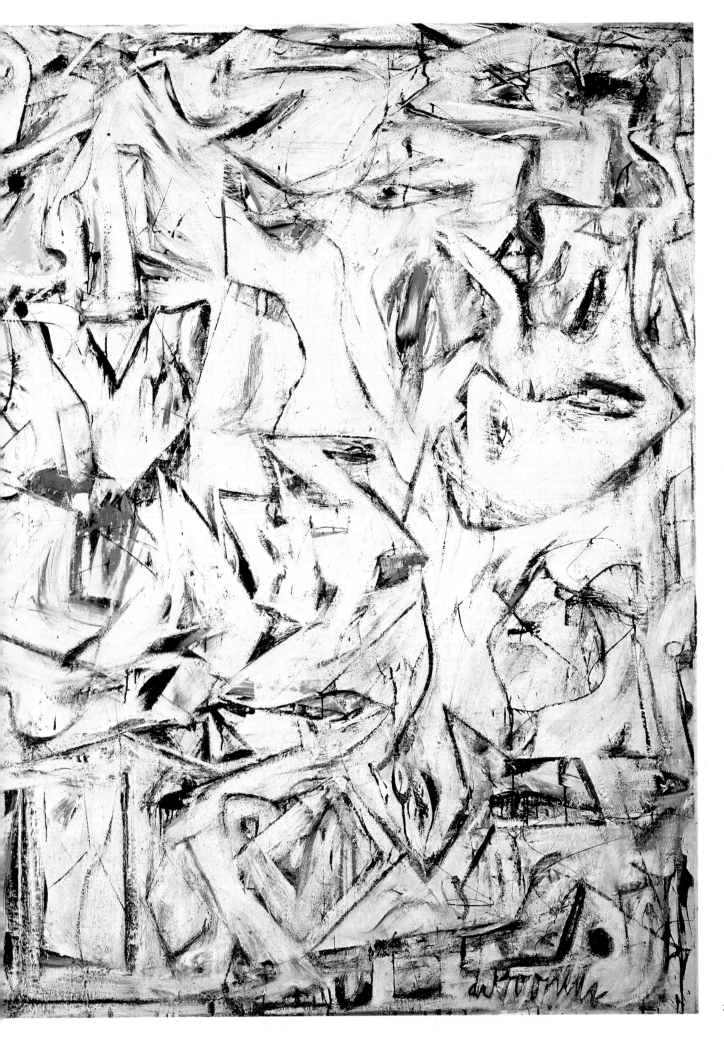

ing's dedication to abstraction, they are filled with figural references. With its heavily worked, wall-like surface, *Attic* contains bits and pieces of Gorky and, above all, Picasso. At least seven Picasso-like "heads" can be identified within *Attic*'s battered fabric. Two at top left, for example, recall *Guernica* (1937) and its studies, particularly the *Head of a Warrior*. De Kooning's painting, like *Guernica*, divides into three vertical zones. *Attic*'s midsection is dominated by a "standing figure" fitted together like a sculpture in progress. A similar armature stretches through the center of *Excavation* and may be a primal ancestor of *Woman I*. Moreover, the offset image at lower left in *Attic* of a smiling model in a bathing suit, legs drawn up to her torso, is a profile prototype for the frontal, splayed-leg pose of de Kooning's Women in the 1960s.

For several reasons, *Excavation* occupies a major place in de Kooning's oeuvre. It is one of his biggest paintings: 80 by 100 in. Those are, incidentally, about the same dimensions as Gorky's largest canvas, *The Liver Is the Cock's Comb* (1944). Although de Kooning has created some of the most powerful Abstract Expressionist paintings, he has not worked on a huge, panoramic scale. Even a big canvas such as *Excavation* has been exceeded in size by works by Pollock, Kline, and Motherwell.[46] Nevertheless, *Excavation*'s size is a factor in its layer by layer revelation of "buried treasure." De Kooning put a lot of color in the painting, much of it bright color, yet he scattered and embedded it in the creamy ground. Originally, *Excavation* was crisper in hue, although, unlike *Town Square* or *Attic*, it was never a predominantly white and black painting. Now, more than thirty years later, the mixture of enamel and oil has yellowed. Seemingly, *Excavation* has a cheesy look and even smell. The yellowish ground appears well fermented, as if substance and color had been aged by vigorous bacterial action. The black strokes, in addition, have in places a honed-edge sharpness, slicing through the thick, weighty yellow with the pressure of a hand cutting chunks of Gouda. The painting's solid mass does not easily admit the irregular network of black lines and strokes.

Harold Rosenberg noted that *Excavation* was "brought to resolution in 1950 after months of doing and undoing, [and it] displays a density of experience more often encountered in poetry than in modern painting. . . . One thinks of Yeats's

Those images that yet
Fresh images beget
That dolphin-torn, that gong-tormented sea; . . ."[47]

Excavation resists inventory. There are bird shapes, fish shapes, eyes. Then, mouthlike shapes and a toothy grimace with no mouth around it. Suddenly, as one makes one's way across this "shipwrecked yellow sea," some shapes will assume figural identities. (Two critics have pointed out that the "visual cue" for the painting was a scene from the 1949 film *Bitter Rice*, with Silvana Mangano and five other women standing in a field up to their knees in water.[48]) Rosenberg noted that *Excavation* "was literally concluded with the image of the door in the bottom-center."[49] At first this may seem much too narrow a reading of the form, but it does

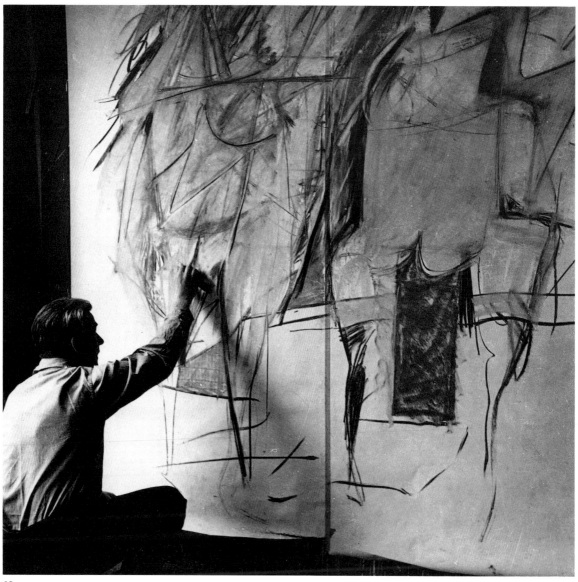

28

indicate the oblique, yet direct correspondence between de Kooning's painting and the rest of the world. Again and again the artist drew upon New York's well-stocked image-bank, as well as his memory of specific forms in art. Schapiro recalls walking with de Kooning one day on Second or Third Avenue when his friend called attention to a weathered blue doorway. De Kooning commented that he'd like to put that shape and new-found color into his paintings.[50] Such reference to a feature in urban life, coupled with the "door" in *Excavation*, may be two sources of the quintessential *Door to the River*, another landmark of Abstract Expressionism [65] painted ten years later.

Excavation is a tremendously rich painting that requires almost as long to look at as it took de Kooning to paint—literally months. Its impact and complexity can be felt immediately, but not its potential for discovery. It becomes a site to be sifted with the care of an archeologist. Yet the person probing *Excavation* soon learns, like

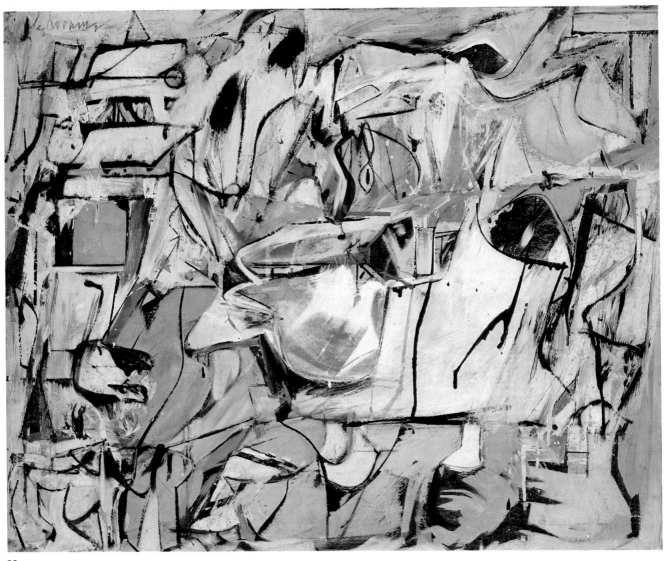

29

the archeologist, that some treasures resist being brought to the surface. If unearthed, they vanish. If individual shapes are excised from de Kooning's painting, their substance and meaning disintegrate.

With this painting, "de Kooning had established his leadership among American painters."[51] *Excavation* was shown at the 1950 Venice Biennale, an exhibition dominated by the Europeans—the grand prize went to Matisse. Europe did not know how to respond to Abstract Expressionism, nor did much of America, which had been educated by modern European masters since the 1920s. Yet the situation was beginning to change. In 1954 de Kooning had a one-man show of twenty-six pictures, including *Woman I*, at the Biennale.[52] Six years later, Kline won a special Biennale prize. While not the top prize—which went to France's Jean Fautrier—there was widespread agreement that Kline would have received first prize except for political shenanigans.[53] Finally, in 1964 an American, Robert Rauschenberg, won the international prize for painting.

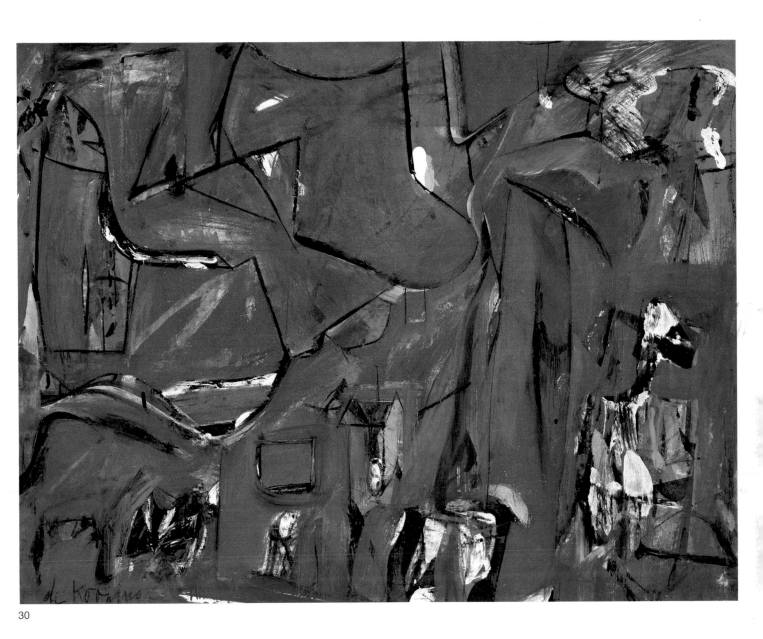

30

29. *Ashville*, 1949
Oil and enamel on cardboard, mounted on
composition board, 26 × 32 in.
The Phillips Collection, Washington, D.C.

30. *Gansevoort Street*, 1950–51
Oil on cardboard, mounted on composition
board, 30 × 40 in.
Mr. and Mrs. Harry W. Anderson, Atherton,
California

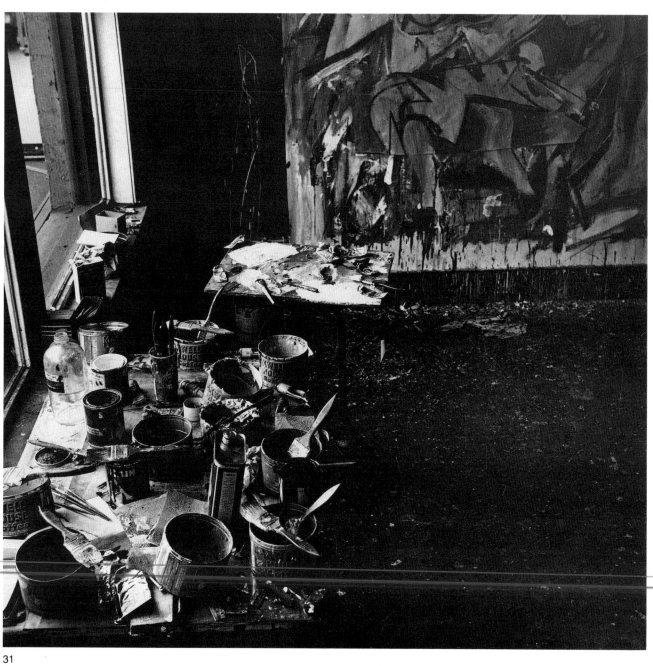

31

3 The Women

In June 1950, just after completion, *Excavation* was removed from the studio and shipped to Venice. A few days later, de Kooning began work on *Woman I*. He was to paint, almost daily, on this [33] canvas for eighteen months to two years. He would paint an image only to scrape it away and begin again. Elaine de Kooning estimates that two hundred individual pictures were created but subsequently wiped out. (Photographs of several stages through which the painting passed have been widely reproduced.[54]) In early 1952 the work seemed near completion, but not for long. Feeling it impossible to finish, de Kooning abandoned it. At the same time, like an ancient siren, the image continued to attract him. After showing the unfinished canvas to Meyer Schapiro and discussing it with him, de Kooning went back to work, pulled off the cutout lips from a Camel cigarette advertisement he had pasted on the head, and repainted the face.[55] In an outburst of energy, he not only completed *Woman I* in June 1952 but pursued the image in multiple manifestations through a series of paintings and drawings stretching into 1953. This coven of sympathetic witches was first exhibited at the Sidney Janis Gallery in March 1953.[56]

A major controversy ensued: which way did de Kooning mean to go—abstract or figural?—as if synthesis were unthinkable. One critic described the Women as "monuments of confusion."[57] The *New Yorker* complained that "he does not . . . commit himself to either their representational or their abstract possibilities but hesitates constantly between the two, and the result is a splashy and confused muddle of pigment that obscures as much as it reveals of the subject."[58] *Time*, on the contrary, declared that de Kooning "had successfully shown again that he is one of the most original artists of the day."[59] Art world pressure to choose sides would be unequaled until 1970, when Philip Guston set off his own culture-shock waves with an exhibition of defiantly nonabstract, cartoonlike pictures. Significantly, amid all the critical hullabaloo challenging Guston's wisdom in turning back to figural imagery, de Kooning remarked to him: "What's the problem? This is all about freedom."[60]

While undoubtedly serious and demanding paintings, de Koon-

31. An early version of *Woman I* in de Kooning's studio, 1950
Photograph by Rudolph Burckhardt

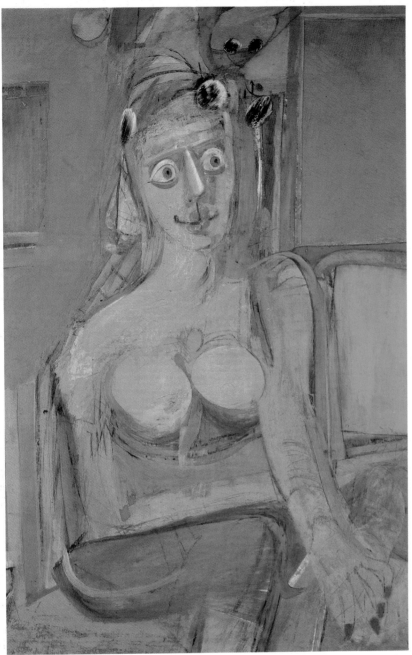

32

ing's Women do have their funny side—one generally overlooked in
cheerless critical appraisals. Referring back to them in 1960, the
artist noted: "I look at them now and they seem vociferous and fe-
rocious. I think it had to do with the idea of the idol, the oracle, and
above all the hilariousness of it."[61] Schapiro has also recalled de
Kooning commenting on the "comic" aspect of women around
Union Square and Fourteenth Street going shopping. "Their grim-
ace and predacity—that got him."

As a major physical feature of *Woman I* and most of the other
ladies from 1950–53, the mouth is a fulcrum of artistic and psycho-
logical ambivalence. Not one of the Women frowns. *Woman I* bares
her teeth and draws back her lips as if ready to hiss. *Woman and*
37 *Bicycle* (1952–53) has two toothy grins, with the lower working as a
fiendishly decorous necklace that calls attention to the mammoth

32. *Woman*, c. 1944
Oil and charcoal on canvas, 46 × 32 in.
Private collection

33. *Woman I*, 1950–52
Oil on canvas, 75⅞ × 58 in.
The Museum of Modern Art, New York
Purchase

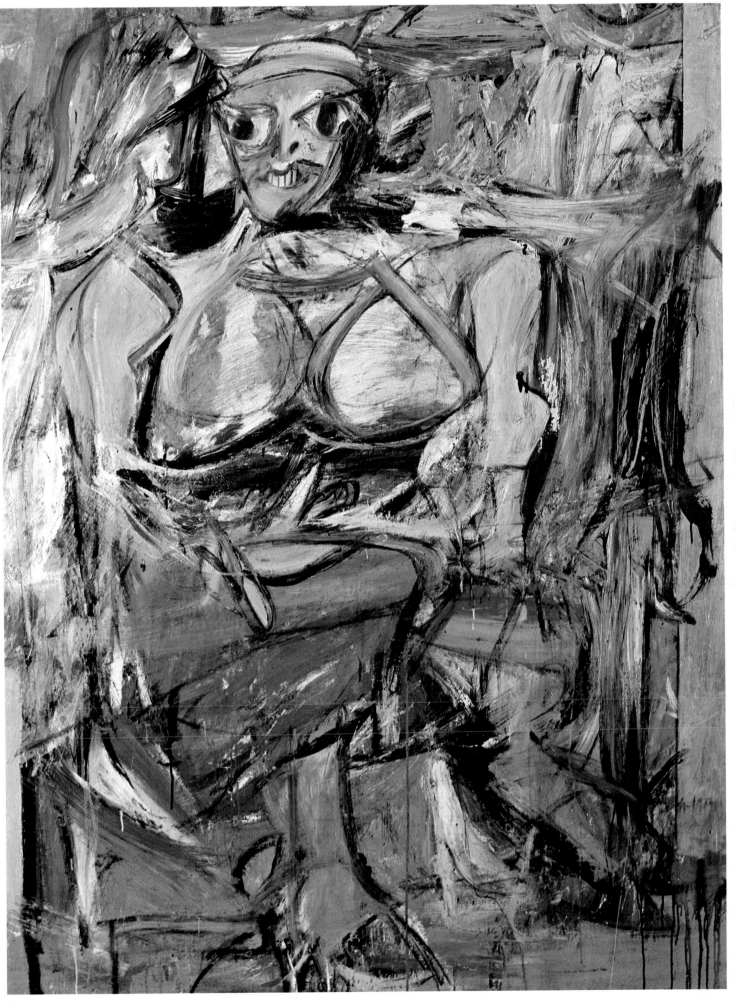

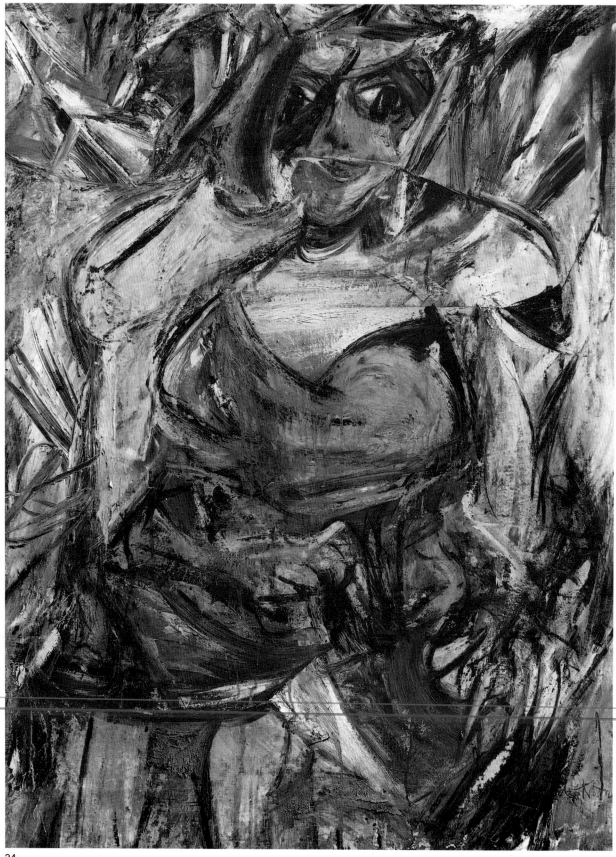

34

34. *Woman II*, 1952
Oil on canvas, 59 × 43 in.
The Museum of Modern Art, New York
Gift of Mrs. John D. Rockefeller 3rd

35. *Woman III*, 1951–52
Oil on canvas, 67⅛ × 48⅛ in.
Tehran Museum of Contemporary Art

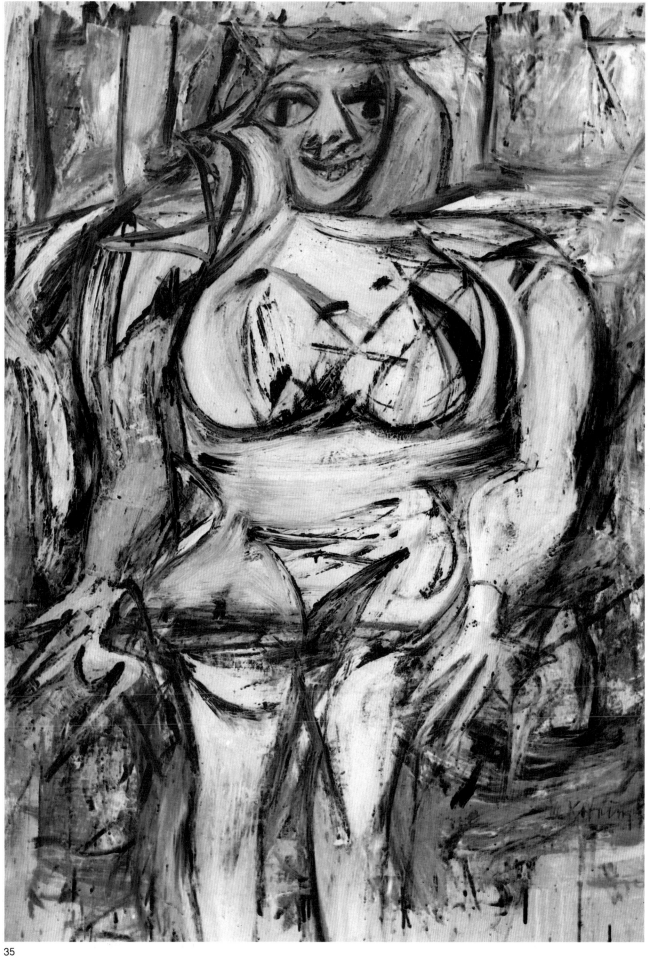

35

36

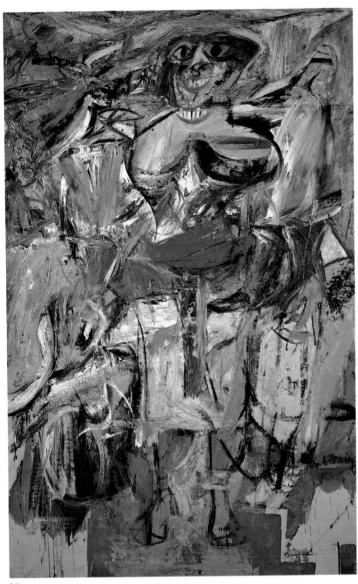

37

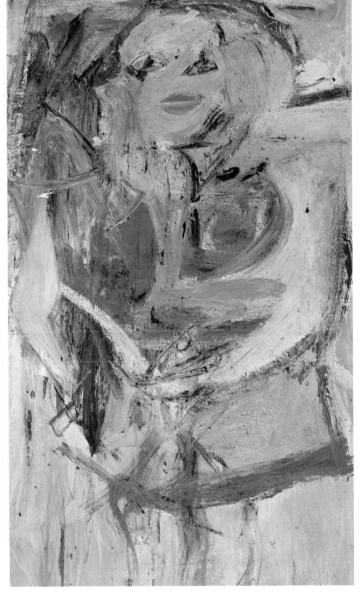

36. *Woman*, c. 1952
Crayon and charcoal on paper, mounted on
canvas, 29½ × 19¾ in.
Musée National d'Art Moderne,
Centre Georges Pompidou, Paris

37. *Woman and Bicycle*, 1952–53
Oil on canvas, 76½ × 49 in.
Whitney Museum of American Art, New York

38. *Marilyn Monroe*, 1954
Oil on canvas, 50 × 30 in.
Neuberger Museum, State University of
New York, College at Purchase

38

breasts below.[62] Her attributes, above all her hourglass figure, conjure up Mae West, another well-endowed woman who always had the upper hand. (In 1964 the artist produced a quirky oil on paper work and called it *Mae West*.)

De Kooning's repeated choice of glamourous women as subjects reflects, among other things, the persistence of the sex symbol in American society. Sometimes she comes on soft and sensuous like Marilyn Monroe, whose name was given to one of de Kooning's pictures of a slightly dizzy, peach-skinned blonde. The work dates from 1954—one of Marilyn's biggest years, during which she married and divorced Joe DiMaggio, entertained troops in Korea, fin-

39

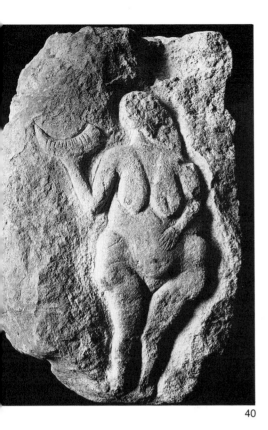

40

ished *The Seven-Year Itch*, and was featured in five *Life* magazine picture spreads. De Kooning had seen her in *Gentlemen Prefer Blondes* the year before.[63] He kept her calendar in his studio,[64] and when asked why he happened to paint her, replied:

"I don't know. I was painting a picture, and one day—there she was."

"Subconscious desire?"

"Subconscious, hell!" he laughed.[65]

De Kooning's Women triumph through their sexuality. Oddly enough, they are not erotic paintings, yet not because their subjects suffer any inhibitions. Some take on aspects of the freak, not cruelly mutilated by the artist, but painted up for a night on the town. Charged up and ready to roar, at heart they are exhibitionists, off-spring of a long line of sideshow and carnival performers who earn their living by being laughably grotesque. In terms of de Kooning's artistic development, the Women descended from his naughty ladies of the mid-1940s. But the 1944 Woman, for example—unlike the gargantuan Graces of the 1950s—does not stare us down frontally, and the longer we look at her the more remote she becomes. She cannot function in our world for a basic, yet surprising reason: actually, she is not a woman, but remains, literally, an object, a mannequin, closer to a puppet than a living model. De Kooning juggles several aspects of ambiguity here. At first we see this as a painting of a woman. Then we reinterpret it as the painting of a mannequin or marionette. Even so, it would be a nonfunctional marionette because one arm is partially severed from the body—at the shoulder—and the left leg seems fused with the hand. We may also wonder about the right hand: where does it go after it disappears abruptly under the other arm? At this point, due to these steps away from the natural world, de Kooning's image is far removed from us, and it is distanced still further by his coalition of mass and space.

By the time of *Woman I*, de Kooning's artistic process added up to a succession of images superimposed on each other. Harriet Janis and Rudi Blesh emphasized de Kooning's attack on the woman's image as he struggled to come to terms with it: "Perhaps never before has an artist placed an image on the canvas in order to attack it physically. Van Gogh and Soutine painted violently but their paintings were momentary releases from the battle they waged with themselves. De Kooning, attacking the canvas, attacked himself."[66] The Women are battlegrounds of abstract brushwork and figurative drawing where imagery undergoes violent metamorphosis. Above her breasts, *Woman III* has three stablike "wounds," displaced stigmata from some contemporary crucifixion.[67]

In *Woman IV*, much of the image's power—like that of a Byzantine icon—is concentrated in the eyes.[68] Her bug-eyes push beyond the head, while the bridge of her nose flares wildly to left and right. The elongated nostrils are a pair of accents, or ditto marks, underscoring the eyes above. De Kooning's treatment of the mouth is also unsettling, for the lips do not anatomically correspond to their edges. He has squashed *Woman IV* against the picture plane, which she has gingerly kissed, leaving her marks behind. The lip-prints

39. *Mae West*, 1964
Oil and charcoal on paper, 23½ × 18¼ in.
Hirshhorn Museum and Sculpture Garden,
Smithsonian Institution, Washington, D.C.

40. *Venus of Laussel*, c. 15,000–10,000 B.C.
Rock relief carving
Musée d'Aquitaine, Bordeaux, France

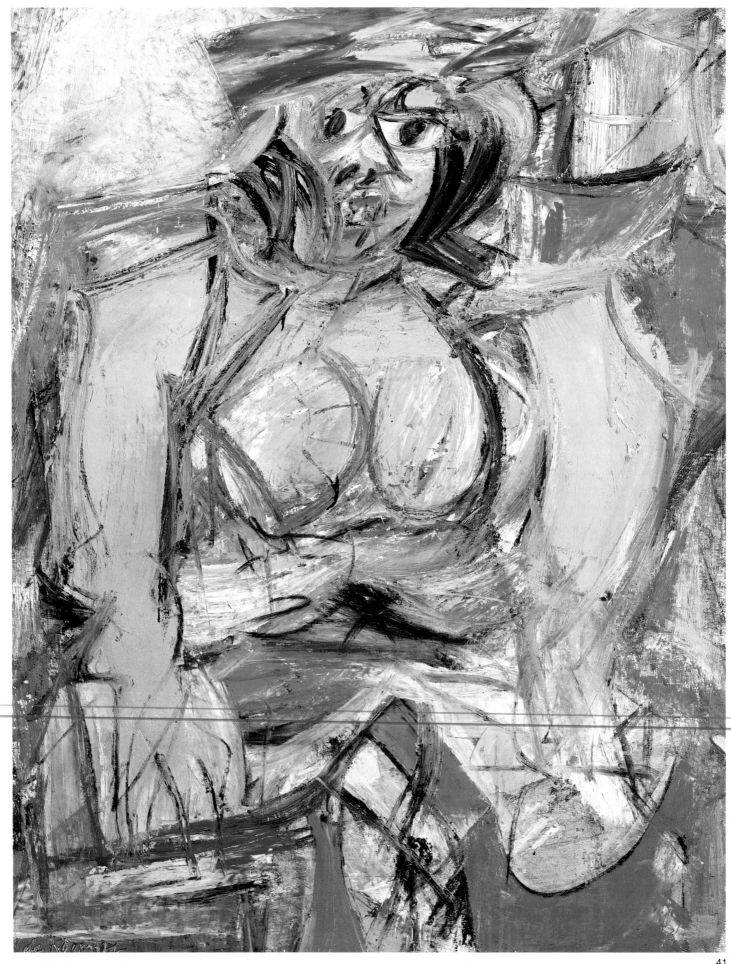

41

show us how she held her mouth a moment ago. Or, could it be that her mouth and lips have been disconnected? De Kooning may be trying to get them together and keep them apart in one image. As details in a major painting, they exemplify a prime paradox of de Kooning's art: it is self-contradictory *and* single-minded. Hess referred to this as "the central issue in de Kooning's art: his creative use of ambiguity."[69] The viability of this artistic idea as de Kooning realizes it may be measured by the degree of our frustration—and excitement—when considering such an image as *Woman IV*, a figure whose creator is always changing his mind. On one hand we fight against the painting as ugly, irrational, insulting to the traditional meaning of art as a well-defined object, but on the other we accept the image as gutsy, motherly, and desperately affectionate.

De Kooning's Women have been perceived by some as symbols of male chauvinism. The artist's well-known comment could be cited as confirming his degradation of womanhood: "Women irritate me sometimes. I painted that irritation in the 'Women' series. That's all." But he went on to say: "I *like* beautiful women. In the flesh; even the models in magazines."[70] If one takes these statements out of context or approaches his paintings as primarily an affront to women, certain essential factors are overlooked. First, de Kooning's Women are his expressionistic, highly personal response to a subject that has been painted, carved, and modeled for centuries.

41. *Woman IV*, 1952–53
Oil and enamel on canvas, 59 × 46¼ in.
Nelson-Atkins Museum of Art, Kansas City, Missouri
Gift of William Inge

42. *Woman VI*, 1953
Oil and enamel on canvas, 68½ × 58½ in.
Museum of Art, Carnegie Institute, Pittsburgh
Gift of G. David Thompson

43. *Woman*, 1953
Oil and charcoal on paper, mounted on canvas, 25⅝ × 19⅝ in.
Hirshhorn Museum and Sculpture Garden, Smithsonian Institution, Washington, D.C.

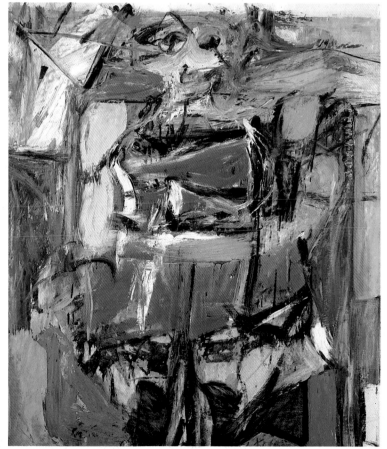

42

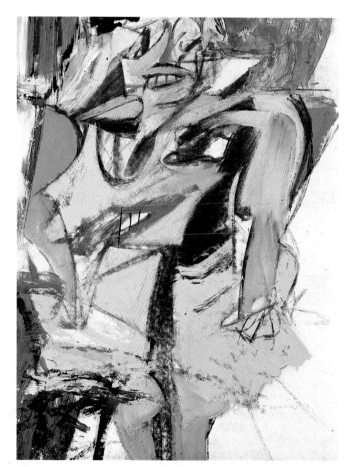

43

44

Paleolithic reliefs, such as the *Venus of Laussel*, testify to woman as subject for art since prehistoric times. Indeed, reviewing the Women in 1953, Sidney Geist commented acerbically: "Her image exists in the vast area between something scratched on the wall of a cave and something scratched on the wall of a urinal."[71]

A further reason why *Woman I* cannot be justly regarded as a degradation of womanhood is related to her powers of deliverance for the artist. By finally coming to grips with her image, de Kooning found redemption as an abstract/figural artist. If he had not finished *Woman I* he would not have stopped painting, but he would always have known that once he had taken on too much. *Woman I* is de Kooning's Senta, a queen of art who rescued him from the existential void. As if to reward her publicly, he painted a crown atop her head.[72] She is as much the embodiment of Abstract Expressionism in figural form as the Statue of Liberty is of "Liberty Enlightening the World." They are both American Dreams, conceived by Europeans. Both indomitable images may also reflect the artists' attitudes toward their mothers. Frédéric Auguste Bartholdi idealized his mother's features, turning them into the stern face of *Liberty*.[73] Hess has suggested a relationship between de Kooning's mother—at one time "bartender in a café largely patronized by sailors"—and the meaning of *Woman I*.[74] A strong-willed woman, de Kooning's mother said she would stay alive until her son came back to Holland to see her, which he did in 1968. She died the next year at the age of ninety-two.[75]

De Kooning's Women share with their prehistoric forebears one feature that, added to their female attributes, makes them archetypes. They are anonymous. They are images of woman in general, not portraits but conceptions. De Kooning retains this generality of image throughout the Women of 1950–55, while embedding it in specific contexts of slashing brushstrokes, scrapings, and impacted planes and spaces. In this regard, de Kooning's Woman has been worked over as thoroughly as a paleolithic figure symbolically used during a rite of passage.

Comparable to Pollock's "classical drip-paintings" or Kline's black and white abstractions of the 1950s, de Kooning's Women are renowned monuments of Abstract Expressionism. They have, not surprisingly, spawned irreverent variations by younger artists, from Peter Saul's dayglo *Woman with Bicycle* to Mel Ramos's *I Still Get a Thrill When I See Bill* (à la Farrah Fawcett) and Joe Brainard's "de Koonings" with cartoonlike *Nancy* heads. Larry Williams, an artist whose preferred medium is transparent tape, even reshaped his own face into a startling likeness of *Woman I*.

44. Larry Williams
Forgeries, from *Metamorfaces*, 1975

45. *Monumental Woman*, 1953
Oil and enamel on canvas, 68½ × 58½ in.
Private collection

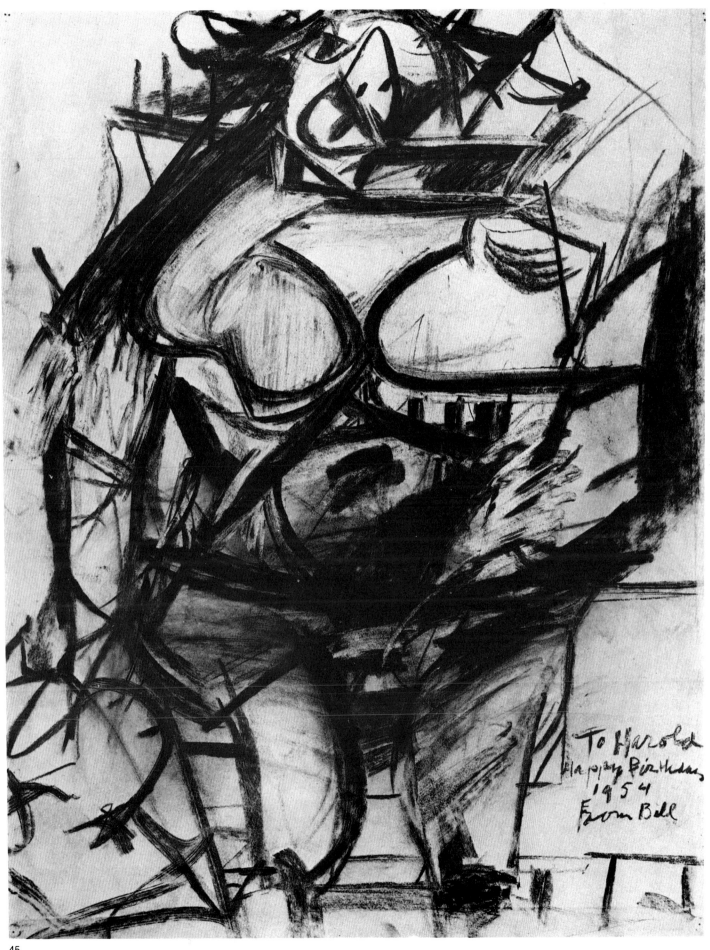

To Harold
Happy Birthday
1954
From Bill

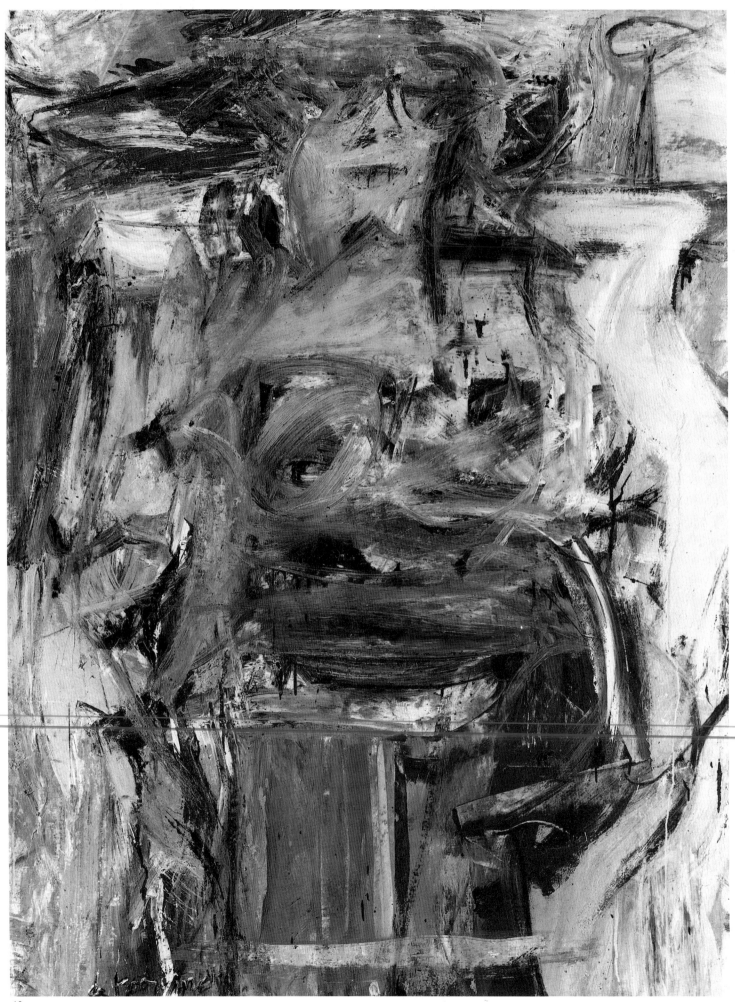

4 The Landscapes

De Kooning painted himself away from Woman by ploughing her under as landscape. By doing so he began, symbolically, to return her body to the earth. *Woman as Landscape* (1955) acquires meaning as artistic burial and resurrection. And since 1955, Woman has turned out to be de Kooning's phoenix, working her way into his consciousness and clambering back to the surface of his paintings.

Woman as Landscape is unfinished. The artist let it out of his studio only because of his dealer's insistence,[76] and this may have saved the painting from the slashing oblivion of de Kooning's brush. At any rate, the image is not so much ensnared by its surroundings as enlarged to fill out the entire picture surface. Here, Woman is like Alice: she starts growing and keeps growing until there is room for little else. Yet unlike Alice, de Kooning's Woman turns into landscape. He spreads her to nearly all the edges of the canvas and comes up with a mountain-mama, treetop tall. As an artist de Kooning faced the problem of how to get Woman and her progeny out of his system—at least for a while. The solution turned out to be a walk in the country.

For centuries the close association of woman and landscape in art has been *de nature*: ancient and Baroque Floras, Giorgione's redolent *Venus*, Ingres's *La Source*, Henry Moore's omniscient figures with the contours and bulk of mountains, valleys, and caves. Like ballet for Balanchine, nature has been essentially female for Western man. Until 1979 hurricanes were given feminine names; in 1955, the year de Kooning pulled away from Woman, Diane hit the east coast. The storm and subsequent flooding eventually took 184 lives and caused more damage than any series of storms yet on record in the United States. The preceding September, Hurricane Edna had struck Long Island and many of de Kooning's works were destroyed. They had been stored in a shed at the "Red House" in Bridgehampton, where the de Koonings had spent the summer with Franz Kline, Nancy Ward, and Ludwig Sander.

Color had stirred up its own storm in some of the Women, such as *Woman V* (1952–53), where the image is assaulted by reds, pinks, greens, blues, whites. In *Woman as Landscape*, de Kooning's color is just as intense in places, but not so fractured. Congealing in sev-

46. *Woman as Landscape*, 1955
Oil on canvas, 45½ × 41 in.
Private collection

eral passages, color stakes separate claims rather than charging, hell-bent, over the entire picture.

Along with the disintegration of woman as image comes an increasing emphasis on autonomous brushwork. Many strokes in *Woman V* and *VI* are hyperactive. Banging into each other, they embed themselves in the figures and their clamorous space. Yet in *Woman as Landscape*, brushwork permeates the figure's bowels as well as disrupts surface planes. The twisting, smearing, flaying strokes pull from inside the figure, opening it up in a madly surgical way. The authority of de Kooning's brushwork in mangling the image internally as well as externally makes it clear that the painter's stroke, liberated from any descriptive function, supplants Woman as the subject of his art.

In 1955–56, on the way back to total abstraction, de Kooning produced a series of wrenching paintings sometimes described as "urban landscapes." Two of the best known are *Easter Monday* and *The Time of the Fire*. Their titles are not descriptive; they are personal tags referring to the specific time de Kooning worked on them. *Easter Monday* was completed on Easter Monday in 1956 and went right from his studio to his one-man show at the Janis Gallery.[77] *The Time of the Fire* was named for the fire in July 1956 that destroyed the Wanamaker Department Store between West Eighth and Tenth streets. Many artists, including de Kooning, were living in the neighborhood and turned out to watch.[78]

Easter Monday is one of the most ambitious and noisy paintings produced during the height of Abstract Expressionism. The amplitude of the work, its range of brushwork, its abundance of planes and spatial congestion, its muscularity and toughness, and the complex substantiality of its surfaces add up to a phenomenal experience that refuses to fade away. As in reading an eight hundred-page novel like Dreiser's *American Tragedy*, one may forget detailed descriptions and incidents, but the scope of the work and its rough edges stick in the mind. In his interview with Harold Rosenberg, de Kooning observed: "A novel is different from a painting. I have said that I am more like a novelist in painting than a poet. But this is a vague comparison because there is no plot in painting. It's an occurrence which I discover by, and it has no message."[79]

The scope and content of *Easter Monday* may be epic, but it is not a long-winded painting. Nor does it invite hours of step-by-step seeing, as does *Excavation*, painted six years before. De Kooning accelerated his abstractions in the late 1950s. The *Women* can be recognized as holding frontal poses: they are standing or sitting and looking. It was what de Kooning did to their images through brushwork and an erratic overlapping of mass and space that energized the paintings. But in *Easter Monday* and *The Time of the Fire* nothing is static—unless one imagines the kind of noise such paintings would emit. Even the space moves. And, as in *Pink Angels* from 1945, it moves fast. These paintings and their contemporaries such as *Saturday Night, Police Gazette,* and *Gotham News* condense not the appearance of New York, but its pace, its instant irritability. All of de Kooning's planes, brushstrokes, color patches hurry to get someplace. They are deliberately loud and brash.

47

47. *The Time of the Fire*, 1956
Oil and enamel on canvas, 59¼ × 79 in.
Private collection

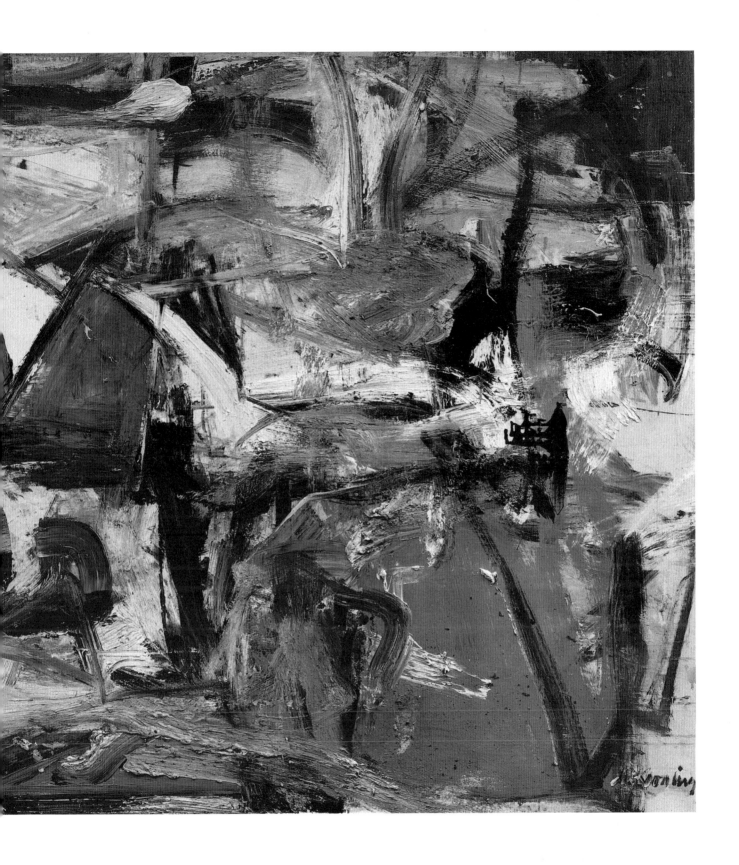

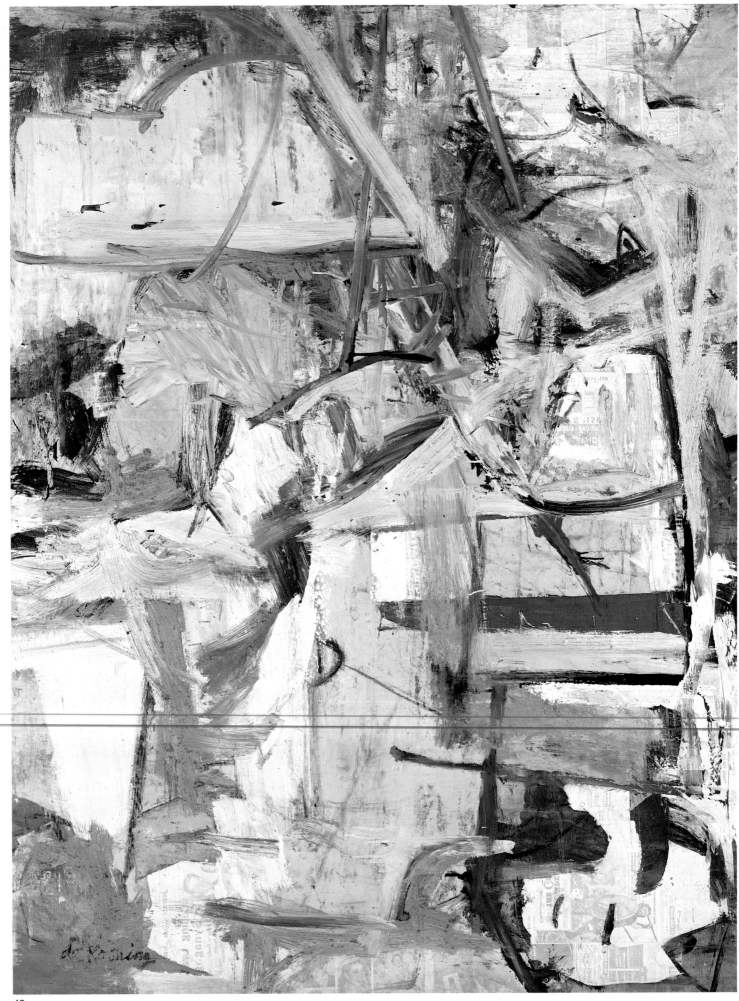

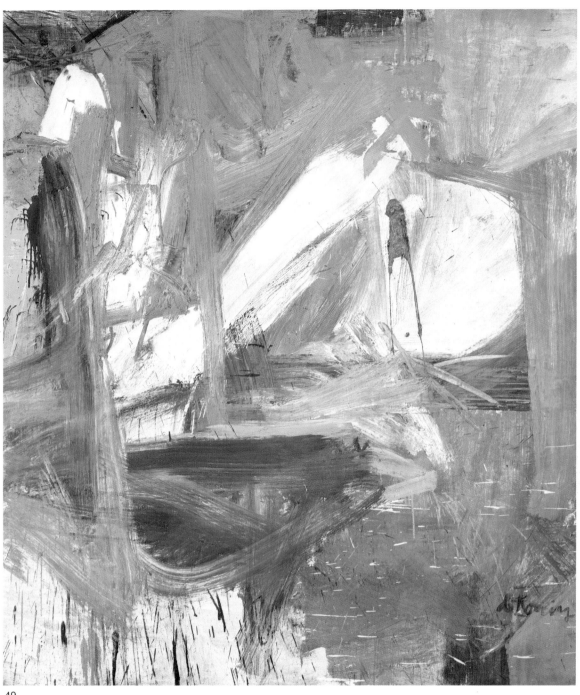

49

48. *Easter Monday*, 1956
Oil and newspaper transfer on canvas,
96 × 74 in.
The Metropolitan Museum of Art, New York
Rogers Fund, 1956

49. *February*, 1957
Oil on canvas, 79 × 69 in.
Mr. and Mrs. S. I. Newhouse, Jr.

No other paintings in the history of Abstract Expressionism are packed with such raw antagonism. De Kooning's splintered stroke changes direction without warning, cutting into the paths of other strokes and planes. In *Easter Monday* a red, dartlike accent at center right takes on the connotations of a wound, a gash opened in the living body of the painting. Similar to some of the Women, these works may be regarded as battlefields for more than stylistic reasons. Sidney Janis has recalled that de Kooning's paintings would sometimes arrive at the gallery punched through with ragged holes: in painting them the artist had rammed his brush through the canvas.[80] As an example of "action painting," this equals in physical intensity Pollock's experience of being "in" the painting.

Particularly when working on big paintings during this period, de Kooning would often press paper—usually newspaper—against certain sections of the work to keep the paint from building up and becoming unworkably thick. When de Kooning peeled off these newspaper sheets they left reversed, offset images, which could be retained, reworked, or completely painted out. An ingenious way of muting white passages, this technique brings to mind the Cubists' use of newspaper cuttings in collage. Yet for de Kooning, these serendipitous impressions provided an odd, semi-readability for some areas of a painting. They reflect his search for a new, non-routine way of picture making. In *Easter Monday* the gray newspaper images—such as an advertisement for *Alexander the Great* in CinemaScope—offer a faded figurative alternative to the strokes on

51

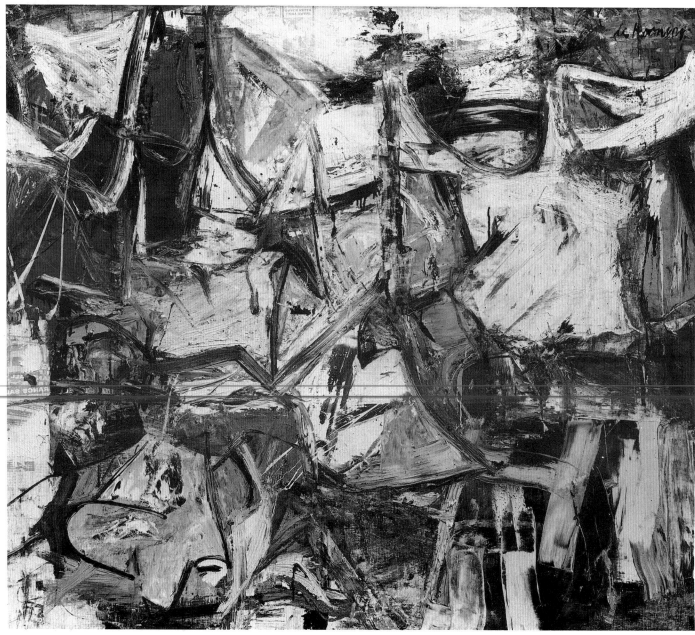

51

50. *Gotham News*, c. 1955–56
Oil, enamel, and charcoal on canvas,
69½ × 79¾ in.
Albright-Knox Art Gallery, Buffalo, New York
Gift of Seymour H. Knox

51. *Easter Monday*, detail. See plate 48.

top. These newspaper "ghosts" might have suggested certain brushstrokes to de Kooning as he worked on the painting. Two short strokes at bottom right correspond to Alexander's two spears. The smaller stroke is even a convex curve like Alexander's shield. However, if any relationship exists between the subject of the movie and de Kooning's own "heroic" activity in creating *Easter Monday*, it remains coincidental.

To keep his paint surfaces malleable, de Kooning sought various ways to retard paint drying. A fellow artist who used a "secret" technique was Landès Lewitin. De Kooning recalls Lewitin as a "serious character who knew more than anyone else—or at least seemed to." When de Kooning asked repeatedly how to keep paintings from drying, Lewitin replied: "Find out for yourself." Then, one night after leaving the Cedar Bar, Lewitin collapsed on the sidewalk. De Kooning got some whisky down him, helped him up, and took him home. Just before dropping off to sleep, he thanked de Kooning, adding, "By the way, it's oil of cloves that prevents the drying."[81]

Occasionally de Kooning has put pieces of drawings together, building them in an additive way. This is not, however, an equivalent of Cubist collage. Whereas Cubism tended to articulate planes, if not in a predictable, then in a measured way, de Kooning abhors the fixed and clearly defined. He found Cubism's pinning down of things anathema and explained: "I am said to be Cubist-influenced. I am really much more influenced by Cézanne than by the Cubists

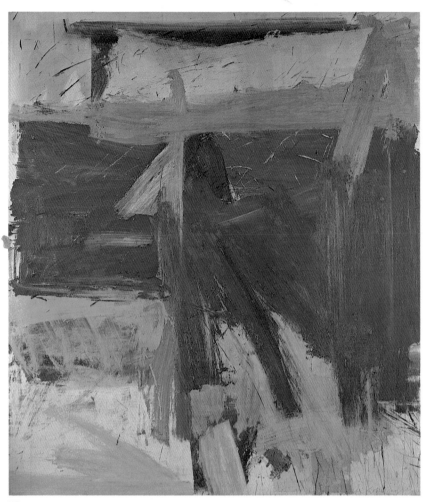

52

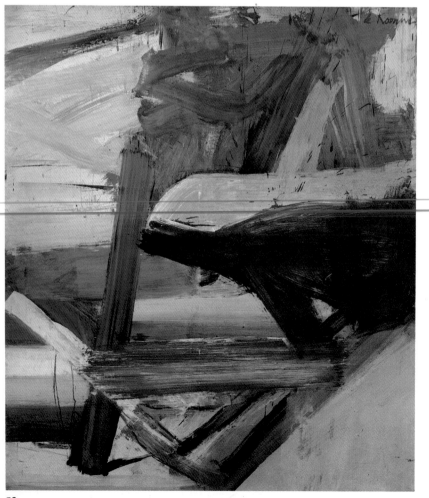

53

52. *Ruth's Zowie*, 1957
Oil on canvas, 80¼ × 70⅛ in.
Private collection

53. *Bolton Landing*, 1957
Oil on canvas, 83½ × 74 in.
Courtesy Xavier Fourcade, Inc., New York

54. *Montauk Highway*, 1958
Oil on canvas, 59 × 48 in.
The Michael and Dorothy Blankfort Collection

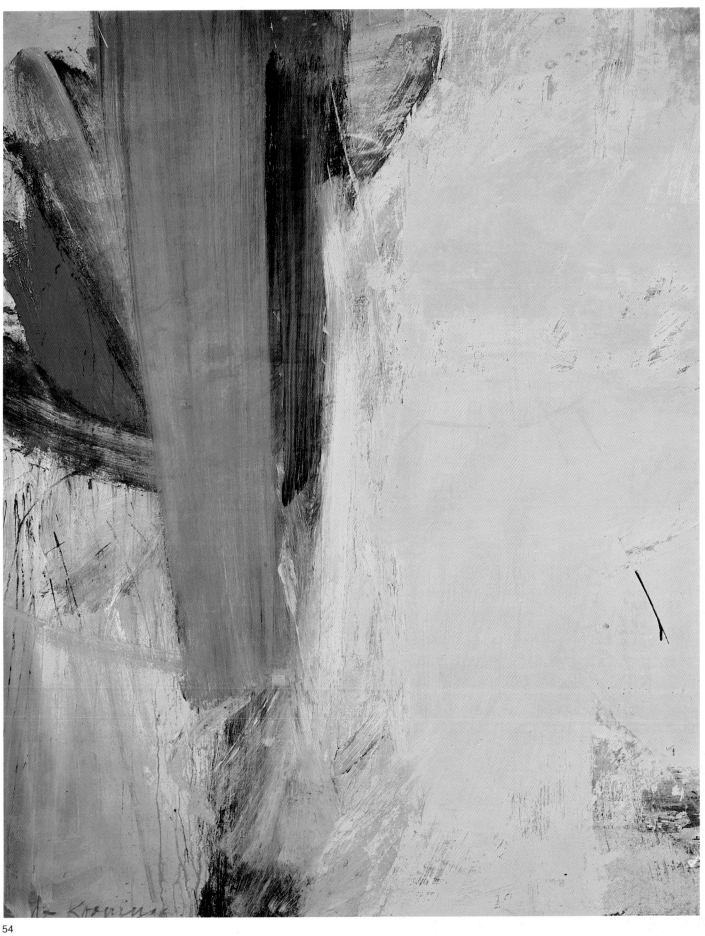

54

because they were stuck with the armature. I never made a Cubist painting."[82] In an important 1958 article, "Epitaph for an Avant-Garde," John Ferren noted why modern American artists working abstractly had turned their backs on Cubism: "We came to see it as the modern academy, the new province of the industrial arts, more suitable perhaps to the flood of mass-produced interior decoration. Cubism was a body of intellectual precepts concerning reality which showed us how and why to make a picture we no longer wanted to make."[83] Indeed, de Kooning's continual search for new means of picture making leads him even further from Cubism today.

As declarations of site and season and, equally significant, as assertions of the artist's synthesis of those elements in the painting process, de Kooning's "abstract landscapes" are monumental locales of Abstract Expressionism. In general, one experiences a quickening of time and space in these earth-shattering canvases from their inception in 1957 to their extrapolation in 1963. From

49, 65 *February* (1957) to *Door to the River* (1960), de Kooning articulates ever-expanding planes while reducing auxiliary painting gestures. As one of his most let-fly, no-holds-barred works, *February* has been described as "the breakthrough . . . all sun, sky, earth, and sea."[84] While certainly consequential, *February* can hardly be considered the single moment when de Kooning finally succeeded in steering clear of woman as subject. Avoiding her meant more than one plunge into a nonfigural context, and, inevitably, she came

64 bobbing to the surface again in *Pastorale* (1963).

February is one of several paintings done in 1957—*Palisade* is another—in which de Kooning wiped out illusionistic depth largely through full-arm gesture. In the black and white works from the late 1940s, depth had been severely restricted. It was nearly excluded from *Excavation* in 1950. Yet in those earlier instances, de Kooning suppressed depth either by smothering it under shapes or by stretching it so close to the picture plane that it warped beyond

52 recognition. In *February* and other paintings of 1957–59—*Ruth's Zowie, Parc Rosenberg, Merritt Parkway*—brushwork pushes depth out of the picture. Made with wide, commercial brushes, the strokes do not define or imply form; they supersede it. Pollock had achieved a comparable liberation of paint from form in 1947 with, of course, completely different means and effect. Rothko may be credited with a similar achievement in his paint- and form-freed epiphanies of color and light beginning in the late 1940s.

De Kooning's abstract landscapes of 1957–60 differ from their urban predecessors (*Easter Monday, The Time of the Fire,* etc.) in having a greater succinctness and unity. They are more cohesive, not so scattered. Strokes do not allude to explosion, do not appear to fly at breakneck speed toward all edges of the canvas. In *February,* de Kooning braces the composition with blue bands at the left and right like a vice. Counterthrusts pull toward the center. If any threat to the painting's power can be imagined, it is a threat of implosion.

Each abstract landscape has a climate of its own: *February,* even if untitled, would produce a sharp, blue-white chill. The warmest

55 abstraction in this series is *Suburb in Havana* (1958), named by de

55. *Suburb in Havana*, 1958
Oil on canvas, 80 × 70 in.
Mr. and Mrs. Lee V. Eastman

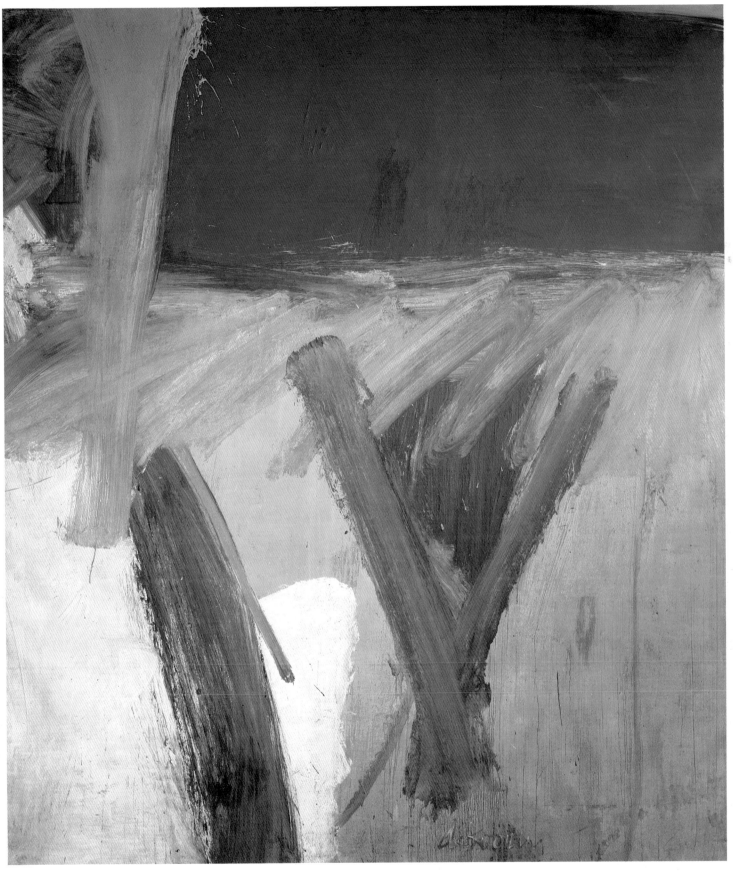

55

Kooning after a trip to Cuba during which he looked for Hemingway's home in the Havana suburbs.[85] An artist once noted that "De Kooning keeps all the paint in front of the picture" and de Kooning's reaction was: "I considered that a great compliment."[86] Everything in *Suburb in Havana* constantly pushes forward and, at the same time, moves across, up, and down, never betraying the flat surface. It is an extremely spare and well-built painting, with all the breadth of a scalding day in late summer. Indeed, it recalls van Gogh's wheatfields, paintings in which he equated yellow-white sun with ocher earth. Geophysical as well as passionate heat radiates from such pictures. Remarkably, *Suburb in Havana* is a hot painting without true red. As a full-bodied affirmation of fired-up picture making, it is also de Kooning's most sparsely settled abstraction—a landscape demanding such indigenous hardiness that few can thrive there.

Much has been said about the relationship between de Kooning and Franz Kline, above all from the time of Kline's first one-man show at the Janis Gallery (March 1956) until his death in May 1962.[87] Noting that they had met in 1943, de Kooning has described Kline as "my best friend."[88] De Kooning's abstract landscapes and the Black and White Rome Drawings (1959–60) bear stylistic correspondences to Kline's brawny, elemental structures. And works such as *Ruth's Zowie, Suburb in Havana,* and *Door to the River*— dominated by wide, vigorous strokes, largely un-reworked—verify de Kooning's grasp and rearticulation of ingredients in Kline's mature style. In spite of instantly recognizable similarities, how-

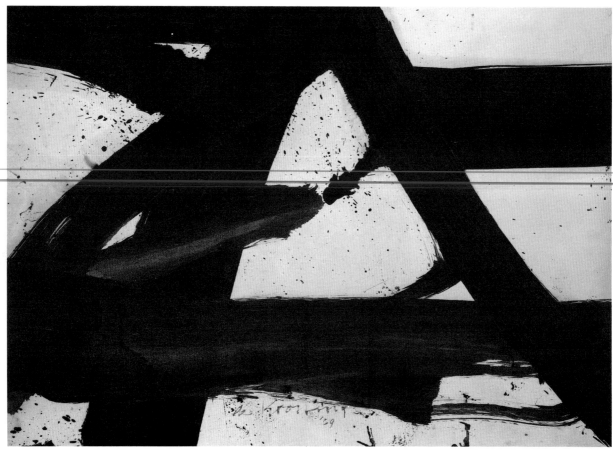

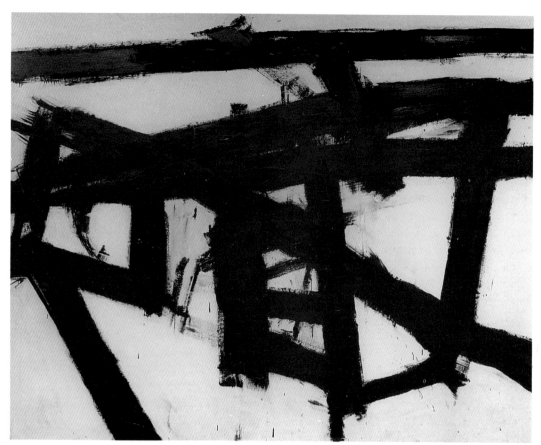

57

ever, each artist's work states a distinct painterly and emotional identity. As close as de Kooning's *Black and White Rome (Two-Sided Single L)* of 1959 may come to Kline, it remains unquestionably de Kooning. 56

Kline's abstractions of the mid-1950s are leaner, more given to structural brawling. His clearly hewn forms allude to three-dimensional space. And his paintings referring to specific places—for example, *Mahoning, New York, Bethlehem*—are logical expositions of thrusts and counterthrusts. Unlike this, de Kooning's abstractions at this time, with all their high-speed grand slams and unkempt surfaces, are spatially congested, indeed they raze space by impinging on the picture plane. 57

One reason for such different approaches to abstraction may lie ultimately in the artists' American and European backgrounds, regardless of Kline's art education in England and de Kooning's total identification with the New York School. Traditionally, Americans—including artists—have been problem-solvers. Kline always sought through the drawing and painting process to make a painting work, to bring it off, to "catch" it. "With de Kooning," Kline observed, "the procedure is continual change, and the immediacy of the change."[89]

Naturally, the Kline/de Kooning influence was reciprocal. De Kooning had an impact on Kline's last work, notably his large paintings with color, 1959–61. In structure, form, scale, and allusion to place, albeit not color, Kline's *Provincetown II* (1959) is the counterpart of *Suburb in Havana*.[90] Kline's last painting, the pervasively blue *Scudera* (1961), reflects de Kooning's *A Tree (Grows) in* 59

56. *Black and White Rome (Two-Sided Single L)*, 1959
Enamel on paper, 28 × 40 in.
Whitney Museum of American Art, New York
Gift in memory of Audrey Stern Hess

57. Franz Kline
Mahoning, 1956
Whitney Museum of American Art, New York

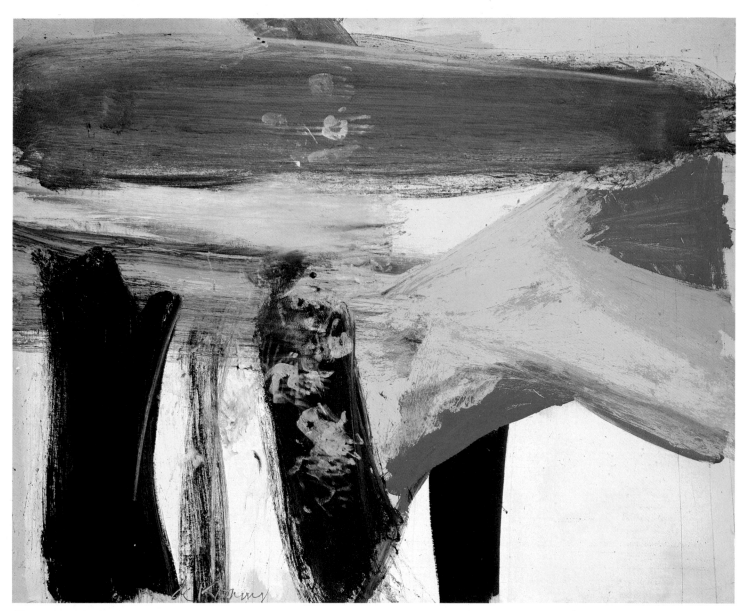

58

Naples of the previous year. Yet the confluence is largely one of intense hue, for while de Kooning's horizontal-vertical integration continues the landscape orientation of his 1957–60 series, *Scudera* moves into a more open-ended treatment of space. In an odd turnabout, with these paintings de Kooning's planar compositions establish particular locales, while Kline's immeasurable space expands toward generalities, both physically and metaphysically. Although the Kline/de Kooning relationship was symbiotic, their work differs in style, technique, and artistic attitude: Kline's gregarious romanticism vs. de Kooning's hard-bitten classicism.

In 1958, at the same time that he was at work on the abstract landscapes, de Kooning produced a group of small paintings in oil, each 8 by 7 in. Truncated forms, compact spatial planes, and densely pigmented surfaces make them, in all likelihood, the most monumental abstractions of their scale ever painted. They seem to

60, 62

58. *Lisbeth's Painting*, 1958
Oil on canvas, 49½ × 63 in.
Sydney and Frances Lewis Collection,
Richmond, Virginia

59. *A Tree (Grows) in Naples*, 1960
Oil on canvas, 78¼ × 70⅛ in.
The Sidney and Harriet Janis Collection
Gift to The Museum of Modern Art, New York

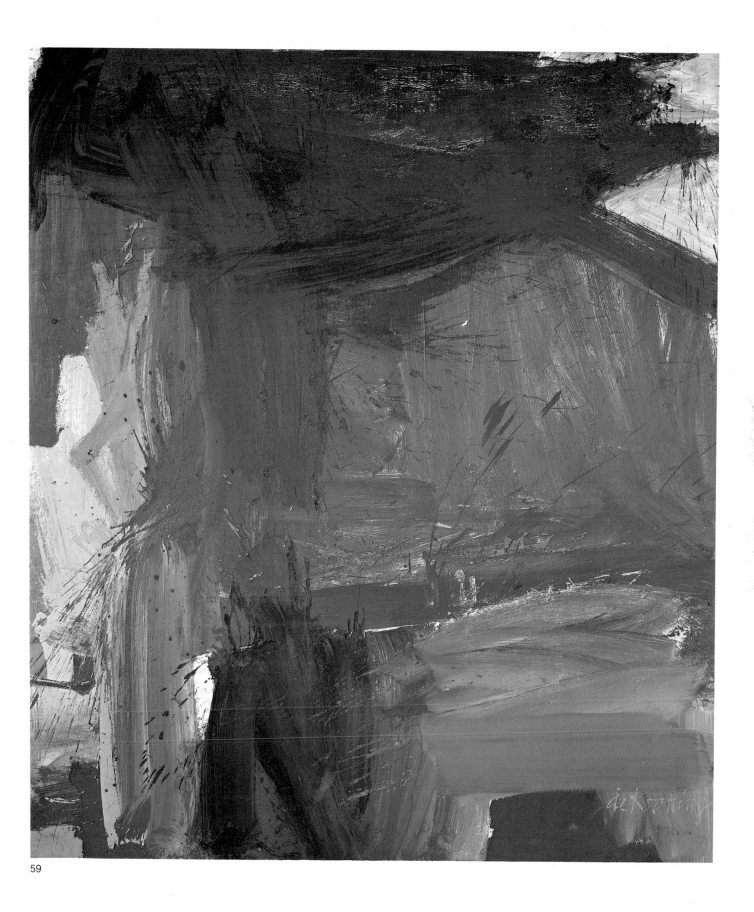

59

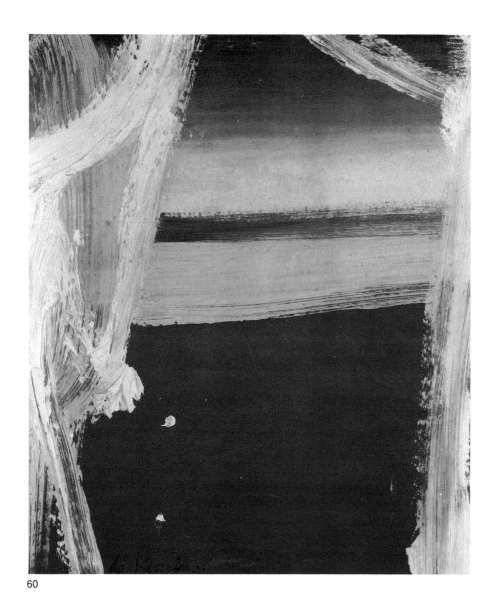

60

be fragments cut from some once-colossal work, self-sufficient pieces small enough to fit in one's hand, yet heavier than earth itself. Oskar Kokoschka once remarked that making a big painting is always easier than a small one,[91] an axiom reaffirmed by the concentrated energy of de Kooning's small, but far from diminutive series. Pantagruelian in toughness and wit, they exemplify another axiom of art history: monumentality exceeds physical scale.

Throughout his career de Kooning has experimented with numerous media, and the mid- to late 1950s was a technically rich period as he worked in pastel, pencil, ink, oil, and enamel, varying greatly the size of his paintings and drawings. Pastels from the mid-'50s illustrate his ongoing consideration of how image relates to 61 scale. In one (*Untitled*, c. 1956–57), marks stretch beyond the outlines of a nearly square "frame." (Even when working small, de Kooning likes an almost-square format.) More remarkable is the range in size of the pastel strokes and the positive/negative exchange they engender. What should be in-between space unpredictably turns into a form as positive as the dark marks flanking it. As

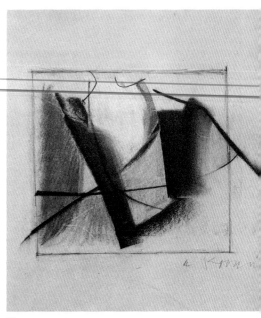

61

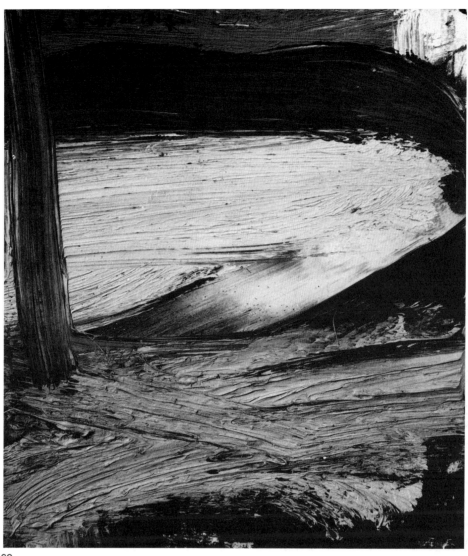

62

well as carrying a strong kinetic charge, the directional thrusts of lines and planes in these drawings convey a sculptural sense: an improvisational geometry ties things together. One thinks of David Smith's late works (*Cube Totem*, 1961; *Cubi XXVI*, 1965).[92] Other, perhaps closer, three-dimensional parallels are Anthony Caro's steel constructions made during the 1960s.[93]

Moving in 1960 toward greater color luminosity in the abstract landscapes, de Kooning stretched yellow, white, and pink planes more tightly than anything since *Excavation* of 1950. Some canvases, such as the ebullient *Rosy-Fingered Dawn at Louse Point* 63 (1963), are amalgams of seemingly transparent zones locked into place by thickly painted, rough-surfaced strata. The brush has been scrubbed and twisted in the semiwet paint to firm up expansive gestures, appropriating to them geological overtones: a full, solid stroke may stand, physically, for a landscape equivalent. Not necessarily a specific landscape feature, this may allude to an unseen, yet surely felt force in nature at a particular place and time. Speaking of his bicycle trips several years ago, de Kooning said: "I go to

60. *Small Painting I*, 1958
Oil on canvas, 8 × 7 in.
Private collection

61. *Untitled*, c. 1956–57
Pastel on paper, 15¾ × 13¾ in.
Collection of the artist

62. *Small Painting III*, 1958
Oil on canvas, 8 × 7 in.
Private collection

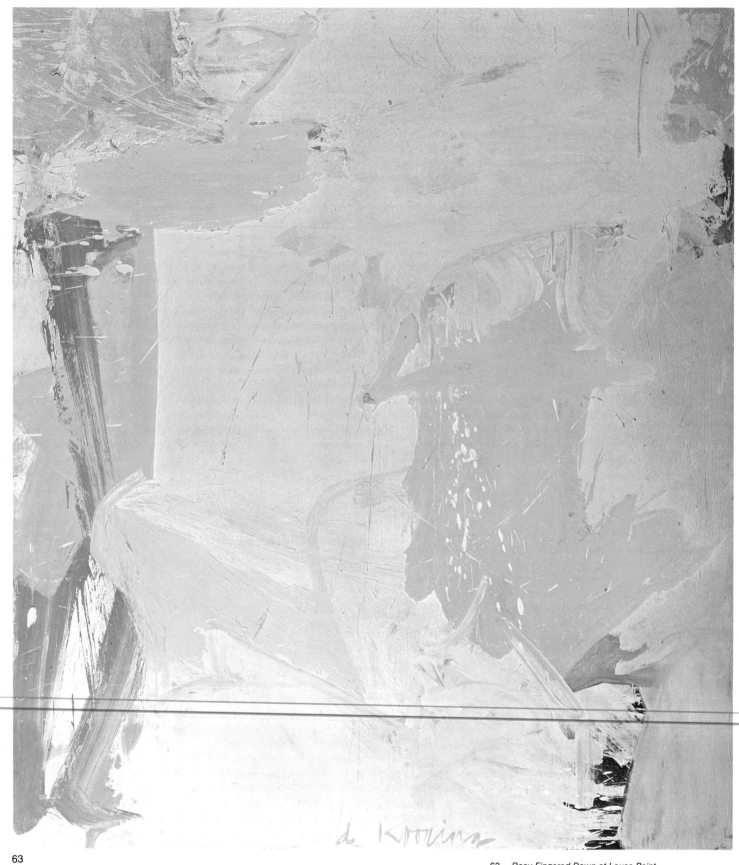

63

63. *Rosy-Fingered Dawn at Louse Point*,
1963
Oil on canvas, 80 × 70 in.
Stedelijk Museum, Amsterdam

64. *Pastorale*, 1963
Oil on canvas, 70 × 80 in.
Private collection

Louse Point, a nice beach on Long Island Sound, where the water is quiet, not wild ocean. I reflect upon it. The water reflects, but I'm reflecting on the water."[94]

Some paintings in this more alkaline than acid series play on elusive transparency. What seems milky or opaque at first later shifts to admit air and sunlight. Surfaces are pulled taut. In 1945, *Pink Angels* had cautioned viewers to keep their distance because of the fast-moving forms caught in a spatial vortex. The paintings of 1961–63, with all their lyricism, lack space to accommodate anyone. Rather, they are craggy, confectionary landscapes flattened by light—intense, saturated light. To be sure, this is remote from the

Impressionist light in works by Monet or Pissarro. Impressionist light is an aesthetic counterpart to transitory phenomena in nature. Monet's brushstrokes refer to natural light while never recreating it. De Kooning's light, on the other hand, is a mixture of everything that constitutes light in nature: color, air, temperature, humidity. And it is light inextricably bound to the substance of paint. One scans these pictures and feels that the artist has enjoyed moving the paint around, teasing it to perform. This was not so six or seven years earlier when—as in *Easter Monday*—the brushstrokes urgently revealed de Kooning's artistic turmoil. Coming soon after the Women, de Kooning's mid-1950s abstractions documented the artist in pursuit of himself. But in these 1961–63 landscape surrogates, it is time to breathe more easily, to sit in the sun, walk on the beach. One dare not relax completely, for these are just as exacting as the earlier paintings, but in an amiable, exhilarating way. De Kooning is not caught up in a life-or-death struggle here, as one feels he was in 1955–56.

From 1957 to 1963 de Kooning's preferred scale for large paintings was 70 by 80 in., a nearly square rectangle. Such canvases are picture-window size, big but not overwhelming in scale. He likes the almost-square proportions, which create an off-center pull. A painting must be dominated by the force and direction of its abstraction, not by its dimensions. "I like squarish forms. So I make paintings 7 to 8; 70 by 80 inches. If I want it bigger, I make it 77 by 88 inches. That is kind of squarish. I like it, but I have no mystique about it. Also, I like a big painting to look small. I like to make it seem intimate through appearing smaller than it is."[95]

In all probability such scale and proportions are also due to de Kooning's penchant for turning a painting while at work on it, something he has always done.[96] Hess points out that with *Pastorale* in 1963 "the emergent shape of a standing figure can be seen if it is assumed for a moment that the left-hand side of the picture is the top."[97] This is a premonition of a new pride of women, younger, more voluptuous, and much more given to contortionist antics than the "heavies" of 1950–55.

In 1963, shortly after painting *Pastorale*, de Kooning moved to The Springs, near East Hampton, and built what has by now become the most legendary artist's studio in America.[98] He had spent summers in eastern Long Island since 1951 and decided to move there to work undisturbed by New York's frenetic art scene. After thirty-five years as a professional artist, having had seven one-man New York shows and with his work gaining acceptance in the United States and abroad, de Kooning—like Picasso and Pollock before him—was becoming a celebrity.[99]

65. *Door to the River*, 1960
Oil on canvas, 80 × 70 in.
Whitney Museum of American Art, New York
Gift of the Friends of the Whitney Museum of American Art

74

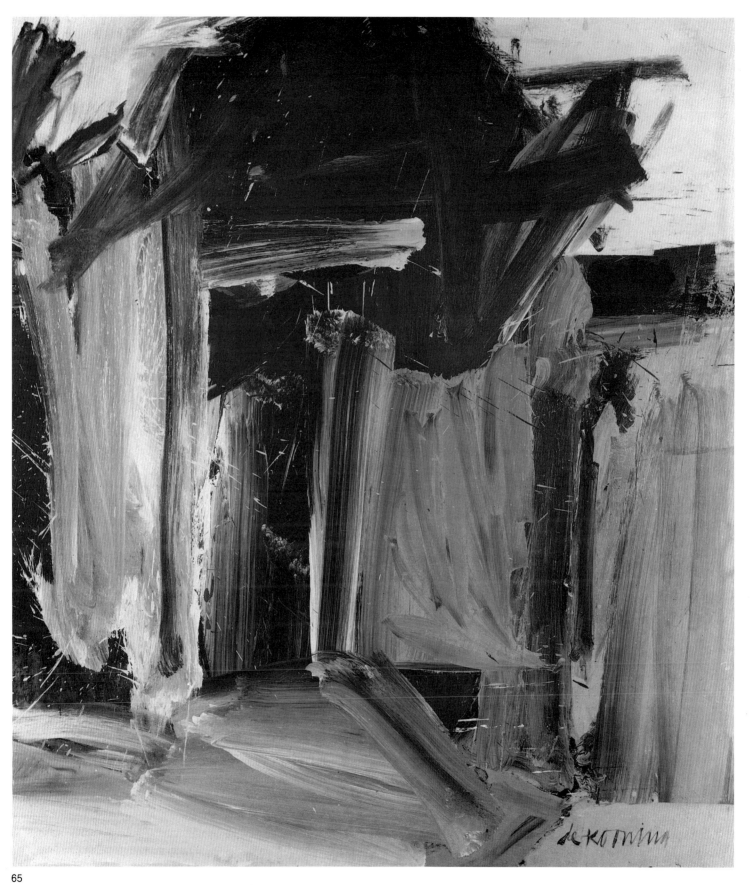

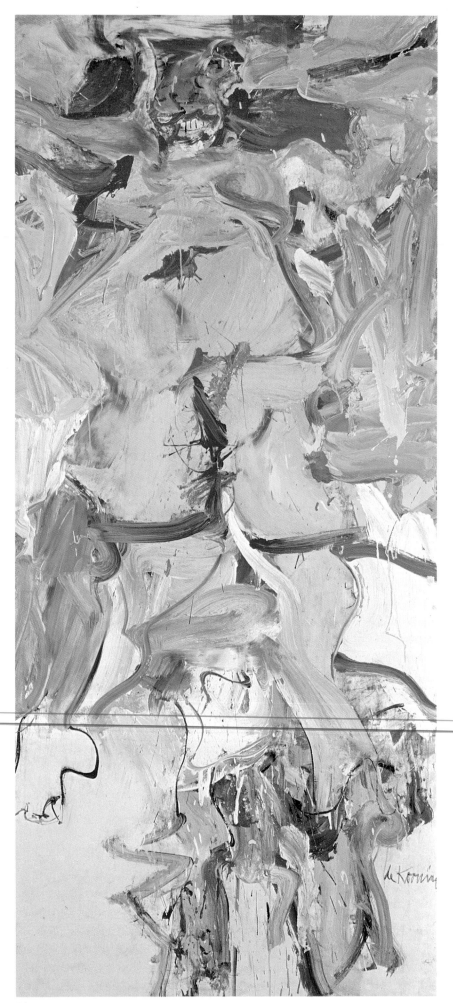

5 Women, Men, and Landscapes

De Kooning's new Women are frolicking, fertile muses, ready to jump up and down in celebration of their host's spacious, light-filled studio. Not only do they grin less threateningly than their older sisters of 1950–55, they also sing, chatter, loll in the water, and straddle sand dunes. One critic noted that these "recent wenches must come across as fundamental as a belch."[100]

In 1964 de Kooning radically changed his format for these jubilant women. An elongated field, instead of the customary near-square, resulted in part from proportions of wooden doors, 80 by 36 in., which he ordered from a Long Island manufacturer. He once thought of lining up these paintings side by side like an improvised polyptych, but gave up the idea, probably because of each figure's relentless personality.[101]

The matriarch of this long-legged group is *Woman, Sag Harbor*, a pun-inflected title originating from an association of place, image, and de Kooning's response to both. "When I made *Woman, Sag Harbor* I just titled it that, because I go to Sag Harbor and I like the town and I frequently have this association. While I was painting it I said to myself, 'That's really like a woman of Sag Harbor, or Montauk, where it's very open and barren.' "[102] In *Woman, Sag Harbor* and other figures of the 1960s—male as well as female—de Kooning vigorously exposes and probes their sexuality. Women are repeatedly opened up, legs lifted and spread frog-fashion. Such splayed poses and well-lubricated genitalia are also features of de Kooning's sculpture.

Unlike some in the Door series, *Woman, Sag Harbor* blatantly flaunts her ambiguity. She may be standing, running, or seated. She may be exhibiting the front or the back of her miraculously mobile torso. Yet regardless of her accessibility by whatever route, over land, sea, or mounds of hot-pink flesh, she descends directly from *Woman I*. Both are water-logged:

De Kooning: Woman I, for instance, reminded me very much of my childhood, being in Holland near all that water. . . .
Rosenberg: You mean you had the water feeling even in New York?

66. *Woman, Sag Harbor*, 1964
Oil on wood, 80 × 36 in.
Hirshhorn Museum and Sculpture Garden,
Smithsonian Institution, Washington, D.C.

67

De Kooning: Yes, because I was painting those women, and it came maybe by association, and I said, "It's just like she is sitting on one of those canals there in the countryside."[103]

Woman I and her Sag Harbor offspring also share "Say cheese" grimaces and, amazingly, wear similar "shoes"—except that the ending of their nether limbs can never be defined so conclusively. (Depending on how *Woman, Sag Harbor* is read, one can also see her as being barefooted.) *Woman I* is the only painting in the early series to include the subject's feet. And while shoes are one possibility, hooves are another—whether cloven or not, de Kooning leaves to the viewer's discrimination.[104]

68 By 1967, in his Woman on a Sign series, de Kooning had kneaded the female body into a yeasty erotic landscape. A parallel exists between the exuberant brutality of these paintings and the mind-

67. *Women Singing*, 1966
Oil on paper, 36⅛ × 24¼ in.
Private collection

68. *Woman on a Sign I*, 1967
Oil on paper, 48½ × 36¼ in.
Private collection

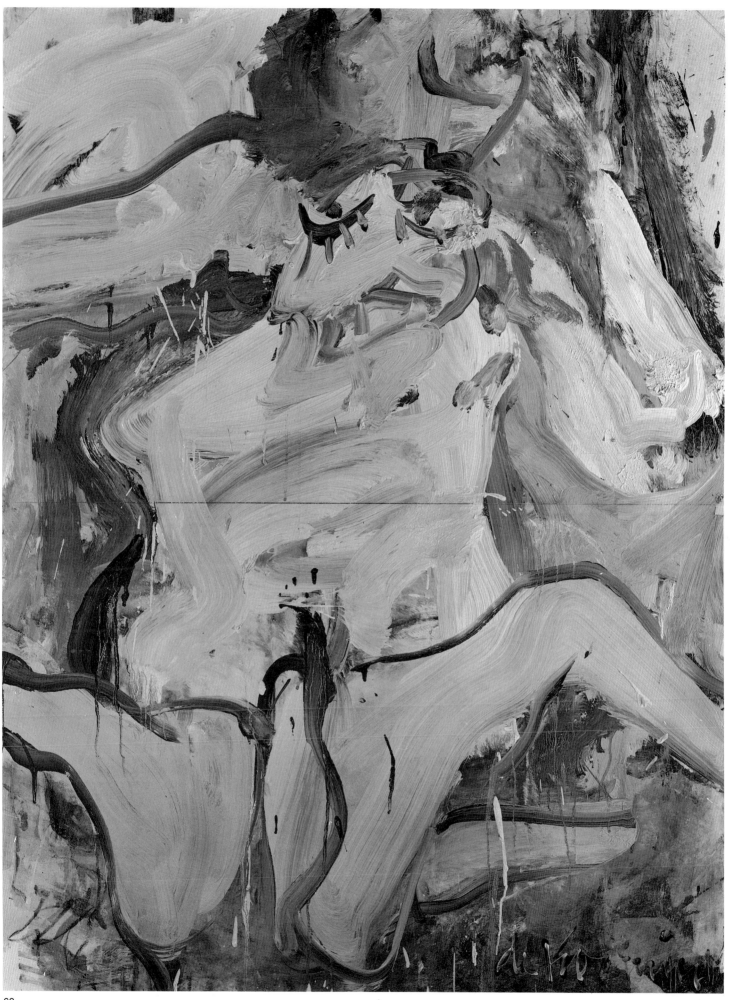

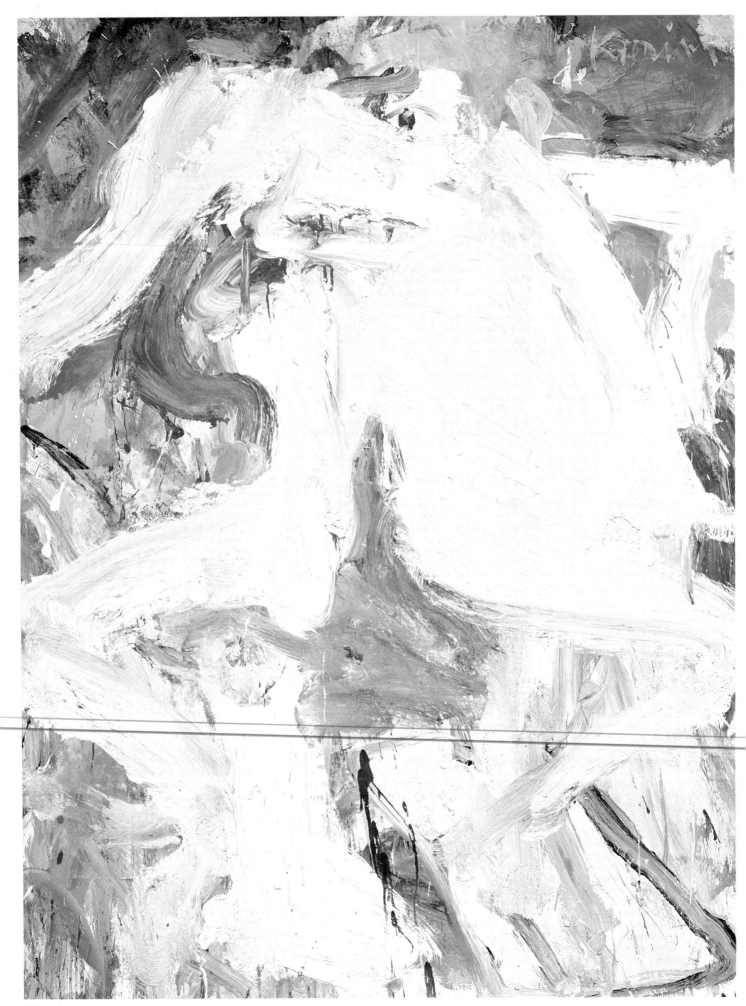

70

69. *Man*, 1967
Oil on paper, mounted on canvas,
56 × 44¾ in.
Courtesy Allan Stone Gallery, New York

70. Hieronymus Bosch
The Garden of Earthly Delights, c. 1500,
Hell, detail
Museo del Prado, Madrid

scalding ritual that opens Pier Paolo Pasolini's 1969 film, *Medea*. Medea's people carry organs and hunks of flesh from a sacrificial victim into the fields, where the human parts, still warm, are hurriedly buried. Afterward, the earth seems to groan with satisfaction. Despite their initial effect of violence, de Kooning's late 1960s paintings of women and Pasolini's primitive ceremony are stark affirmations of life. De Kooning declares the endurance of woman as icon. That the image could suffer such drastic dissection and yet prevail! In the Woman on a Sign series the figure is like a wornout, overstuffed chair. Its springs are busted. Its upholstery is ripped and covered with stains. Its legs are wobbly, but every time you sit down in it you sigh with relief. You know you've come home. De Kooning's women have the same ability to welcome us with a smothering embrace.

By no means are all de Kooning's figures made after the East Hampton move images of accommodation. His figural repertoire is as extensive as any contemporary painter's and extends to breaking down the human form and rebuilding it in unruly ways. Hardly an acknowledgment of the body's morphology, this process may be de

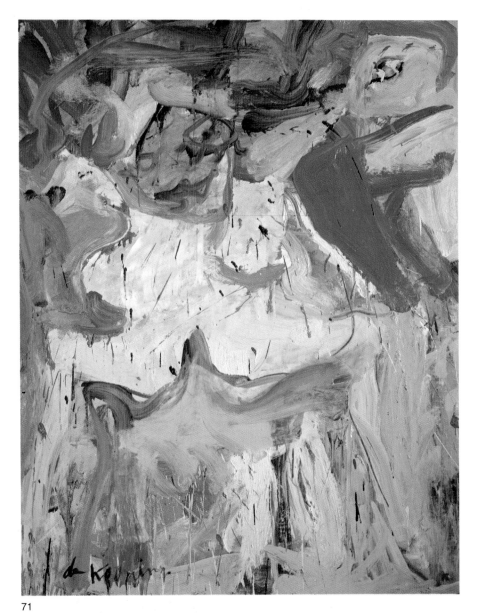

71

71. *The Visit*, 1967
Oil on canvas, 60 × 48 in.
The Tate Gallery, London

72. *Two Figures in a Landscape*, 1967
Oil on canvas, 70 × 80 in.
Stedelijk Museum, Amsterdam

72

73

Kooning's resuscitation of the human comedy. From the apes to homo sapiens and then—as if evolution had been derailed—de Kooning's 1967 *Man*.

Squatting on creaky legs, *Man* is ready to pounce on and gobble up whatever voluptuaries happen by. Unlike the fluorescent *Women*, he embodies the grotesque. As funny as Pinocchio, yet as sad as Giacometti's suspended *Nose* of 1947. In 1906–7 Picasso had outrageously reformed female anatomy in *Les Demoiselles d'Avignon*, and he had amplified figural distortions in Surrealist works of the 1920s and '30s. In *Man*, de Kooning pushes human identity to riotous extremes without either the geometric restructuring of Cubism or Surrealism's pictorially legible reorganization of body parts. The only contemporary artist approximating this drastic remaking of the human figure is Francis Bacon, whom de Kooning visited in London in 1968.[105] But even though *Man* bespeaks the anger of Bacon's tormented protagonists, he is not victimized by that artist's sinister manipulations and intolerable isolation.

De Kooning's *Man* is a taffylike grafting of human anatomy onto

73. *La Guardia in a Paper Hat*, 1972
Oil on canvas, 55¾ × 48 in.
Private collection, New York

something else. That we're not sure what it is puzzles us all the more. A useful key to source and meaning can be found in the *Hell* panel of Hieronymus Bosch's *Garden of Earthly Delights*. Seated 70 on a high stool is a bird-headed persona usually identified as Satan.[106] He devours one sinner while excreting others out the bottom of his throne in a gaseous blue bubble. Here is a devilish forebear for de Kooning's *Man*. A yellowish-brown patch above *Man*'s head corresponds to the inverted kettle worn by Satan. A flesh-colored right angle beside *Man* may be interpreted as an arm or part of a chairlike support. Beyond formal likeness, both figures have also undergone metamorphosis, display ravenous appetites, and experience catharsis. The brown, triangular shape penetrating *Man* carries explicit sexual references, but it also connotes the same body function enjoyed by Satan as Hell Mouth and Cloaca Maxima.

In considering de Kooning's predominant colors from the East Hampton move until his one-man show at the Janis Gallery in 1972—the show that introduced his sculpture to New York—one first encounters citrous and sticky yellows, followed by increasingly juicy pinks and corpuscular reds. Indeed, de Kooning emerges as one of the major painters of our time attuned to red, ranking with Matisse, Rothko, Guston, and, in sculpture, Calder. Not until the mid-1960s, however, did he really let fly with red. But in a painting such as *The Visit* (1967), tomato-paste crimson makes it to 71 the surface with a vengeance. Assaulting pinks and oranges, it storms over the picture's streaked and brush-swept terrain. Rarely in art history has a figurative painter turned red into a more voracious hue. Full-throated and visceral, it ravages forms in paintings from the early 1970s. At times de Kooning uses a brush dripping with red to draw on a painting at an advanced stage of development. In *Barnes Hole Bridge* (1971), a red-orange armature ties together an otherwise "impressionistic" and vapid landscape. *Red* 75 *Man with Moustache* (1971), one of de Kooning's most entertaining figures—a synthesis of Bozo, Santa Claus, and Ingres's Monsieur Bertin—is red all over. In *Flowers, Mary's Table* of the same 76 year, red covers only some areas, partially fusing with yellows, pinks, and white in others. But it is the red that pushes everything into place, even de Kooning's signature.

In *Montauk I* (1969), red plays a localized role in the top half of 74 the painting, jostling forms in volumetric and calligraphic ways while a figure slides in and out of its contours. Red facial features also spar with a cyclopean eye reminiscent of that peering out from the snout-stretched face of the 1967 *Man*. Unlike the eye on the prow of a ship in Greek vases, this one cannot be depended upon to guide us safely through troubled waters. On the contrary, the big eye of *Montauk I* simply stares back, a faceless burlesque of the viewer's—and artist's—perceptive ability. De Kooning's inclusion of a feature wrenched from its anatomical context originated in the late 1940s in such paintings as *Mailbox* and *Secretary* (both 1948), 22 with their headless grins. It may be a remnant of Surrealism, reinvoked as an expressionistic catalyst. One feels that for some of the 1960s paintings de Kooning rummaged through his memories of Surrealism, drawing upon a movement he never joined, yet found useful.

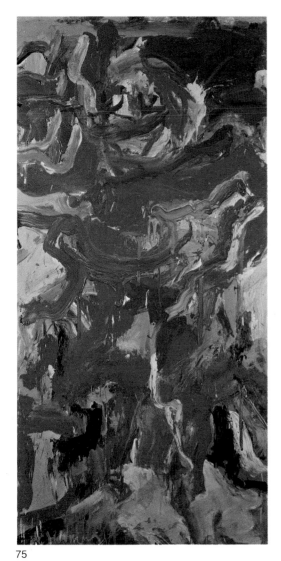

75

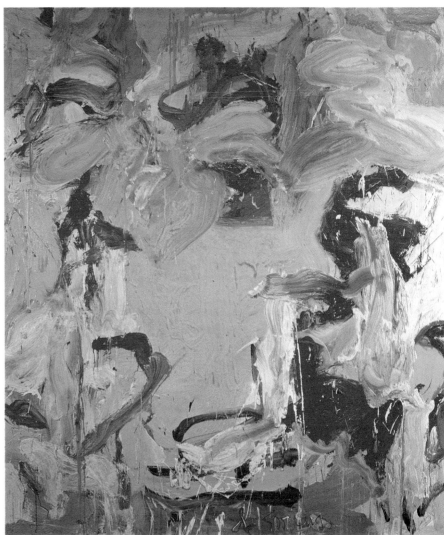

76

74. *Montauk I*, 1969
Oil on canvas, 88 × 77 in.
Wadsworth Atheneum, Hartford, Connecticut
The Ella Gallup Sumner and Mary Catlin
Sumner Collection

75. *Red Man with Moustache*, 1971
Oil on canvas, 73 × 36 in.
Courtesy Xavier Fourcade, Inc., New York

76. *Flowers, Mary's Table*, 1971
Oil on canvas, 80 × 70 in.
Graham Gund

Montauk I and *Two Figures in a Landscape* (1967) point up de 74, 72
Kooning's retention of the near-square for works with figural as
well as landscape elements. Both are based on the seven to eight
ratio, with *Montauk I* hung vertically and *Two Figures* horizon-
tally. Preferring the thinner, "door" proportions for a while in
1964–66, de Kooning never abandoned the blockier format, which
had crystallized eight to ten years earlier in the abstract landscapes.
As he had put it in 1951 at the Museum of Modern Art's symposium
"What Abstract Art Means to Me": "If I stretch my arms next to the
rest of myself and wonder where my fingers are—that is all the
space I need as a painter."[107] Even now, he continues to utilize the
near-square proportions.

Major "non-Women" paintings of the late 1960s such as *Two Fig-
ures in a Landscape* and *The Visit* are among de Kooning's most
complex works of the last fifteen years. They cannot be catego-
rized. Even for de Kooning, they are a new genre: not the custom-
ary duets of women side by side, but two figures, one dominant,
the other defiantly in second place. The protagonists of *The Visit*
(1967) engage in a problematic tête à tête. (Fortunately, the stages of
this major canvas were documented in a sequence of photographs

reproduced in Thomas Hess's *De Kooning: Recent Paintings*, 1967.) From the outset, two presences—one near the center, the other at top right—figure in the painting. These survive, though greatly remade, in the finished work. An additional open-mouthed head, strangely reminiscent of the yawning, shrieking heads in Picasso's 1930 *Crucifixion*, can be seen at the left, about to take a bite out of the central figure's breast. Picasso of 1907–8 may also be a penultimate source for the central figure's masklike, smiling face. The ultimate source—which, to be sure, remains elusory in any de Kooning—may be Rubens, Brueghel, or Nature herself, to wit: a cat, a pekingese, even a preying mantis. The splayed pose of the central figure may derive in a less circuitous route from Toulouse-Lautrec's color lithograph *The Seated Clowness* of 1896. De Kooning favored this pose again and again in the 1960s, in large and small paintings and in drawings. It is the basic pose in four versions of *Woman on a Sign* (1967). And two women nearly beside themselves with glee hold this pose in an untitled charcoal drawing now in the Stedelijk Museum. It illustrates de Kooning's ability to turn an awkward, yet comic pose into a witty paradigm while avoiding caricature—comparable on the theatrical level to Anita Loos's *Gentlemen Prefer Blondes*.

For all its macabre levity, however, *The Visit* doesn't send us away laughing. Far from an open-armed visit, this meeting of ruthless predators and victim parallels that in Friedrich Duerrenmatt's play of the same name. A review of *The Visit* as performed at the Tyrone Guthrie Theater in Minneapolis appeared in the *New York Times*, September 13, 1967, affording a possible source for the title.[108]

From the same year, *Two Figures in a Landscape* is perhaps the most complicated figural painting of the late 1960s, surpassed in resilient ambiguity only by *Montauk I*. Unlike *Woman as Landscape* (1955), the later work does not portray the human figure opened into landscape but two figures embedded in a chaotic matrix without associative elements. Indeed, the figures are summarized so stringently that they approach total abstraction. This is as far as any major painter has gone in pushing the human form to the limits, while retaining its identity. The next step would be abstraction, a step de Kooning took in *Montauk I*.

As in certain of the "door pictures," as well as in *The Visit*, paint drips, drizzles, and pours in *Two Figures*. It is landscape caught in a deluge. The surface is a rapid-fire survey of de Kooning's paint handling, which clouds the figures' legibility and creates a complex weave of abstract and near-abstract elements. In 1943 Pollock had lodged figures in dense, unchartered environments, thus obscuring their identities *(Guardians of the Secret, Pasiphaë)*. In a similar but broader way, de Kooning makes it impossible for the figures to extricate themselves from either the landscape or each other. Their incongruous heads, moreover, provoke reexamination of one's initial impression that the figures are human.

One of de Kooning's frequently quoted aphorisms is: "Content is a glimpse. . . ."[109] If everything is changing, never fixed, then one's perception must inevitably be incomplete and always in flux. For de Kooning, even the glimpses slip away before they can be pinned

77. *Untitled (Crucifixion)*, 1966
Charcoal on paper, 17 × 14 in.
Collection of the artist

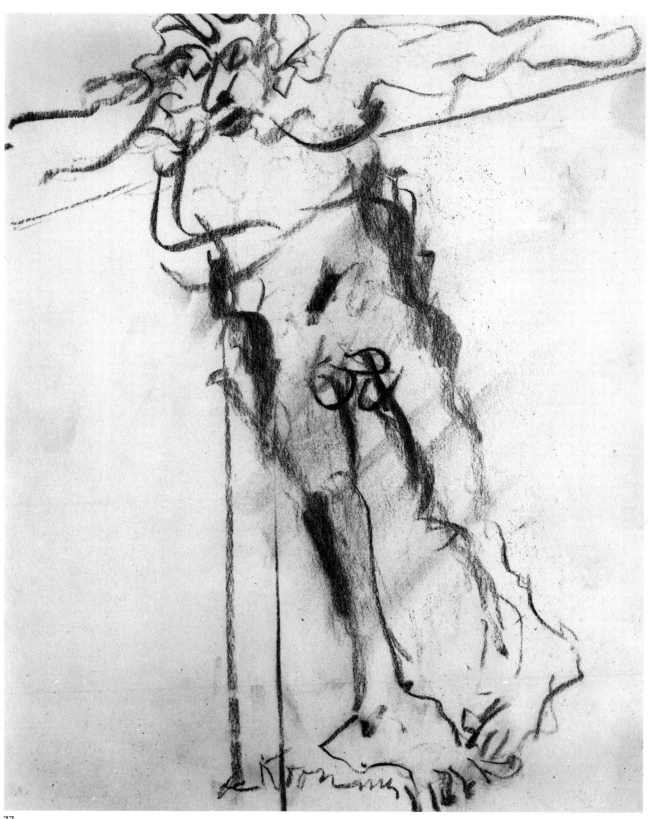

77

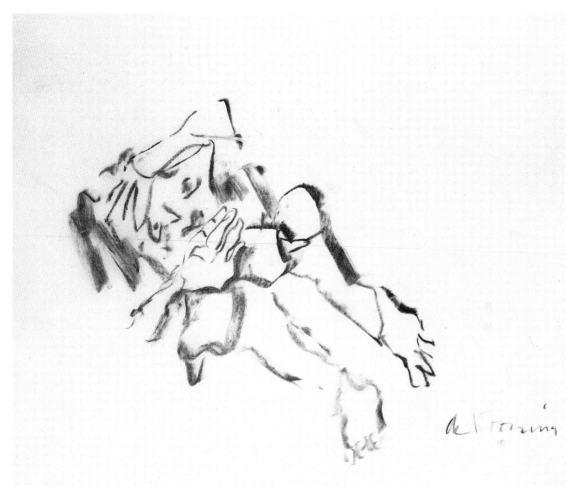

78

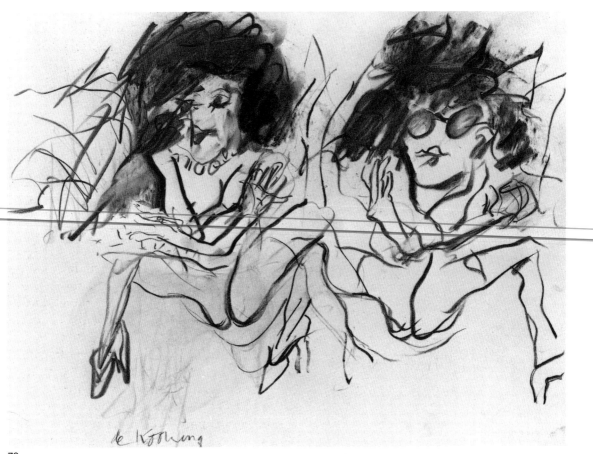

79

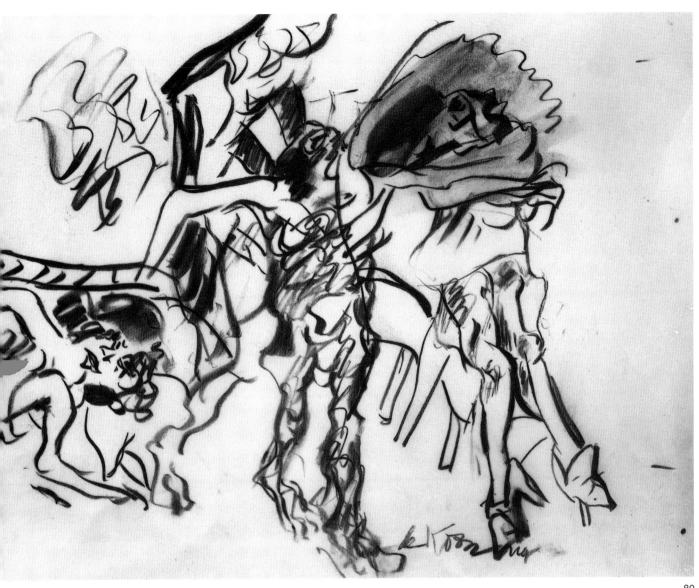

80

78. *Untitled*, 1966–67
Charcoal on paper, 18¾ × 23¾ in.
Private collection

79. *Untitled*, 1968
Charcoal on paper, 19 × 24 in.
Stedelijk Museum, Amsterdam

80. *Untitled (Figures in Landscape)*,
1966–67
Charcoal on paper, 18¾ × 24 in.
Private collection

down. His practice in the 1960s of drawing with closed eyes under-scores his attempt to arrest the illusory and discover the unex-pected. Significantly, many of these drawings are in charcoal, a medium that blurs or fades out. "The pad I used was always held horizontally. The drawings often started by the feet . . . but more often by the center of the body, in the middle of the page. There is nothing special about this, I admit, and am certain that many art-ists have found similar ways . . . but I found that closing the eyes was very helpful to me."[110] He also noted: "I have to do them very fast. Otherwise they don't come out right."[111]

Like many of de Kooning's paintings, the drawings are filled with surprises, some shocking, others subtle. One drawing features a 78 slanted woman who puts to shame the entire family of "no-necks" in *Cat on a Hot Tin Roof*; she is no-body—all head, hands, breasts, and legs. In another untitled drawing of 1966–67, figures slip out of 80 themselves. A crouching woman has great trouble pulling herself

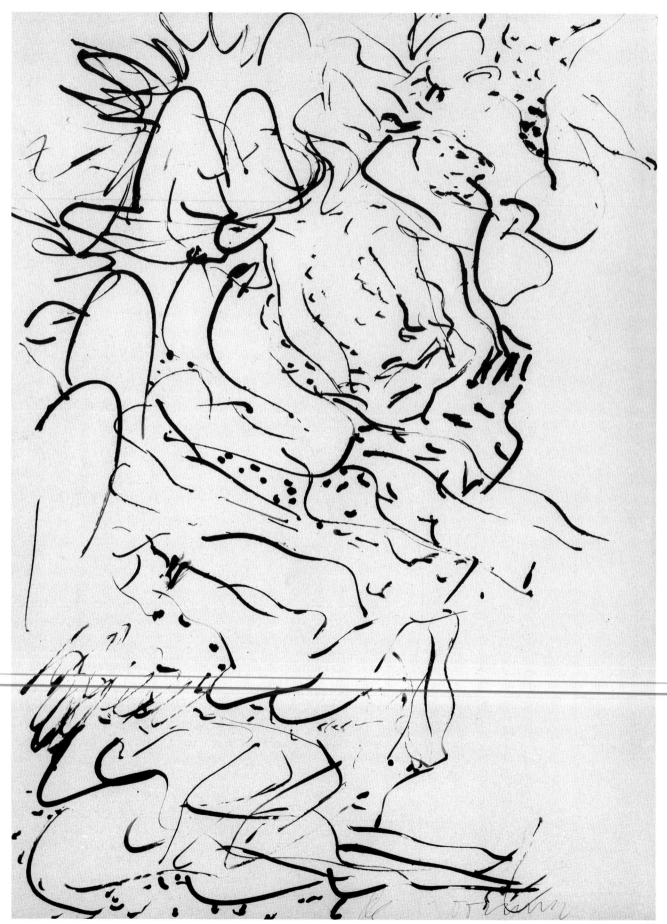

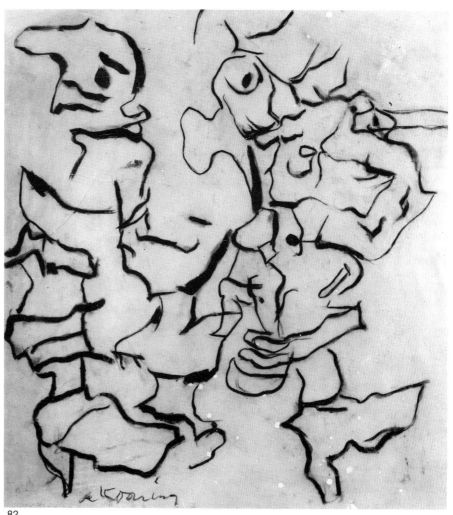

82

81. *Untitled, after Breughel (Spoleto)*, 1969
Ink on paper, 25½ × 18½ in.
National Gallery of Art, Washington, D.C.

82. *Two Figures*, 1974
Charcoal and traces of oil paint, mounted on
canvas, 46 × 42¼ in.
Courtesy Xavier Fourcade, Inc., New York

together, yet doesn't seem at all unhappy about it. Beside her, a hairy man reaches out toward a second woman—chickadee-faced. Although more intact than their gnomelike companion to the left, this couple is also frayed at the edges.

Such a drawing highlights a fundamental question: why do men and women appear together in de Kooning's drawings, but rarely in his paintings? Pairs of figures abound in the paintings: two women, two men, adult and child, and two figures of ambiguous gender. Yet seldom in his paintings do men and women meet, though landscape would provide a natural setting for such encounters. Recognized solutions by Giorgione, Watteau, Manet, and Cézanne, among others, offer monuments to sociability, idyllic repartee, sad farewell, and mutual indifference. Perhaps recognizing the danger of psychological overkill, as well as an artistic surfeit, Picasso eliminated men from the final *Demoiselles d'Avignon*. The three equally important but disparate themes in de Kooning's art—women, men, and landscapes—might diminish each other's viability if painted together. Of course, this is speculation, for de Kooning may yet produce paintings in which all three cohabit on the highest artistic level.

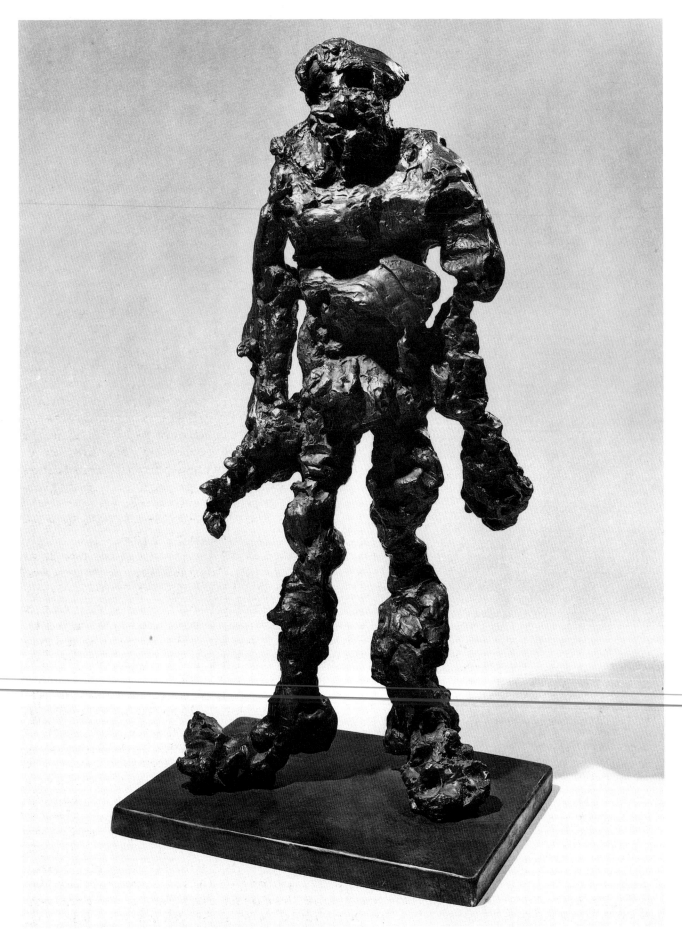

 Sculpture and Late Paintings

With the exception of Barnett Newman, de Kooning is the only first generation Abstract Expressionist painter to produce important sculpture.[112] He did not begin to model clay seriously until late in his career—in 1969—and by 1974 had created more than a dozen figures of various sizes and poses, some of which are as perplexing as his paintings from the late 1960s.[113] Subsequently cast in bronze or polyester resin, the figures push their original clay to its technical limits as a modeling material. The outworn credo of "truth to the medium" has never been one of de Kooning's concerns, yet his sculpture oddly affirms it. The lumpiness, pliability, even moistness of the clay survive in the casts. Not surprisingly, the overriding subject of de Kooning's sculpture has been the human figure. A few of his first series, *Thirteen Little Sculptures*, do not reveal a recognizable image, but all of them are thoroughly organic.

De Kooning's sculpture is demanding even for those who know his two-dimensional work well. Demanding because of the natural impulse to relate this outlandish but disarmingly down-to-earth sculpture to his painting and, moreover, to see it in the context of figural sculpture of the last one hundred years. Reflecting on his mangled and gouged bodies—which lack skeleton or musculature and present only a minimal attempt to turn clay into surrogate flesh—one may feel that these are tongue-in-cheek pieces, if not spoofs on the history of the sculptural figure from Rodin and Bourdelle to Matisse, Picasso, and Moore. Facing up to them on artistic terms might at first seem easier without the background of de Kooning's painting and drawing. Yet that background persists and can be instructive. In some ways, namely their subject matter and loosely handled surfaces, de Kooning's sculptures are extensions of his concerns in painting. Yet, in part because of medium, the sculptures are tighter, less baffling forms.

Some figures are more clearly related to painting and drawing than others. The archetypal *Clam Digger* (1972)—and how ironic that the best-known de Kooning sculpture represents a male, grubby but hardly frightening—derives indirectly from *Red Man with Moustache* and *Man on the Dunes* (both 1971). A precedent for *Clam Digger*'s physiognomy is also seen in a charcoal drawing, 83

75

83. *Clam Digger*, 1972
Bronze, height: 57½ in.
Courtesy Xavier Fourcade, Inc., New York

84

84 *Walking Figure* (c. 1968), although proportions and pose have changed in the sculpture. The idea for the sculpture came to de Kooning "while he was bicycling near the beach at Montauk. . . . In the distance, lit from behind by a bright sun, he saw men with clam digging tools standing in the shallows."[114] A squat, smiling, and bug-eyed *Clam Digger* also pops up in de Kooning's suite of lithographs from 1970, although the printed fellow resembles a standing man less than a terribly good-natured humanoid mollusk. Descendant of these kindred *Clam Diggers* is the 1974 *Man* (charcoal and oil), a quizzical being whose truncated torso rides atop a pair of booted profile feet.

Stark silhouette and crustaceous surface make the sculptural *Clam Digger* an uncomfortable figure, one to be approached cautiously and understood slowly. Like much of his painting since 1960, de Kooning's sculpture requires patient and repeated viewing to grasp the play between overall form and concentrated detail.

84. *Walking Figure*, c. 1968
Charcoal on paper, 23¾ × 18¾ in.
Private collection

85. *Untitled No. 4*, 1969
Bronze, height: 6½ in.
Courtesy Xavier Fourcade, Inc., New York

86. Michelangelo
Day, 1526–31
San Lorenzo, Florence

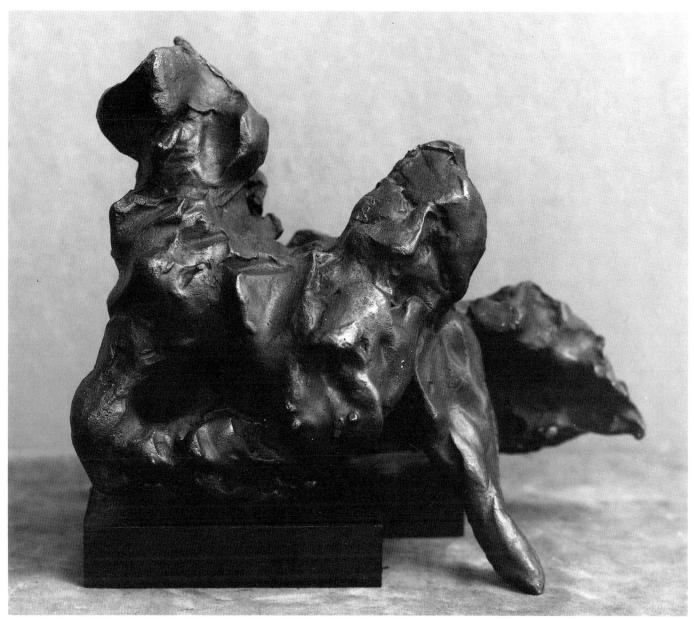

85

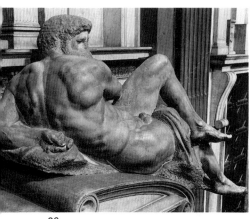

86

While *Clam Digger*'s body is built from small clay masses that add up to wobbly contours and rough surfaces, some areas bear the tracks of de Kooning's cutting stroke. He has scraped clay away from the distended belly, as if shoving paint across canvas. The bands of paint in *Red Man with Moustache*, for example, have scooped-out counterparts in *Clam Digger*. Indeed, the wide, smooth cuts imply a kind of "painting" into the clay after establishing the figure's general form. Not only does this underscore *Clam Digger*'s malleability and increase surface complexity, it also reiterates the sculpture-making process. Form is arrived at by the laying on, scraping off, and laying on again of brush- and finger-sized areas. Although composed of masses, de Kooning's sculpture is rarely volumetric. It pushes space aside, rather than filling it.

De Kooning's eclecticism, his awareness and extrapolation of elements from other artists' work—from Michelangelo to Rodin, Picasso, and Reuben Nakian—is as evident in his sculpture as in his

painting. While in Italy during the winter of 1959–60, de Kooning visited the Medici tombs in Florence, "where he peered in back of the smooth figures to catch a glimpse of Michelangelo's chisel marks."[115] Linking Michelangelo and de Kooning, which at first seems either blasphemous or inane, actually amounts to a commingling of bodies distorted for emotional effect. Both artists retain the bulk of the human form while subjecting it to extremely difficult poses. The bent head and lifted leg of *Night*, as well as the twist of her torso, are Mannerist prototypes for de Kooning's re-formation of the body in his prodded and pulled figures—for different purposes, to be sure. One of de Kooning's small figures from 1969 *(Untitled No. 4)* shares the pose of Michelangelo's *Day*, not seen frontally as installed in the Medici Chapel, but from the right side. The figure may even be a composite of *Day*'s crossed legs and *Night*'s upper torso with bent arms. The similarity becomes more striking when considering *Night* from the side, as de Kooning did when visiting the chapel.

De Kooning wore gloves while modeling some of the sculptures. In fact, his assistant David Christian "remembers buying all kinds of gloves—rubber gloves, garden gloves, abrasive gloves, in all different sizes."[116] Having worn two pairs at once while making *Seated Figure on a Bench* (1972), de Kooning recalls that this helped him achieve "a better sense of scale."[117] Given the limitations the gloves imposed, forms had to be built up in larger masses, without a deflection of interest to smaller details. This is akin to de Kooning's modeling of the *Thirteen Little Sculptures* in 1969 for the most part with his eyes closed.[118]

At times, *Seated Figure on a Bench* has been mistakenly identified as female, yet there is no question that it, like *Clam Digger* of the same year, is male. This is important to an understanding of the figure as a member of the artist's ludicrous entourage, but is also

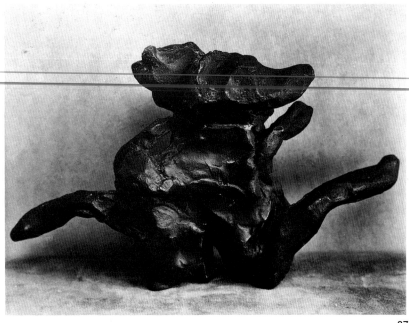

87. *Untitled No. 2*, 1969
Bronze, height: 6½ in.
Courtesy Xavier Fourcade, Inc., New York

88. *Seated Figure on a Bench*, 1972
Bronze, height: 38 in.
Courtesy Xavier Fourcade, Inc., New York

87

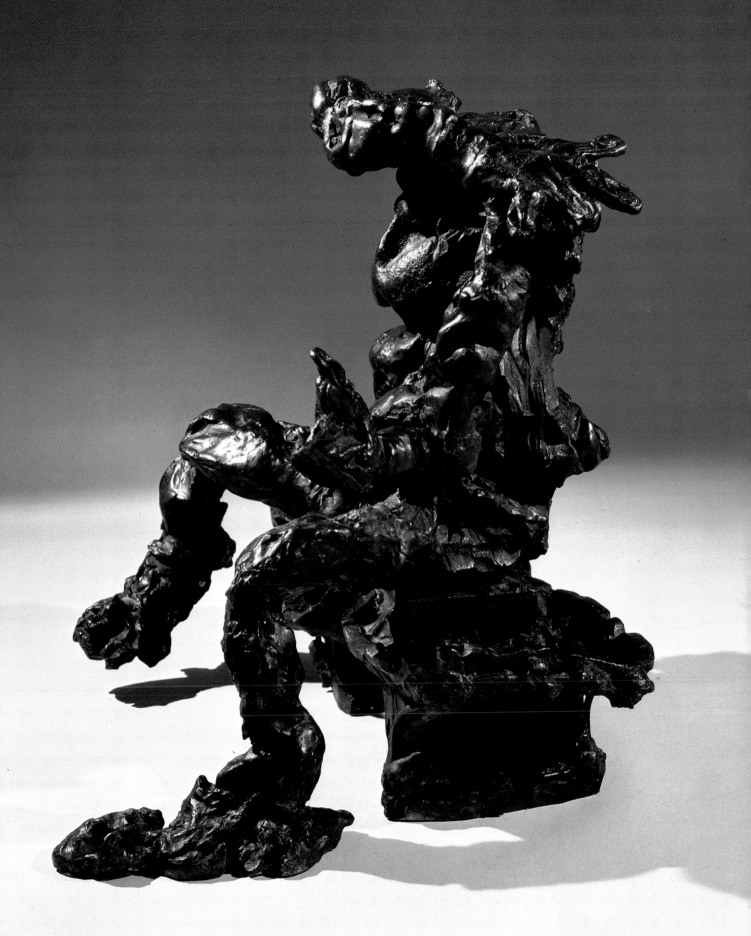

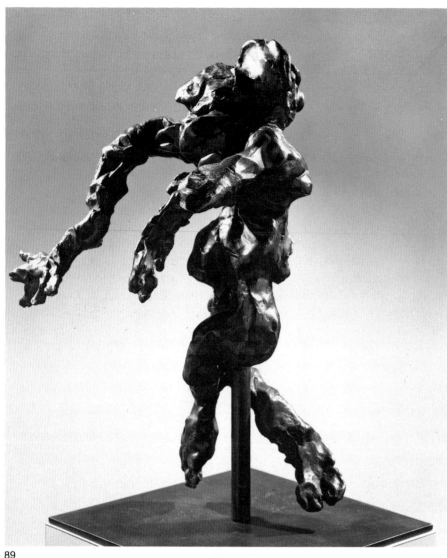

89

crucial to the sculpture's meaning vis-à-vis de Kooning. Wearing oversized gloves and with hands kneading the air, *Seated Figure on a Bench* becomes, on one level, a self-parody of a painter modeling in clay and, on another, an outrageously funny instance of metamorphosis gone awry—much like Bottom turned into an ass in *A Midsummer Night's Dream*. De Kooning turns the figure into an anthropomorphic form, something more (and less) than human.

Several sculptures, including the mummylike *Large Torso* (1974), have Brobdingnagian hands, too large to do anything but just hang around. The only horrific image in de Kooning's sculpture, *Large Torso* suggests decomposition, a macabre melt-down of the body. Smaller, less imposing figures, supported by pipe-armatures, seem to be floating or flailing the air. *Untitled No. 13* (1969), spread-eagled against a piece of molding, embodies de Kooning's long-lived interest in the crucifixion theme. And the eyeless stare, gashlike mouth, and compact form of *Head No. 4* (1973) make it an ominous rival of Picasso's *Death's Head* of 1944; both have mesmeric powers of simultaneous attraction and repulsion.

De Kooning's sculptures are serious and technically accomplished adaptations of an expressionistic painting style to clay

89. *Cross-Legged Figure*, 1972
Bronze, height: 24 in.
Courtesy Xavier Fourcade, Inc., New York

90. *Head No. 3*, 1973
Bronze, height: 19½ in., with base
Courtesy Xavier Fourcade, Inc., New York

91. *Head No. 4*, 1973
Bronze, height: 10½ in.
Courtesy Xavier Fourcade, Inc., New York

92. *Large Torso*, 1974
Bronze, height: 34 in.
Courtesy Xavier Fourcade, Inc., New York

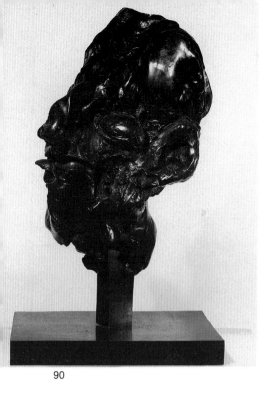

90

modeling. In 1950 he noted: "Flesh was the reason why oil painting was invented."[119] His sculptures from twenty years later affirm that he has "invented" a modeling technique to turn his painted figures into three dimensions. While decidedly monochromatic, de Kooning's cast sculptures activate a coloristic play between light and shadow. Some are as visually energetic yet tectonically irrational as Bernini's baldacchino in Saint Peter's. Indeed, the twist is a key gesture in each. Equally important, de Kooning's sculptures are some of the funniest—and ugliest—images of the human body from our century, surpassing in deliberate vulgarity previous modern works such as Boccioni's *Antigracioso* of 1912, a purposely "anti-graceful" portrait of his mother. Like *Women I–VI*, de Kooning's sculptures have annihilated conventional beauty as a major element in figural art. But unlike the grossly distorted figures from the Middle Ages or Renaissance that symbolized evil or degenerate spirits, de Kooning's figures thrive beyond an allegorical context as specimens of boorish but robust mortality.

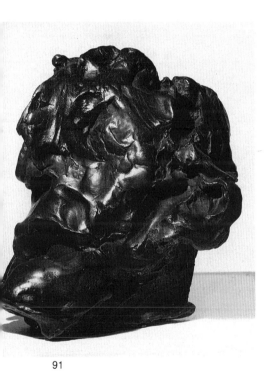

91

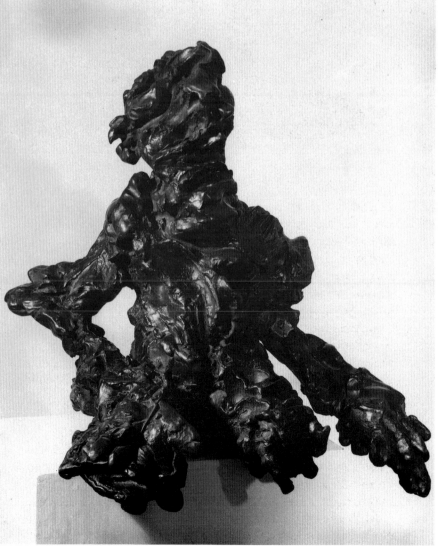

92

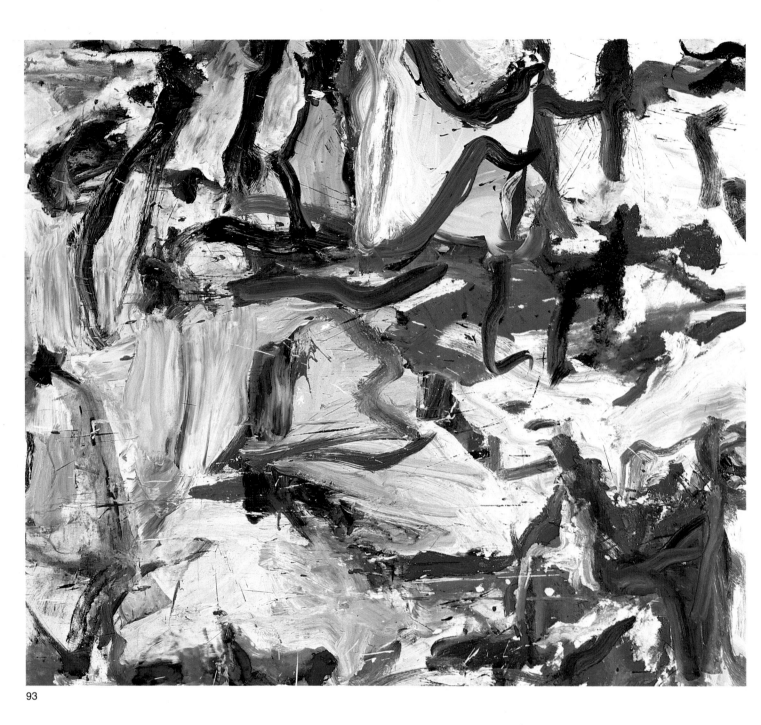

93

Just as intrusive are de Kooning's paintings of the last seven years,
paintings that are hard to take, yet, paradoxically, also easy-going
and open-handed. For the most part abstract, they are nevertheless
filled with intimations of landscape. Woman seems to have gone
underground—or underwater—yet her plashy figure occasionally
emerges from the slathered strokes, as in *Untitled XI* (1981). If one
looks long enough she, or part of her discombobulated anatomy,
may flash by. Hidden behind a panoply of colored patches and
smears in *Untitled XIV* (1977), she peeks out at our world, reveal-
ing her presence yet camouflaging her form like a camera-shy water
sprite.

More equivocal than the abstract landscapes of 1957–63, these
late paintings are still evocations of place. They refer not only to

93. . . . *Whose Name Was Writ in Water*,
1975
Oil on canvas, 77 × 88 in.
The Solomon R. Guggenheim Museum,
New York

94. *Untitled V*, 1976
Oil on canvas, 77 × 88 in.
Mr. and Mrs. Oscar Kolin

95. *Untitled XIV*, 1977
Oil on canvas, 55 × 59 in.
Private collection

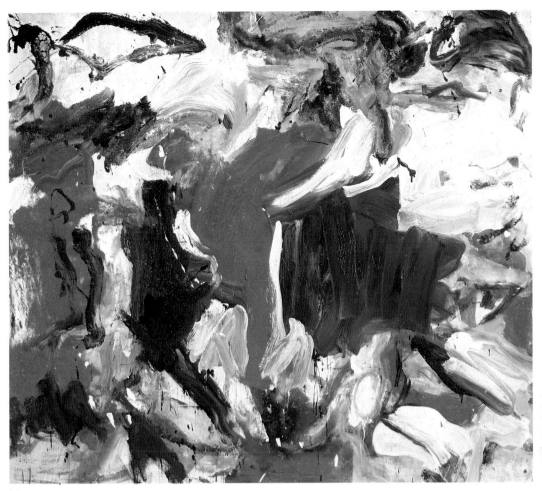

94

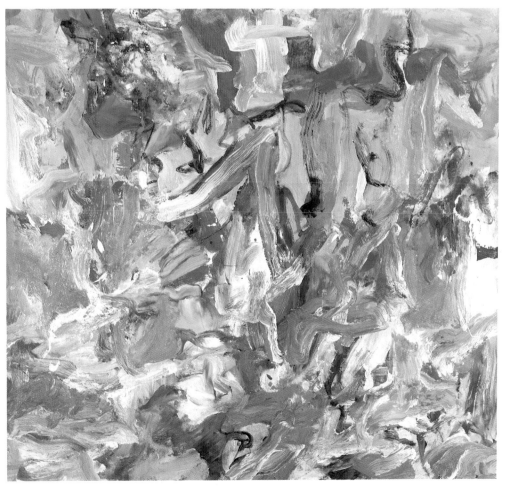

95

Suffolk County from East Hampton to Montauk Point, with its ebb and flow of clouds, water, dunes, and shimmering foliage, but also reflect the spacious vistas of de Kooning's own studio. Most are untitled, perhaps a problem for clue-hungry viewers, but de Kooning has never attached great pictorial significance to titles even though he has used them. In this respect he differs from some of his Abstract Expressionist colleagues, above all Gorky. During an Artists' Session at Studio 35 in 1950, de Kooning pointed out: "I think that if an artist can always title his pictures, that means he is not always very clear."[120] Feeling the same today, he prefers merely to tag paintings numerically. Exceptions nearly always include place names or references to landscape features: *Water . . . Soft Banks, and a Window; Two Trees on Mary Street . . . Amen!* (both 1975), and *East Hampton I* (1977).

17, 93 Like *Light in August* (c. 1946), *. . . Whose Name Was Writ in Water* (1975) is one of the few works bearing a "literary" title. It is an elliptic version of John Keats's epitaph written by the poet for his own tombstone in Rome's Protestant Cemetery: "Here lies one whose name was writ in water."[121] Expansive composition and variegated surface make the painting a visually tactile experience. At the same time, its eellike paint slithers activate a spatial fluidity in which planes, brushstrokes, and clottings constantly shift relationships. Everything keeps moving in unforeseen ways. If the painting is turned on its side with the right edge as bottom, figural associations—even reminiscent of some de Kooning sculptures—begin to coalesce. Throughout the late 1970s, however, de Kooning worked against such specificity of external reference. In a sense, the world outside the paintings with its bounty of forms is irrelevant—not expendable, to be sure, but a realm of natural phenomena apart from yet corresponding to the paintings themselves. De Kooning's late works, like those from earlier periods, are not abstractions from nature, nor variations on it. At best they are responses to it, not consciously dictated but intuitively articulated. And more than before, the late paintings are a return to nature, not only in theme but through the searching act of painting, whereby de Kooning repeatedly questions his own relationship to nature as well as testing again and again his inventive powers.

Careful study of the late abstractions is eye opening in two ways. First, de Kooning's ingenuity as a conjurer of forms and manipulator of paint continues to amaze. How many ways can paint be put on canvas? De Kooning's work provides an extensive answer. Second, elements from his earlier art slip in and out. The splayed *V*, accordianlike zigzag, priapic triangle, double prong, and baggy loop reappear, usually fuller in form and less acerbic than in 99 younger days. *Untitled IV* (1981), for example, is largely an extension across the canvas of wide red and white streaks that had origi- 50 nally filled the lower-right corner of *Gotham News* (c. 1955–56). 97 Heavy with garish Thalo green, *Untitled V* (1980) even contains a replication of the "boot" or "slipper" shape from Gorky's *Gardens in Sochi* (1940–43). In their use of saturated color, loosely applied with respect for the autonomy of paint, other recent works also recall Gorky's later canvases such as *Water of the Flowery Mill* (1944).

As displays of light and hue fused with the substance of paint, de Kooning's paintings from 1975–79 merit comparison with Monet's late work. Zooming in on a close-up of a late Monet, one approaches the degree of abstraction, variation in paint viscosity, and range of dry-to-humid ambience realized in de Kooning's late pictures. However, de Kooning is not seeking an Impressionistic correspondence with the color, intensity, and direction of natural light. His late paintings can no more be labeled "abstract-impressionist" than those by Philip Guston from the early 1950s. De Kooning's upfront physicality, the malleability of his forms and their spatial flux, exceed optical sensation. In a late Monet, such as *Irises by the Pond* 98 (c. 1920–24), one stands at the edge, dazzled by light, color, and painterly touch. But in a late de Kooning, the artist shoves us into the water, trips us into the underbrush, heaves us into the sky. And, regardless of natural locale, he backs us up against the wall of his studio. Far from plein-air paintings, these canvases are strenuous kinetic exercises conditioned at times by de Kooning's sculpture making. They can be lyrical and pleasurable, but equally plangent and grabby.

With his 1975–79 pictures, de Kooning makes viewers reconsider their way of "reading" abstract painting. In some cases—*Untitled XIII* (1975), for example—one section will blur while an adjacent area remains clearly in focus. Such passages make us readjust our way of scanning a painting. The process of concentrating at first on an entire canvas and then refocusing on parts of it no longer obtains. Details ranging in scale from a few inches to several feet must be integrated with views of the entire canvas through extended seeing. A viewer has to cope with two visual/physical responses at

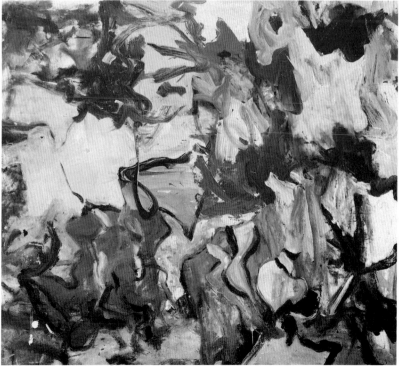

96. *Untitled XI*, 1975
Oil on canvas, 77 × 88 in.
Courtesy Xavier Fourcade, Inc., New York

96

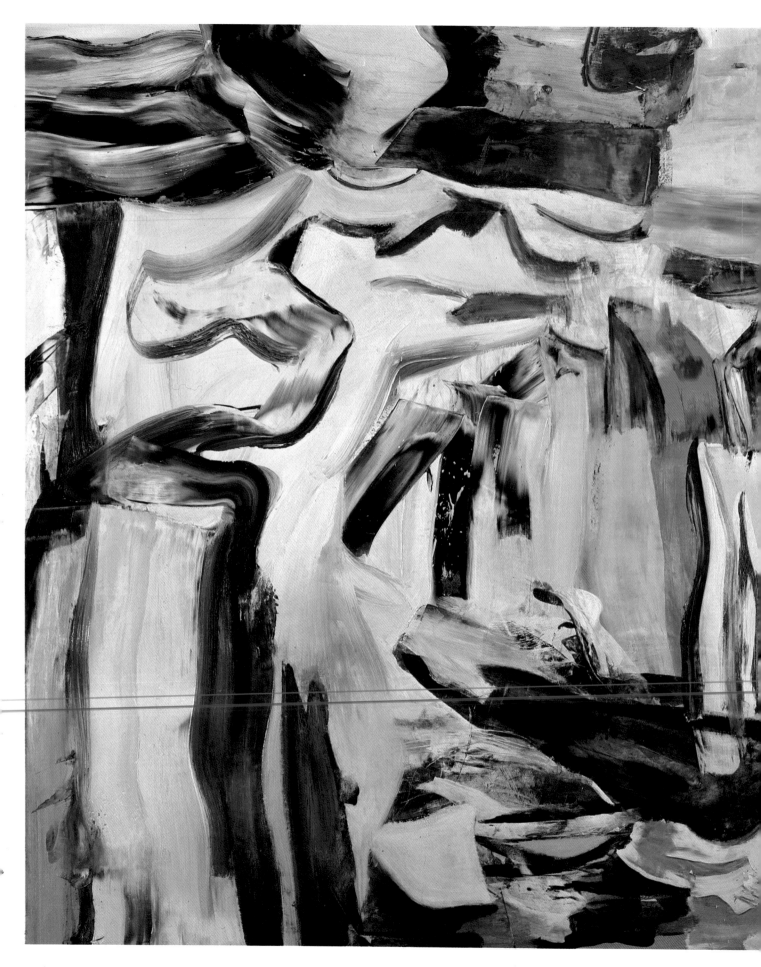

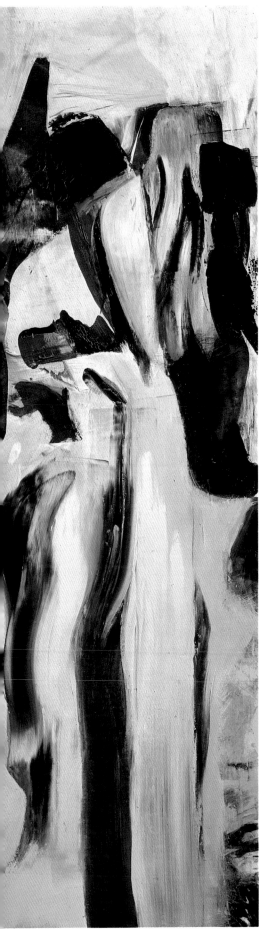

98

97. *Untitled V*, 1980
Oil on canvas, 70 × 80 in.
Courtesy Xavier Fourcade, Inc., New York

98. Claude Monet
Irises by the Pond, c. 1920–24
Oil on canvas, 78½ × 59¼ in.
Virginia Museum, Richmond

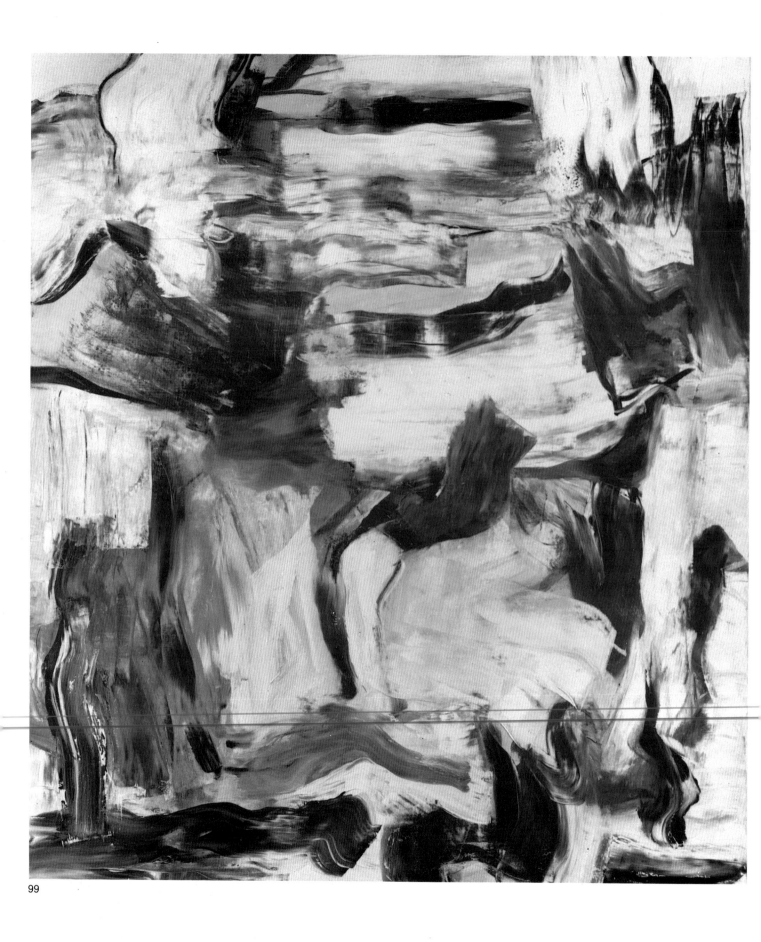

99

once: to take in simultaneously parts of a painting and the complete work. Intensifying this dual pull, de Kooning compounds an apparently self-generating composition with carefully worked (and reworked) details.

De Kooning is constantly concerned with keeping all parts of a painting going at once. While not new, this has become crucial to his work since 1975. "I want a picture to seem as if it had grown naturally, like a flower; I hate the look of interventions—of the painter always butting in."[122] Of course, "spontaneous generation" was part of the myth of Abstract Expressionism, with Pollock its major exponent. In 1950 Pollock summarized his responsibility as a painter in Hans Namuth's film: "The painting has a life of its own. I try to let it live."[123] In retrospect, this seems remarkably close to de Kooning's attitude, not in his figural works or the 1956–60 abstractions, but in his loose-limbed paintings since 1975.

As would be expected, de Kooning's paintings shown in 1975 with sculpture at the Fourcade, Droll Gallery drew mixed critical response. Tom Hess regarded them as a synthesis of Woman and water, adding that "Woman, for de Kooning, is the human equivalent of water; more than a vessel, she embodies it in planes of rippling flesh."[124] In contrast, feeling that the figure had been "swallowed up" by landscape, Hilton Kramer noted that "one may recoil at times from an incontinence that borders on incoherence, but there is never any doubt that we are in touch with something individual and deeply felt, with something personally explored."[125] Criticism that acknowledges de Kooning as the old master of Abstract Expressionism yet undercuts his most recent work as self-indulgent or overextended has continued in the 1980s. Harold Rosenberg's ex cathedra irony is as apt today as in 1964: "Like Western civilization, like humanity itself, de Kooning is constantly declared by critics to be in a state of decline, if not finished for good."[126]

De Kooning's past achievements are so extensive that it is difficult for some critics to see the new work on its own terms. If Zola advised Paris in the 1860s to forget a thousand things about painting to understand Manet, perhaps today's critics should forget a thousand de Koonings in order to see and evaluate his latest work. However, while formally instructive, such a disinterested approach would prove unnecessarily limited, for it is equally if not more important to see these new developments as part of an ongoing oeuvre. Given the vast amount of art produced by de Kooning—hundreds of paintings and thousands of drawings in widely varied modes across a career of more than sixty years—placing his 1980s work in context is even more informative to any critical process than it would be with other, less prolific artists.[127]

In 1955 Clement Greenberg stated that de Kooning "enjoys both the advantages and the liabilities of an aspiration larger, perhaps, than that of any other living artist. . . . The dream of a grand style hovers over all this—the dream of an obviously grand and an obviously heroic style."[128] Today, viewing de Kooning's manifold art from a historical perspective, no single "heroic style" can be discerned. Closest to it would be the black and white paintings of 1946–49, *Excavation* of 1950, the Women of 1950–55, and the ab-

99. *Untitled IV,* 1981
Oil on canvas, 80 × 70 in.
Courtesy Xavier Fourcade, Inc., New York

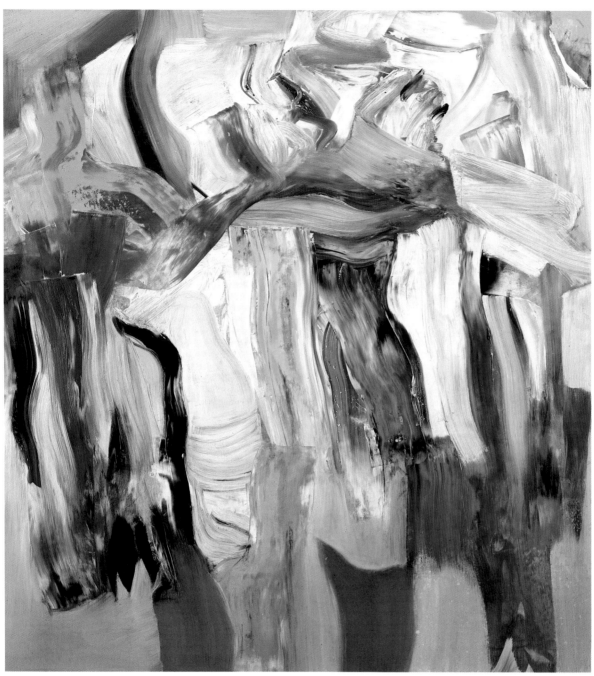

100

stractions immediately thereafter, which culminated in such distillations of Abstract Expressionism as *Suburb in Havana* (1958) and *Door to the River* (1960). It is unlikely that any one de Kooning style or period will emerge to transcend all others. He has not codified a unique "classic" style comparable to Pollock's poured paintings, Rothko's color/light fields, or Newman's "zips." And unlike Mondrian, whom he once described as "that great merciless artist . . . the only one who had nothing left over,"[129] de Kooning continues to change. In doing so he evades circumscription by his previous work.[130]

Oblivious to criticism and unafraid of the judgment of art history, de Kooning continually broadens his formal acuity and deepens his commitment to the making of art. He has no tradi-

100. *Untitled XI*, 1981
Oil on canvas, 60 × 55 in.
Courtesy Xavier Fourcade, Inc., New York

101. *Untitled I*, 1982
Oil on canvas, 80 × 70 in.
Courtesy Xavier Fourcade, Inc., New York

102. *Untitled III*, 1982
Oil on canvas, 80 × 70 in.
Courtesy Xavier Fourcade, Inc., New York

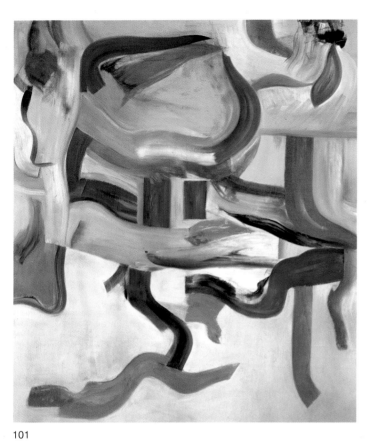

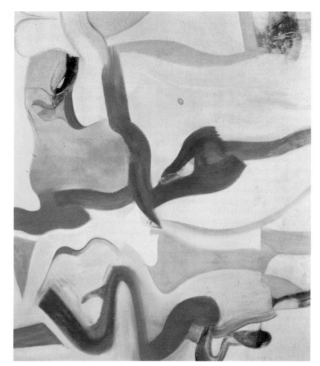

101

102

tional religious faith, yet his work offers ethical sustenance, verifying as a fact of our problematic existence the actuality and integrity of equivocation, yet tempering it with surprise and humor. His work affirms the persistence of will as the source of the creative impulse. Still catching glimpses, he struggles in the insular comfort of his well-stocked, spotless studio to keep them glimpses. Aware of their mysterious origins, he refuses to betray them by trapping them in a de Kooning style.

N O T E S

1. Thomas B. Hess, "Is Today's Artist with or against the Past," *Artnews 57* (Summer 1958): 27. See Thomas B. Hess, *Willem de Kooning* (New York: Museum of Modern Art, distributed by New York Graphic Society, 1968), p. 124. Hereafter cited as Hess, *de Kooning*, 1968.

2. Letter from Dr. Walter Lagerwey, Calvin College, September 10, 1982. "De Kooning is not as common as Koning; that is, the article *de* is more often not present, and the spelling with a double *oo* is less common as well. In Belgium the name generally appears as De Kooninck."

3. David Sylvester interview with de Kooning, "Content Is a Glimpse," in Hess, *de Kooning*, 1968, p. 147.

4. Ibid.

5. Thomas B. Hess, *Willem de Kooning*, 1959, pp. 114–15.

6. Interview, Elaine de Kooning, New York, December 2, 1982.

7. Interview, Rudolph Burckhardt, New York, November 24, 1982. Since the 1930s, de Kooning has always thought of himself as a New Yorker. "It's not so much that I'm an American: I'm a New Yorker." "Content Is a Glimpse," in Hess, *de Kooning*, 1968, p. 147.

8. "De Kooning Work Sold to Australia," *New York Times*, September 24, 1974, p. 27. De Kooning's *Two Women* (1954–55) set a new record when it sold for $1.2 million in 1983.

9. Quoted in Avis Berman, "Willem de Kooning," p. 73.

10. Interview, Elaine de Kooning.

11. Ibid.

12. Interview, John Ferren, New York, April 4, 1967. Ferren's description of Pollock was in no way a disparagement, but simply a characterization of the archetypal, uncommunicative American artist as stereotyped by persons in and out of the art world.

13. Quoted in James T. Valliere, "De Kooning on Pollock," p. 604.

14. Hess, *de Kooning*, 1959, p. 11. See also B. H. Friedman, *Jackson Pollock, Energy Made Visible* (New York: McGraw Hill, 1972), p. 253.

15. Interview, Meyer Schapiro, New York, October 23, 1982.

16. The only media he has not worked in are watercolor and acrylics. Interview, Elaine de Kooning.

17. Discussing art in the late 1930s and '40s, de Kooning would often say, "Picasso is the man to beat." Interview, Burckhardt. Cf. Pollock's comment from the early 1940s: "Damn that Picasso, just when I think I've gotten somewhere I discover that bastard got there first." Quoted in William S. Rubin, "Pollock as Jungian Illustrator: The Limits of Psychological Criticism," *Art in America* 67 (December 1979): 88.

18. Quoted in David Shapiro, *Jim Dine* (New York: Harry N. Abrams, 1981), p. 204.

19. Hess states that Gorky and de Kooning met through the painter Mischa Resnikoff. Hess, *de Kooning,* 1959, p. 114. De Kooning, however, has said that he met Gorky, as well as Stuart Davis, through John Graham: "Graham, Stuart Davis and Arshile Gorky at that time were known as the Three Musketeers. They were the three outstanding modern artists." Quoted in Valliere, "De Kooning on Pollock," p. 603.

In 1949, in a well-known letter to *Artnews*, de Kooning commented on the idea that *he* had influenced Gorky: "Now that is plain silly. When about fifteen years ago, I walked into Arshile's studio for the first time, the atmosphere was so beautiful that I got a little dizzy and when I came to, I was bright enough to take the hint immediately." *Artnews* 47 (January 1949): 6. Further details about the relationship with Gorky are included in Karlen Mooradian's interview with de Kooning, *Ararat* 12 (Fall 1971): 48–52.

20. Harold Rosenberg, *Arshile Gorky, The Man, the Time, the Idea* (New York: Grove Press, 1962), p. 66.

21. Hess, *de Kooning,* 1959, p. 114.

22. Ibid.

23. Interview, Willem de Kooning, East Hampton, August 9, 1971. Also borne out in interviews with Burckhardt, Denby, and Elaine de Kooning.

24. Hess, *de Kooning,* 1968, p. 21. Denby was one of the first collectors of de Kooning's art. See "The Thirties" and "Willem de Kooning" in Denby's *Dancers, Buildings, and People in the Streets* (New York: Horizon Press, 1965), pp. 261–76. Denby's likeness is particularly close to that of *Seated Man* (c. 1939) in the Hirshhorn Museum and Sculpture Garden, Smithsonian Institution, Washington, D.C.

25. Interview, Burckhardt. Elaine de Kooning also notes that Bill painted part of one of her student still lifes into the lower left corner of the portrait.

26. Interview, Edwin Denby, New York, November 24, 1982.

27. Hess, *de Kooning,* 1968, p. 21. Denby also wrote a poem, "The Shoulder," inspired by de Kooning's difficulties. In it he observes "the shoulder of a man is shaped like a baby pig" and refers to it later as "half orchid, half tumor." Denby, *Collected Poems* (New York: Full Court Press, 1975), p. 4. When asked the origin of this verbal/visual association, Denby noted that de Kooning may have suggested it himself. Interview, Denby.

28. Hess, *de Kooning,* 1968, p. 18.

29. Burckhardt recalls de Kooning saying after completing this meticulous portrait that if he

kept making drawings like it, he'd go crazy. Interview, Burckhardt.

30. Ibid. For the relationship between de Kooning and Ingres see Melvin P. Lader, "Graham, Gorky, de Kooning, and the 'Ingres Revival' in America," *Arts Magazine* 52 (March 1978): 94–99. Elaine de Kooning also recalls her husband's greater admiration for Soutine than van Gogh. Interview, Elaine de Kooning.

31. "Elaine de Kooning remembers that after stopping work on one magnificent painting, the artist reluctantly admitted that it was 'pretty good' but decided that it had to be moved 'two inches to the left.' Instead of cutting down the right side and piecing out some space to the left, he proceeded to paint over the whole image, meticulously shifting each element—and in the process lost the whole image." Hess, *de Kooning,* 1968, p. 22.

32. Hess, *de Kooning,* 1959, p. 120. It was also his first painting reproduced in an art magazine: *Art Digest* 16 (January 15, 1942): 18. The review noted: "A strange painter is William Kooning [sic] who does anatomical men with one visible eye, but whose work reveals a rather interesting feeling for paint surfaces and color."

33. Hess, *de Kooning,* 1968, pp. 18–20.

34. Interview, Denby. He adds that in at least one instance—an untitled painting in the Burckhardt collection—de Kooning regarded the "geometric abstraction" on one level as corresponding to a woman's body.

35. Hess, *de Kooning,* 1959, p. 26.

36. David A. Anderton, *The History of the U.S. Air Force* (New York: Crescent Books, 1981), pp. 113, 116–20.

37. The show was enthusiastically reviewed by Renée Arb in *Artnews* 47 (April 1948): 33, which also reproduced *Painting* (1948), now in the Museum of Modern Art. Four years before Harold Rosenberg's famous article on "Action Painting" (*Artnews 51*, September 1952), Arb observed that de Kooning's "process of painting becomes the end. . . . His subject seems to be the crucial intensity of the creative process itself. . . ."

Clement Greenberg also praised the show highly, calling de Kooning "one of the four or five most important painters in the country." Recognizing such major characteristics of de Kooning's art as "indeterminateness or ambiguity," Greenberg attributed them to "his effort to suppress his facility. There is a deliberate renunciation of will in so far as it makes itself felt as skill, and there is also a refusal to work with ideas that are too clear." "Art," *The Nation* 116 (April 24, 1948): 448.

38. Denby, *Dancers,* p. 262.

39. Interview, Denby and Burckhardt.

40. "Content Is a Glimpse," in Hess, *de Kooning,* 1968, p. 147.

41. Hess, *de Kooning,* 1968, pp. 50–51.

42. Ibid. Hess corrected his earlier statement that de Kooning turned to black and white paintings because he "could not afford a plentiful supply of tube colors." Hess, *de Kooning,* 1959, p. 116.

43. De Kooning liked jazz and played it—Louis Armstrong, for example—on his phonograph as early as the 1930s. One of the few

artists to have a good phonograph at that time, de Kooning played his records very loud, including Stravinsky's "Symphony of Psalms," flamenco, and some Mozart. Interview, Burckhardt.

44. The title *Orestes* was given to the painting not by the artist but by the owners of the magazine *Tiger's Eye.* Charles F. Stuckey, "Bill de Kooning and Joe Christmas," p. 77.

45. Interview, Denby. See de Kooning's comment on his first trip to Paris in 1968: "the French have very neat, crisp lettering." Hess, *de Kooning,* 1968, p. 13.

46. For example: Pollock's *Number 31, 1950 (One)*, 8′ 8″ by 17′ 6″; Kline's *New Year Wall: Night* (1960), 10′ by 16′; Motherwell's *Reconciliation Elegy* (1978), commissioned for the East Building, National Gallery of Art, Washington, D.C., 12′ by 40′. Several years after *Excavation* had been acquired by the Art Institute of Chicago, de Kooning saw it again and "wondered if it wasn't too large." Katharine Kuh, "The Story of a Picture," *Saturday Review* 52 (March 29, 1969): 38.

47. Harold Rosenberg, *The Anxious Object; Art Today and Its Audience* (New York: Horizon Press, 1964), p. 117.

48. This "cue" was first pointed out by Kuh, "Story of a Picture" and was reiterated by Stuckey, "Bill de Kooning," pp. 67–69.

49. Harold Rosenberg, *De Kooning* (New York: Harry N. Abrams, 1974), p. 23.

50. This incident occurred in the late 1940s or early '50s. Interview, Schapiro.

51. Rosenberg, *Anxious Object,* p. 117.

52. Four black and white de Koonings had been shown along with paintings by Pollock and Gorky in 1950. Lawrence Alloway, *The Venice Biennale 1895–1968* (Greenwich, Conn.: New York Graphic Society, 1968), p. 139.

53. "Brickbat Biennale," *Time* 76 (July 4, 1960): 54. Interview, Adelyn D. Breeskin, Washington, D.C., January 30, 1968.

54. Hess and Burckhardt, "De Kooning Paints a Picture," *Artnews* 52 (March 1953): 30–33ff. Hess, *de Kooning,* 1959, pls. 111–20. E. A. Carmean, Jr., *American Art at Mid-Century: The Subjects of the Artist* (Washington, D.C.: National Gallery of Art, 1978), pp. 157–82.

55. Other than telling de Kooning not to get discouraged and to keep on with it, Schapiro doesn't recall in detail what they talked about at this meeting in the artist's Tenth Street studio.

56. Leo Steinberg described de Kooning's *Woman* as "part witch, part farmer's daughter, part mother and part whore; a power too comprehensive and immediate to be watched and rendered with controlling skill." *Other Criteria: Confrontations with Twentieth-Century Art* (New York: Oxford University Press, 1972), p. 260.

57. Otis Gage, "The Reflective Eye: The Success of the Failure," *Art Digest* 27 (April 15, 1953): 4.

58. Robert M. Coates, "The Art Galleries," *New Yorker* 29 (April 4, 1953): 96.

59. "Big City Dames," *Time* 61 (April 6, 1953): 80.

60. Ross Feld, *Philip Guston* (New York:

George Braziller and San Francisco: San Francisco Museum of Modern Art, 1980), p. 14.

61. "Content Is a Glimpse," in Hess, de Kooning, 1968, p. 149.

62. Woman and Bicycle was the last canvas de Kooning painted for the 1953 Janis show. In contrast to the Women I–VI, it was painted quite fast. Interview, Burckhardt.

63. Interview, Elaine de Kooning.

64. Hess, Drawings, p. 41. "There is probably a certain historical justice to the fact that someone titled one of de Kooning's smaller paintings after her."

65. Quoted in Selden Rodman, Conversations with Artists (New York: Capricorn Books, 1961), p. 104.

66. Harriet Janis and Rudi Blesh, De Kooning, p. 61.

67. In 1950 and again in the 1960s, de Kooning made drawings on the crucifixion theme. Hess, Drawings, pls. 43–44, 116–19.

68. Woman I's hypnotic stare and Joan Crawford shoulders may derive from Tell Asmar idols, c. 2600 B.C. Sally Yard, "Willem de Kooning's Women," p. 101.

69. Hess, de Kooning, 1968, p. 15.

70. Quoted in Rodman, Conversations, p. 102.

71. Sidney Geist, "Work in Progress," Art Digest 27 (April 1, 1953): 15. Leo Steinberg also referred in 1955 to de Kooning's Woman as "disastrously erotic in some remote, paleolithic way. Like the Venuses of Willendorf and Mentone she is all vulgar warmth and amplitude; like them she stands huge, stupid, and receptive, without arms or feet, innocent of that acquired grace which is bred into the girls we think we know." Other Criteria, pp. 259–60.

72. A combination pink crown/doctor's mirror is also affixed above the forehead of Woman II (1952).

73. Marvin Trachtenberg, The Statue of Liberty (New York: Viking Press, 1976), p. 60.

74. De Kooning's parents divorced when he was about five years old and his mother eventually won custody of him. Hess, de Kooning, 1968, p. 12.

75. Interview, Elaine de Kooning. The artist's trip "home" was also for his retrospective, which opened at the Stedelijk Museum, September 19, 1968.

76. Hess, de Kooning, 1968, p. 102.

77. Ibid., p. 50.

78. Ibid., p. 102.

79. Harold Rosenberg, "Interview with Willem de Kooning," p. 57.

80. Interview, Sidney Janis, New York, April 8, 1971.

81. Interview, Willem de Kooning, East Hampton, August 17, 1980.

82. Rosenberg, "Interview with Willem de Kooning," p. 55.

83. John Ferren, "Epitaph for an Avant-Garde," Arts Magazine 33 (November 1958): 24.

84. Janis and Blesh, De Kooning, p. 67.

85. Letter, Lee V. Eastman, August 30, 1982.

86. Quoted in Hess, De Kooning: Recent Paintings, p. 14.

87. See Elaine de Kooning, essay in Franz Kline, Memorial Exhibition (Washington, D.C.: Gallery of Modern Art, 1962), p. 8. Reprinted in Artnews 61 (November 1962): 31. She describes Kline's "friendship with Willem de Kooning [as] a dynamic and inspirational relationship (like that of Monet and Renoir, as against the intellectual collaborative ties that linked Picasso to Braque)." See also Philip Larson, "De Kooning's Drawings" in De Kooning, Drawings/Sculptures, sec. IV, and Lawrence Alloway, "De Kooning: Criticism and Art History," p. 50.

88. Interview, Willem de Kooning, East Hampton, August 9, 1971. See Harry F. Gaugh, "Kline's Transitional Abstractions, 1946–50," Art in America 62 (July–August 1974): 43–47.

89. Quoted in Rodman, Conversations with Artists, p. 108.

90. See Harry F. Gaugh, Franz Kline, The Color Abstractions (Washington, D.C.: Phillips Collection, 1979), p. 19.

91. Interview, Oskar Kokoschka, Villeneuve, August 21, 1965.

92. Rosalind E. Krauss, Terminal Iron Works, The Sculpture of David Smith (Cambridge, Mass.: MIT Press, 1971), pp. 117, 174. De Kooning visited Smith at Bolton Landing and saw his sculpture covering the hillsides around the studio. Hess, de Kooning, 1968, p. 101. One abstract landscape of 1957 is entitled Bolton Landing.

93. Such Caro works as The Horse (1961), Early One Morning (1962), and Yellow Swing (1965). See William Rubin, Anthony Caro (New York: Museum of Modern Art, 1975), pp. 27, 41, 64. The parallels with Caro are primarily structural, not extending to the artists' different uses of color.

94. Quoted in Carole Agus, "de Kooning," Newsday, September 5, 1976, part II, p. 3.

95. Rosenberg, "Interview with Willem de Kooning," p. 56.

96. Interview, Elaine de Kooning, December 2, 1982.

97. Hess, Recent Paintings, p. 14.

98. De Kooning had begun designing the new studio by winter 1961. Judith Wolfe, Willem de Kooning, p. 11.

99. This does not mean that his work was accepted by every critic. Reviewing the 1962 show at the Janis Gallery, Sidney Tillim commented that since de Kooning's Women of 1950–53 his "output has been confused, inconclusive, and increasingly fragmentary. (I don't see how people can deny it, but they do.)" "Month in Review," Arts Magazine 36 (May–June 1962): 82. Tillim also noted that never having privacy ("partly his own fault"), de Kooning "has had to live out his fallibility in public, protected only by a myth of which he seems to be the principal victim now that Pollock is dead."

100. Vivian Raynor, "In the Galleries—Joseph Cornell, Willem de Kooning," Arts Magazine 39 (March 1965): 53.

101. Hess, Recent Paintings, p. 24.

102. Rosenberg, "Interview with Willem de Kooning," p. 58. Titles of other paintings in this series reflect the identification of subject with places around East Hampton: Woman Acabonic, Woman Springs (both 1966). Regarding Woman Acabonic, de Kooning said in 1981: "I think she maybe is a woman who makes hats. She's kind of funny-looking; she's here for the weekend. . . . Well, she's turning into her forties, I guess. It's true, isn't it? She's sweet and friendly. Don't you think so?" Quoted in Wolfe, de Kooning, p. 14.

103. Rosenberg, "Interview with Willem de Kooning," p. 57.

104. In seventeenth-century scenes of the Temptation of St. Anthony by a beautiful lady (sometimes holding a glass of wine), her feet, barely visible beneath her long gown, are revealed as devilish claws.

105. Hess, de Kooning, 1968, p. 124. Hess notes that de Kooning admired Bacon's work "since the screaming cardinal [sic] pictures." When the artists met, Bacon impressed de Kooning more as a great raconteur than a painter. Interview, Elaine de Kooning, December 2, 1982.

106. De Kooning has always been fascinated by Bosch's work. Ibid. A figure topped by a beak-faced head is also the subject of de Kooning's Clam Digger (oil on paper, 1966).

107. The Museum of Modern Art Bulletin 18 (Spring 1951): 7.

108. Dan Sullivan, "Theater: 'The Visit' in Minneapolis," New York Times, September 13, 1967, p. 41. (The film version of The Visit had been released in 1964). The Visit was painted "in the winter of 1966–67." Hess, Recent Paintings, 1967, p. 34. Hess regards the title as referring to the appearance and reappearance of secondary figures in the painting while de Kooning worked on it.

109. "Content Is a Glimpse," in Hess, de Kooning, 1968, p. 148.

110. De Kooning: Drawings, n.p.

111. Wolfe, de Kooning, p. 14.

112. Occasionally, Pollock had modeled in clay and in the late 1960s Gottlieb made a few painted steel pieces.

113. De Kooning began making sculpture in the Rome studio of Herzl Emmanuel. Peter Schjeldahl, "De Kooning's Sculpture" in De Kooning: Drawings/Sculptures, sec. II. See reply by Florence Hunter, "Friendly Influence?" Art in America 62 (July–August 1974): 112.

114. Schjeldahl, "De Kooning's Sculpture," sec. III.

115. Hess, Drawings, p. 49. During de Kooning's first visit to Rome in 1959–60 "he made drawings that cross the border between the picture plane and the bas-relief. . . . It was no coincidence, I believe, that Rome was where he made his first sculptures."

116. Wolfe, de Kooning, p. 15.

117. Ibid.

118. Schjeldahl, "De Kooning's Sculpture," sec. I.

119. "The Renaissance and Order," in Hess, de Kooning, 1968, p. 142.

120. Quoted in Bernard Karpel, Robert Motherwell, and Ad Reinhardt, Modern Artists in America, first series (New York: Wittenborn, Schultz, 1951), p. 14.

121. Douglas Bush, John Keats, His Life and Writings (New York: Macmillan, 1966), p. 198. The final words of the epitaph are also part of Oscar Wilde's poem The Grave of Keats. De

Kooning may have come across the line when visiting Rome in 1959–60. Interview, Elaine de Kooning, December 2, 1982. Hess notes that "writ in water" is a favorite de Kooning quote. Thomas B. Hess, "Water Babes," p. 75.

122. Quoted ibid., p. 74.

123. Some of Pollock's comments in the film were reworked from previously published statements. See Francis V. O'Connor, *Jackson Pollock* (New York: Museum of Modern Art, 1967), p. 40.

124. Hess, "Water Babes," p. 75.

125. Hilton Kramer, "Painting at the Limits of Disorder," p. 31.

126. Rosenberg, *The Anxious Object*, p. 123.

127. For an evaluation of the state of de Kooning criticism in 1975, see Alloway, "De Kooning: Criticism and Art History." De Kooning's own appraisal of other artists tends to be inclusive; he has never been impressed so much by a single work as by an artist's whole output. Interview, Elaine de Kooning, December 2, 1982.

128. Greenberg, *Art and Culture* (Boston: Beacon Press, 1965), p. 213. For the decline in Greenberg's critical regard of de Kooning's work in the later 1950s and 1960s, see Hess, *de Kooning*, 1968, pp. 138–39, n. 11.

129. "Content Is a Glimpse," in Hess, *de Kooning*, 1968, p. 145.

130. "De Kooning today knows that he 'must change to stay the same.'" Jack Cowart, "De Kooning Today," p. 16.

103. Elaine and Willem de Kooning in the porch-studio of Leo Castelli's house, East Hampton, August 23, 1953
Photograph by Hans Namuth

103

Artist's Statements

"The attitude that nature is chaotic and that the artist puts order into it is a very absurd point of view, I think. All that we can hope for is to put some order into ourselves. When a man ploughs his field at the right time, it means just that.

"Insofar as we understand the universe—if it can be understood—our doings must have some desire for order in them; but from the point of view of the universe, they must be very grotesque."

From "The Renaissance and Order," written in 1950 for a lecture series at Studio 35 in New York. Published in *Transformation* 1, no. 2 (1951). Quoted in Thomas B. Hess, *de Kooning*, 1968, pp. 141–43.

"The first man who began to speak, whoever he was, must have intended it. For surely it is talking that has put 'Art' into painting. Nothing is positive about art except that it is a word. Right from there to here all art became literary. We are not yet living in a world where everything is self-evident. It is very interesting to notice that a lot of people who want to take the talking out of painting, for instance, do nothing else but talk about it. That is no contradiction, however. The art in it is the forever mute part you can talk about forever.

"For me, only one point comes into my field of vision. This narrow, biased point gets very clear sometimes. I didn't invent it. It was already here. Everything that passes me I can see only a little of, but I am always looking. And I see an awful lot sometimes."

From "What Abstract Art Means to Me," written for a symposium at the Museum of Modern Art, February 5, 1951. Published in *The Bulletin of The Museum of Modern Art*, pp. 4–5.

"The *Women* had to do with the female painted through all the ages, all those idols, and maybe I was stuck to a certain extent; I couldn't go on. It did one thing for me: it eliminated composition, arrangement, relationships, light—all this silly talk about line, color and form—because that was the thing I wanted to get hold of. I put it in the center of the canvas because there was no reason to

put it a bit on the side. So I thought I might as well stick to the idea that it's got two eyes, a nose and mouth and neck. I got to the anatomy and I felt myself almost getting flustered. I really could never get hold of it. It almost petered out. I never could complete it and when I think of it now, it wasn't such a bright idea. But I don't think artists have particularly bright ideas. Matisse's *Woman in a Red Blouse*—what an idea that is! Or the Cubists—when you think about it now, it is so silly to look at an object from many angles. Constructivism—open, not closed. It's very silly. It's good that they got those ideas because it was enough to make some of them great artists."

"The *Woman* became compulsive in the sense of not being able to get hold of it—it really is very funny to get stuck with a woman's knees, for instance. You say, 'What the hell am I going to do with that now?'; it's really ridiculous. It may be that it fascinates me, that it isn't supposed to be done. A lot of people paint a figure because they feel it ought to be done, because since they're human beings themselves, they feel they ought to make another one, a substitute. I haven't got that interest at all. I really think it's sort of silly to do it. But the moment you take this attitude it's just as silly not to do it."

"Content is a glimpse of something, an encounter like a flash. It's very tiny—very tiny, content. When I was painting those figures, I was thinking about Gertrude Stein, as if they were ladies of Gertrude Stein—as if one of them would say, 'How do you like me?' Then I could sustain this thing all the time because it could change all the time; she could almost get upside down, or not be there, or come back again, she could be any size. Because this content could take care of almost anything that could happen."

"I still have it now from fleeting things—like when one passes something, and it makes an impression, a simple stuff."

"I read somewhere that Rubens said students should not draw from life, but draw from all the great classic casts. Then you really get the measure of them, you really know what to do. And *then*, put in your own dimples.

"Isn't that marvelous.

"Now, of course, we don't do that. You've developed a little culture for yourself, like yoghurt; as long as you keep something of the original microbes, the original thing in it will grow out. So I had—like most artists—this original little sensation, so I don't have to worry about getting stuck. As to the painting being finished. I always have a miserable time over that. But it is getting better now. I just stop. I sometimes get rather hysterical and because of that I find sometimes a terrific picture. As a matter of fact, that's probably the real thing, but I couldn't set out to do that. I set out keeping in mind that this thing will be a flop in all probability, and it sometimes turns out very good."

From "Content Is a Glimpse," excerpts from a BBC interview with David Sylvester, December 30, 1960. Published in *Location* (New York) (Spring 1963). Quoted in Hess, *de Kooning*, p. 151.

104

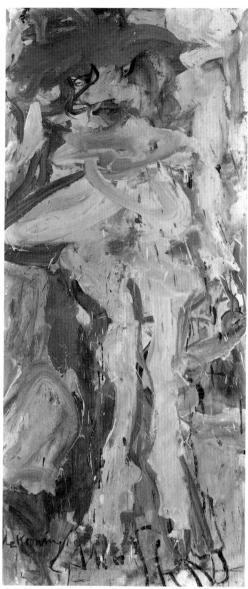

105

"DE KOONING: If you have nothing to do and want to meditate and have no inspiration, it might be a good idea to make a sphere.
ROSENBERG: Out of what?
DE KOONING: Out of plaster. It's easy. You can add to it, you can sandpaper it. But you mustn't use calipers or any other instrument. You could never make that sphere because you would never know.
ROSENBERG: You mean, you wouldn't know when you had produced a perfect sphere? Or you wouldn't know how to go about making it?
DE KOONING: You can imagine yourself doing it. Let's say you make it about 12 inches, but you don't use a ruler. It is very hard to know what 12 inches is without a ruler.
ROSENBERG: Do you want it to be a sphere of a certain size or just round?
DE KOONING: Well, you could start to make it 12 inches. Then you turn it around and say, 'Gee, I have to sandpaper this a little more.' Then the next time you say, 'I have to add a little more here.' You keep turning it around and it will go on forever because you can only test it by eye.
ROSENBERG: If you didn't feel that you had to add or subtract, would you be convinced you had a perfect sphere? I mean, if you got to the point where you felt there was nothing you could do to it. Then it would be a sphere, wouldn't it?
DE KOONING: Yes, but that can never happen.
ROSENBERG: You don't think one would ever get that feeling?
DE KOONING: No, because a sphere is social. If they give you a ball bearing, you know it is absolutely right?
ROSENBERG: You would take their word for it.
DE KOONING: Most things in the world are absolutes in terms of taking someone's word for it. For example, rulers. But if you yourself made a sphere, you could never know if it was one. That fascinates me. Nobody ever will know it. It cannot be proven, so long as you avoid instruments. If I made a sphere and asked you, 'Is it a perfect sphere?' you would answer, 'How should I know?' I could insist that it looks like a perfect sphere. But if you looked at it, after a while you would say, 'I think it's a bit flat over here.' That's what fascinates me—to make something I can never be sure of, and no one else can either. I will never know, and no one else will ever know.
ROSENBERG: You believe that's the way art is?
DE KOONING: That's the way art is."

From Harold Rosenberg, "Interview with Willem de Kooning," pp. 54–58.

104. *Queen of Hearts*, 1943–46
Oil and charcoal on fiberboard, 46⅛ × 27⅝ in.
Hirshhorn Museum and Sculpture Garden, Smithsonian Institution, Washington, D.C.

105. *Woman Acabonic*, 1966
Oil on paper, mounted on canvas, 80½ × 36 in.
Whitney Museum of American Art, New York
Gift of Mrs. Bernard F. Gimbel

Notes on Technique

Throughout his career de Kooning has retained the idea of the studio as a thoroughly organized, well-lighted, spotless place for the making of art. Photographs of de Kooning's studios over the years reveal them to be, for instance, the antithesis of Giacometti's Paris studio with its ever-encroaching shadows and dust-covered clutter. Elaine de Kooning has recalled that several days after first meeting him, she visited his studio: "It was the cleanest place I ever saw in my life."[1] De Kooning's predilection for light—obvious in certain phases of his art, such as the large abstractions since 1975—is equally obvious in his attitude toward his studio. Commenting on a visit to Rothko's East Sixty-ninth Street studio, de Kooning noted in a 1979 interview: "I couldn't figure out why he didn't clean the skylight. You know I'm a clean bug. I want everything light and bright. And his skylight was so dirty, but I didn't tell him that and I thought if I had that place I would clean that skylight."[2] De Kooning's art may have a random, improvisational, and at times even gritty look, but it is the work of a well-scrubbed artist.

De Kooning's media are not all-inclusive; he has not worked in acrylics or watercolor, nor often in pen and ink. Yet his media are numerous, varied, and frequently combined. Much of the time "mixed media" accurately, if somewhat generically, describes his choice of materials. Just as he has fluctuated stylistically between figural imagery and abstraction, de Kooning has also merged painting and drawing. Indeed, he has drawn with a brush in his paintings and achieved in his charcoal drawings a painterly modulation of tone and texture. Charcoal drawn into a still-wet oil painting was a major characteristic of his work during the 1950s—perhaps the most notorious example is *Woman I*'s frenzied stare.[33]

Repeatedly, de Kooning experiments with ways to get paint on a surface and move it around. His machete-cut stroke, made with a wide commercial brush, is a dominant feature of the 1955–56 "urban landscapes." Later, in the 1950s series of "abstract landscapes," his brushes increased to several inches in width. In fact, de Kooning's brushstroke has become as much a sign of Abstract Expressionism as Pollock's skeins of poured enamel and Rothko's rag- and brush-worked expanses of color/light. De Kooning has had a con-

106. Two views of de Kooning's paint pots, 1982
Photographs by Linda McCartney

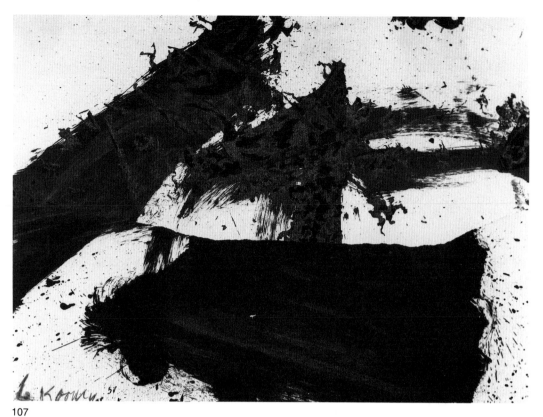

107

tinuing interest in working an entire painting at once, and he has always tried to keep a painting's surface uniformly wet. Sometimes, when the paint becomes too thick, he covers the canvas with paper (frequently newspaper) and presses it to remove the excess paint. Some of these newspaper sheets bearing images of women became "monoprints" when pulled off surfaces of paintings in progress. One of the best known, *Brancusi* (1966), takes its name from the Brancusi furniture advertisement printed on the *New York Times* page. (Ironically, the figure's robust, organic forms do recall Brancusi's sculpture, such as the white marble *Leda* of 1920.)

In the late 1950s de Kooning began mixing oil paint with a few drops of water—usually in salad bowls. In the 1960s his mixture consisted of a very high-grade commercial oil paint mixed with a little safflower oil, a few drops of benzine, and a few drops of water. Sometimes he also added a few drops of kerosene to make the blending easier. He stopped such mixing, however, about four or five years ago and now blends paint only on the palette or painting surface itself.[3] Never liking to pile paint up on a canvas, in the mid-1970s he used palette knives to scoop paint and slide it across a thoroughly wet surface. Such areas could be reworked many times and could be painted into with a brush. Now he applies and scrapes off paint with broad, flat spatulas, preferring that the tracks of a brush not intrude into the surface.

De Kooning's supports have been as varied as his means of applying paint to them. He has painted on canvas, composition board, cardboard, wooden doors, and many kinds of paper, sometimes mounting the paper on more substantial backings. Some paintings

107. *Untitled*, 1959
Ink and collage on paper, 27¾ × 39¼ in.
Hirshhorn Museum and Sculpture Garden,
Smithsonian Institution, Washington, D.C.

108. Verso of plate 107

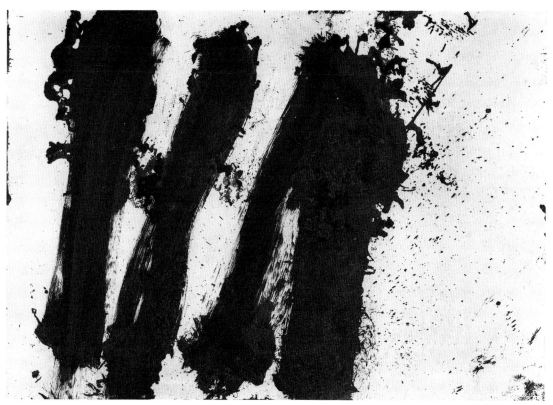

108

consist of several mountings. One in the series of 1964 Women, for example, an oil on vellumlike paper, was first mounted on paper that, in turn, was mounted on Masonite.[4] De Kooning has also drawn on tracing paper. In fact, tracing part of a painting and then reworking the tracing or carrying it over to another work has been a recurring de Kooning practice.[5] On a very few occasions in the mid-1960s de Kooning would spray a vellumlike vegetable parchment—chosen particularly for its wet strength and grease resistance—with white natural or synthetic resin, adding to the surface's luminosity and shine.[6] Examples are *Sphinx* and *Mae West* (both 1964).

109, 39

In his Rome Drawings, made during the winter of 1959–60, de Kooning painted with black ink on Italian-made paper (Fabriano), which was painted on one or both sides and then torn up to be used in a collage. Impressive for their scale (roughly 30 by 42 in.) and stark black imagery, these are comparable to other de Kooning collages from the late 1950s made of torn ink drawings. Some have "alternative" drawings on the verso—usually unseen—that offer a visual key to de Kooning's selection process (see *Untitled*, 1959).

107 , 108

Although not so prevalent in his oeuvre as painting and drawing, de Kooning's collages are some of his most assured works in both abstract and figural modes. In the early 1950s he produced quantities of drawings on the Woman theme in charcoal, pastel, pencil, and crayon. Some are collages, assembled from two or three drawings; at times one drawing bears the image of the body, topped by another drawing with the head. The reciprocity between drawing and painting while de Kooning worked on *Woman I* was surely as

crucial to his creative process as it was with Picasso and *Les Demoiselles d'Avignon*.

During the last year, de Kooning has followed an early-morning schedule: he gets up between 5:30 and 6:00, has a quick breakfast, and is in the studio by 8:30. He works on one painting at a time, concentrating on it day after day until completed. If he gets stuck with that painting, he sets it aside and begins another. He always paints on stretched canvas backed with styrofoam for firm support. Unlike the late 1930s and early '40s when de Kooning sometimes listened to music on his phonograph while painting, nowadays he works in total silence. And more time is spent looking critically at a work in progress than actually applying paint to it.[7]

NOTES

1. Quoted in George Dickerson, "The Strange Eye and Art of de Kooning," p. 68.

2. Quoted in Joseph Liss, "Willem de Kooning Remembers Mark Rothko: 'His House Had Many Mansions,'" *Artnews*, p. 43.

3. Interview, Elaine de Kooning, New York, December 2, 1982.

4. Letter to the author from Antoinette Owen, conservator, Hirshhorn Museum and Sculpture Garden, Washington, D.C., December 9, 1982.

5. Interview, Elaine de Kooning.

6. Letter, Antoinette Owen.

7. Telephone conversation, Elaine de Kooning, March 12, 1983.

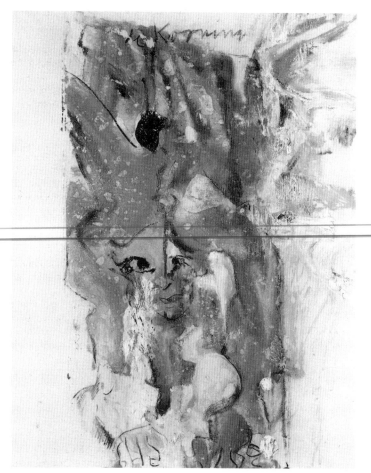

109. *Sphinx*, 1964
Oil and charcoal on paper, 23½ × 18¼ in.
Hirshhorn Museum and Sculpture Garden,
Smithsonian Institution, Washington, D.C.

109

Chronology By Anna Brooke

1904 April 24—born in Rotterdam to Leendert and Cornelia Nobel de Kooning. Parents divorce when he is about five years old. Court assigns Willem to his father and his sister to his mother, but she appeals the decision and wins custody of Willem. His mother owns a bar; his father owns a wine and beverage distribution company.

1916 Leaves grammar school to work as apprentice to the local commercial art and decorating firm of Jan and Jaap Gidding. Attends the Rotterdam Academy of Fine Arts and Techniques at night (until 1924). Influenced by Professor Jongert, a teacher at the academy. Graduates as a certified artist and craftsman.

1920 Leaves the Giddings to work with Bernard Romein, art director and designer for a department store in Rotterdam. Through Romein develops interest in Jugendstijl, de Stijl, Mondrian, Frank Lloyd Wright, Jan Toroop, and the Paris moderns. Reads Walt Whitman's poetry. Rents a studio and lives with two friends.

1924 Travels to Belgium with friends. Visits museums, works as a commercial artist and at various jobs.

1925 Returns to Rotterdam.

1926 Emigrates illegally to the United States with Leo Cohen on *S.S. Shelley*. August 15—lands in Newport News, Virginia. Goes to Boston on a coaler working as a stoker, then to Rhode Island by train; to South Street, New York, by boat; and finally to Hoboken, New Jersey, by ferry. Lives at Dutch Seamen's Home, Hoboken. Works as a house painter.

1927 Moves to New York City. Lives on West Forty-second Street in the theater district. Works at commercial art jobs, department store displays, sign painting, and carpentry (until 1935).

1928 Spends summer in Woodstock, New York, at artists' colony.

1929 Meets John Graham, Stuart Davis, and other New York artists.

Late 1920s–early 1930s Meets Arshile Gorky, possibly at artist Mischa Resnikoff's studio.

1930s Works as assistant painter, American Music Hall Night Club.

1934 Joins the Artists' Union, 60 West Fifteenth Street, which publishes *Art Front*.

1935 Meets poet Edwin Denby, photographer-painter Rudolph Burckhardt, musicians and composers Virgil Thomson and Aaron Copeland. Works for the Federal Arts Project (W.P.A.) for one year with Fernand Léger on a project for the French Line Pier and on a mural project for the Williamsburg Federal Housing Project in Brooklyn. Leaves W.P.A. because he is not a U.S. citizen. Paints full-time.

1936 Lives at 147 West Twenty-first Street. Meets critic-poet Harold Rosenberg. September—included in his first group exhibition, *New Horizons in American Art*, Museum of Modern Art, New York. Begins series of men in interiors (possibly 1937).

1937 Moves to 156 West Twenty-second Street. Meets Elaine Fried, an art student; she becomes a student of his. Receives commission for one section of a three-part mural, *Medicine*, for the 1939 New York World's Fair Hall of Pharmacy. Meets David Smith and Barnett Newman.

1938 Begins first series of Women.

1940 March—*Harper's Bazaar* publishes his fashion illustrations. Commissioned to design costumes for Nini Theilade's ballet, *Les Nuages*, with music by Debussy, for Ballet Russe de Monte Carlo, performed at Metropolitan Opera House, April 9. Designs murals for the U.S. Maritime Commission for *S.S. President Jackson*, American President Lines, of which four panels, *Legend and Fact*, still exist

at the National Gallery, Washington, D.C.

1942 Begins friendship with Jackson Pollock.

1943 Moves to Carmine Street in Greenwich Village. Remodels studio on Fourth Avenue between Tenth and Eleventh streets. December 9—marries Elaine Fried (separated in 1956; begin living together again in 1979). Helena Rubenstein buys *Elegy*. Meets Franz Kline at Conrad Marca-Relli's studio.

1945 January—paints watercolor entitled *The Netherlands* for "United Nations," a series of advertisements for Container Corporation of America.

1946 Designs backdrop for the dance *Labyrinth* by Maria Marchowsky, performed at New York Times Hall, April 5; Milton Resnick assists in execution of backdrop. Begins series of black and white abstractions, which are first exhibited in 1948.

1948 April—first solo exhibition held at Charles Egan Gallery; also, makes first visit to East Hampton, spending weekend with Kline, Egan, Pollock, and Lee Krasner. Meets critic Thomas Hess. April—first museum purchase, *Painting*, 1948, made by the Museum of Modern Art, New York. Summer—teaches at Black Mountain College, North Carolina. November—included for the first time in *Annual Exhibition of Contemporary American Painting*, Whitney Museum of American Art, New York.

1949 Fall—becomes a charter member of the Eighth Street Artists "Club"; participates in Friday night symposia at the "Subjects of the Artist: A New School" and delivers a lecture there, *A Desperate View*.

1950 Writes a lecture, *The Renaissance and Order*, which is delivered for him by Robert Motherwell at Studio 35, Eighth Street, New York; the lecture is published in 1951 in *Transformation*. Begins *Woman I*. Summer—one of six artists selected by Alfred Barr for *XXV Venice Biennale*, de Kooning's first foreign group

110

exhibition. Winter—commutes to New Haven as visiting critic at Yale University Art School for one semester (1950–51).

1951 February—writes a paper, *What Abstract Art Means to Me*, delivered by Andrew Ritchie at a symposium at the Museum of Modern Art. Spends summers at Leo Castelli's house in East Hampton (until 1953). October—wins the Logan Medal and Purchase Prize for *Excavation* in the *60th Annual American Exhibition*, Art Institute of Chicago. October—included in the *I Bienal*, São Paulo, Brazil.

1953 Robert Rauschenberg erases a de Kooning drawing. December—included in the *II Bienal*, São Paulo.

1954 June—one of two painters selected by the Museum of Modern Art to represent the United States in the *XXVII Venice Biennale*. Spends summer with Elaine, Kline, Nancy Ward, and the artist Ludwig Sander in Bridgehampton, Long Island.

1956 Daughter, Lisa, born. Included in the *XXVIII Venice Biennale*.

1957 Makes first etching, for Harold Rosenberg's poem *Revenge*, published in 1960 by the Morris Gallery, New York. Begins painting "abstract landscapes."

1958 Travels to Venice. Moves to a larger loft, at 831 Broadway. Visits David Smith at Bolton Landing and Josef Albers in New Haven. Late summer—rents Marca-Relli's house in The Springs (until January 1959).

1959 Spends the summer in Southampton, New York.

1959–60 December–January—spends the winter in Rome. Works in the artist Afro's studio on the via Margutta. Makes abstract black enamel drawings on paper.

1960 Returns to New York. Goes to San Francisco. Makes first two lithographs, in black and white, at the invitation of Karl Kasten and Erle Loran at University of California, Berkeley; works are printed by Nathan Oliveira and George Miyasaki. Elected to National Institute of Arts and Letters, New York. Spring—backdrop for *Labyrinth*, 1946, his largest work, found in Maria Marchowsky's studio, New York.

1961 March 13—becomes United States citizen. Begins plan for a studio on land in The Springs, East Hampton. Buys a cottage in The Springs from Peter Fried, his brother-in-law, and starts to build his studio.

1963 June—moves to The Springs from his loft on Broadway. Begins a new series of Women.

1964 January—first solo exhibition of drawings held at James Goodman Gallery, Buffalo, New York. Receives the Guggenheim International Award. September 14—receives the Presidential Medal of Freedom from President

Johnson, along with twenty-nine other artists, musicians, etc. Begins painting Women on door panels.

1965 April—first United States museum retrospective held at Smith College Museum of Art. Suit brought between de Kooning and his dealer, Sidney Janis, for breach of contract.

1967 Begins Woman on a Sign series.

1968 January—makes first trip to Paris, with Thomas Hess and Xavier Fourcade, to see an Ingres exhibition and visit the Louvre. Returns via London, where he meets Francis Bacon. June—first solo exhibition held in Europe, at M. Knoedler and Company, Paris. September—returns to Holland for the first time since 1926 for the opening of his first major solo traveling exhibition, at the Stedelijk Museum, Amsterdam, organized by the Museum of Modern Art. Receives the Talens Prize International.

1969 Summer—meets sculptor Herzl Emmanuel while visiting Rome and makes first small sculptures at his foundry. Visits Spoleto Festival. Travels to Japan with his dealer Xavier Fourcade. Visits Tokyo, Kyoto, Ise, Mount Fuji; travels to Osaka with the artist Isamu Noguchi to see the waterworks he was building for the World's Fair. Looks at Sumi ink drawings.

1970 Encouraged by Henry Moore, experiments with enlarging small sculptures in different materials (including polyester resin with a bronzelike coating). Begins to make large-scale sculptures.

1971 September—first solo exhibition of lithographs held at M. Knoedler and Company, Paris.

1972 October—first exhibition to include sculpture held at Sidney Janis Gallery, New York.

1973 May 6—receives $1000 honorarium and the Brandeis University Seventeenth Annual Creative Arts Award.

1974 Australian National Gallery, Canberra, purchases *Woman V* for $850,000, a record sum paid for a work by a living American artist.

1975 Receives the Gold Medal for Painting, National Institute of Arts and Letters, New York. Receives the Edward MacDowell Medal. Begins new series of abstractions strongly reflecting his East Hampton environment.

1978 December—elected to the American Academy of Arts and Letters, New York.

1979 Joint recipient, with Eduardo Chillida, of the $50,000 Andrew W. Mellon prize for the *Pittsburgh International Series*, Museum of Art, Carnegie Institute. April—on seventy-fifth birthday, the Dutch government makes him an Officer of the Order of Orange-Nassau.

1982 April 25—shows his work to Queen Beatrix of The Netherlands at the World Trade Center, New York. Becomes Associate Elect, National Academy of Design, New York.

1983 May—retrospective of past twenty-two years of work opens at the Stedelijk Museum, Amsterdam; tour to Louisiana Museum, Humlebaek, Denmark, and Moderna Museet, Stockholm. December—major retrospective opens at the Whitney Museum of American Art; tour to the Centre Pompidou, Paris, and the Akademie der Künste, Berlin.

110. Willem and Elaine de Kooning in his studio, June 1950
Photograph by Rudolph Burckhardt

111. Willem de Kooning (right) and Franz Kline (second from right) with artist Ludwig Sander (eighth from right) and others outside Betty Parsons Gallery, late 1950s
Photograph by Fred McDarrah

111

Exhibitions

Solo Exhibitions

1948

Willem de Kooning, Egan Gallery, New York, April 12–May 12.

1951

Willem de Kooning, Egan Gallery, April 1–30, and tour to Arts Club of Chicago.

1953

Willem de Kooning: Paintings on the Theme of the Woman, Sidney Janis Gallery, New York, March 16–April 11.

De Kooning 1935–1953, Museum School, Museum of Fine Arts, Boston, April 21–May 8, and tour to Workshop Center, Washington, D.C.

1955

Recent Oils by Willem de Kooning, Martha Jackson Gallery, New York, November 9–December 3.

1956

De Kooning, Sidney Janis Gallery, April 2–28.

1959

de Kooning, Sidney Janis Gallery, May 5–30.

1961

Willem de Kooning, Paul Kantor Gallery, Beverly Hills, California, April 3–29.

1962

Recent Paintings by Willem de Kooning, Sidney Janis Gallery, March 5–31.

1964

"Woman" Drawings by Willem de Kooning, James Goodman Gallery, Buffalo, January 10–25.

Willem de Kooning: Retrospective Drawings 1936–1963, Allan Stone Gallery, New York, February.

1965

Willem de Kooning, Paul Kantor Gallery, March 22–April 30, and tour to Aspen Institute, Colorado.

Willem de Kooning: A Retrospective Exhibition from Public and Private Collections, Smith College Museum of Art, Northampton, Massachusetts, April 8–May 2, and tour to Hayden Gallery, Massachusetts Institute of Technology, Cambridge.

1966

De Kooning's Women, Allan Stone Gallery, March 14–April 2.

1967

De Kooning: Paintings and Drawings since 1963, M. Knoedler and Company, New York, November 14–December 2.

1968

Willem de Kooning: Three Decades of Painting, J. L. Hudson Gallery, Detroit, March 19–April 13.

De Kooning: Peintures récentes, M. Knoedler and Company, Paris, June 4–29.

Willem de Kooning, Stedelijk Museum, Amsterdam, September 19–November 17, and tour to Tate Gallery, London; Museum of Modern Art, New York; Art Institute of Chicago; Los Angeles County Museum of Art. Organized by the Museum of Modern Art, New York.

1969

Willem de Kooning January 1968–March 1969, M. Knoedler and Company, New York, March 4–22.

De Kooning: Disegni, XII Festival dei Due Mondi, Palazzo Ancaini, Spoleto, June 28–July 16.

1971

De Kooning New Lithographs, M. Knoedler and Company, Paris, September 28–October 23.

Willem de Kooning: The 40's and 50's, Allan Stone Gallery, October 17–November 1.

Seven by de Kooning, Museum of Modern Art, December 30–February 28, 1972.

1972

Willem de Kooning: Paintings, Sculpture, and Works on Paper, Baltimore Museum of Art, August 8–September 24.

De Kooning, Sidney Janis Gallery, October 4–November 4.

Willem de Kooning: Selected Works, Allan Stone Gallery, October 17–November 11.

1973

Willem de Kooning: Paintings, Drawings, Sculpture, Gertrude Kasle Gallery, Detroit, May 19–June 30.

Willem de Kooning, Collection d'Art Galerie I, Amsterdam, November 3–December 6.

1974

Lithographs 1970–1972: Willem de Kooning, Art Gallery, University of Alabama, Tuscaloosa, March 4–April 15, and tour to Amarillo Art Center, Texas; Fine Arts Gallery of San Diego; Tucson Museum of Art, Arizona; Santa Barbara Museum of Art; Indianapolis Museum of Art; Joslyn Art Museum, Omaha; Everson Museum of Art, Syracuse; Georgia Museum of Art, Athens; Grunewald Center for the Graphic Arts, University of California, Los Angeles; Simon Fraser University, Burnaby, British Columbia; San Jose Museum of Art, California; Krannert Art Museum, University of Illinois, Champaign; University Art Museum, University of Texas at Austin; Sarah Campbell Blaffer Gallery, University of Houston. Organized by Fourcade, Droll, New York.

De Kooning: Drawings/Sculptures, Walker Art Center, Minneapolis, March 10–April 21, and tour to National Gallery of Canada, Ottawa; Phillips Collection, Washington, D.C.; Albright-Knox Art Gallery, Buffalo; Museum of Fine Arts, Houston; Washington University Gallery of Art, Saint Louis.

Willem de Kooning: Grafiken 1970–1971, Galerie Biedermann, Munich, September 26–November 9.

Willem de Kooning, Richard Gray Gallery, Chicago, October 4–November 16.

De Kooning: Major Paintings and Sculpture, Pollack Gallery, Toronto, October 15–November 15.

1975

De Kooning, Fuji Television Gallery, Tokyo, September.

De Kooning: New Works, Paintings and Sculpture, Fourcade, Droll, October 25–December 6.

De Kooning, Galerie des Arts, Paris, October 29–November 29.

Matrix 15, Wadsworth Atheneum, Hartford, Connecticut, December–January 1976.

De Kooning: Paintings, Drawings, Sculpture 1967–1975, Norton Gallery of Art, West Palm Beach, Florida, December 10–February 15, 1976.

1976

De Kooning: New Paintings and Sculpture, Seattle Art Museum, February 4–March 14.

Willem de Kooning: Beelden en lithós, Stedelijk Museum, March 5–April 19, and tour to Wilhelm-Lehmbruck Museum, Duisburg; with paintings added, Cabinet des Estampes, Musée d'Art et d'Histoire, Geneva; and Musée de Peinture et de Sculpture de Grenoble.

Willem de Kooning, Collection d'Art Galerie I, May 1–July 1.

Willem de Kooning: Paintings, Drawings, Sculptures, James Corcoran Gallery, Los Angeles, May 20–June 26.

Willem de Kooning: Recent Paintings, Gimpel Fils, London, June 29–August 12, and tour to Gimpel and Hanover, Zurich.

De Kooning: New Paintings 1976, Xavier Fourcade, New York, October 12–November 20.

1977

Willem de Kooning: Peintures et sculptures récentes, Galerie Templon, Paris, September 15–October 30.

Willem de Kooning: Paintings and Sculpture, Museum of Contemporary Art, Belgrade, October 1–December 1, and tour to Museum of Modern Art, Ljubljana, Yugoslavia; Romanian National Museum of Art, Bucharest; National Museum, Warsaw; Branch Post, Krakow, Poland; Helsinki National Museum of Art; Amerika Haus, East Berlin; Caja de Ahorros, Alicante, Spain; Fundacion Juan March, Madrid; Oslo Nasjonalgalleriet; and Dordrechts Museum, The Netherlands. Organized by United States Information Agency and Hirshhorn Museum and Sculpture Garden, Smithsonian Institution, Washington, D.C.

Willem de Kooning, Collection d'Art Galerie I, October 8–December 11.

De Kooning: New Paintings, Xavier Fourcade, October 11–November 19.

The Sculpture of de Kooning with Related Paintings, Drawings, and Lithographs, Fruit Market Gallery, Edinburgh, October 15–November 12, and tour to Serpentine Gallery, London. Organized by the Arts Council of Great Britain.

Willem de Kooning: Recent Works, James Corcoran Gallery, November 11–December 5.

Willem de Kooning: Drawings, Visual Arts Museum, New York, November 15–December 9.

1978

Willem de Kooning in East Hampton, Solomon R. Guggenheim Museum, New York, February 10–April 23.

The Willem de Kooning Exhibition, Museum of Art, Science and Industry, Fairfield, Connecticut, June 3–11.

Willem de Kooning: Matrix 12, University Art Museum, University of California, Berkeley, September–November.

De Kooning 1969–78, Gallery of Art, University of Northern Iowa, Cedar Falls, October 21–November 26, and tour to Saint Louis Art Museum; Contemporary Arts Center, Cincinnati; Akron Art Institute.

1979

De Kooning: New Paintings 1978–79, Xavier Fourcade, October 20–November 17.

Willem de Kooning: Pittsburgh International Series, Museum of Art, Carnegie Institute, Pittsburgh, October 26–January 6, 1980.

1980

Willem de Kooning: Paintings, Sculpture, Drawings, Richard Hines Gallery, Seattle, January 23–March 8.

De Kooning: Late Paintings and Drawings, Richard Gray Gallery, February 16–March.

Willem de Kooning, Hans Strelow Gallery, Düsseldorf, November.

1981

Willem de Kooning: Drawings of the Seventies, Janie C. Lee Gallery, Houston, April 4–30.

Willem de Kooning: Works from 1951–1981, Guild Hall Museum, East Hampton, May 23–July 19.

1982

Willem de Kooning: Paintings and Drawings, C. Grimaldis Gallery, Baltimore, February 3–28.

Willem de Kooning, Collection d'Art Galerie I, March 13–April 11.

Willem de Kooning: New Paintings 1981–1982, Xavier Fourcade, March 17–May 1.

1983

Willem de Kooning, Stedelijk Museum, Amsterdam, May 11–July 4, and tour to Louisiana Museum, Humlebaek, Denmark; Moderna Museet, Stockholm.

De Kooning: The Complete Sculpture, Xavier Fourcade, May 14–June 30.

Willem de Kooning, Whitney Museum of American Art, December 7–February 12, 1984, and tour to Centre Pompidou, Paris; Akademie der Künste, Berlin.

1936

New Horizons in American Art, Museum of Modern Art, New York, September 14–October 16.

1939

Painting and Sculpture in the World of Tomorrow, New York World's Fair, Summer–Fall.

1942

Group show, McMillen, Inc., New York, January.

1944

Abstract and Surrealist Art in America, Mortimer Brandt Gallery, New York, November 29–December 30.

1948

Annual Exhibition of Contemporary American Painting, Whitney Museum of American Art, New York, November 13–January 2, 1949. Also included in 1950, 1951, 1952, 1953, 1954, 1956, 1959, 1963, 1965, 1967, 1969, 1972, and 1981.

1949

The Intrasubjectives, Kootz Gallery, New York, September 14–October 3.

1950

Black or White: Paintings by European and American Artists, Kootz Gallery, February 28–March 20.

American Painting 1950, Virginia Museum, Richmond, April 22–June 4.

XXV Venice Biennale, June–September. Also included in 1954 and 1956.

Fourth Annual Exhibition of Contemporary American Painting, California Palace of the Legion of Honor, San Francisco, November 25–January 1, 1951.

1951

Abstract Painting and Sculpture in America, Museum of Modern Art, New York, January 23–March 25.

Ninth Street Show, 60 East Ninth Street, May 21–June 10.

60th Annual American Exhibition: Paintings and Sculpture, Art Institute of Chicago, October 25–December 16.

I Bienal de São Paolo, Museu de Arte Moderna de São Paulo, São Paulo, Brazil, October–December. Also included in 1953.

1952

Expressionism in American Painting, Albright Art Gallery, Buffalo, May 10–June 29.

Pittsburgh International Exhibition of Contemporary Painting, Carnegie Institute, Pittsburgh, October 16–December 14. Also included in 1955, 1958, 1961, 1964, and 1970.

1954

Younger American Painters, Solomon R. Guggenheim Museum, New York, May 12–July 25.

1955

The New Decade: Thirty-five American Painters and Sculptors, Whitney Museum of American Art, Spring, and tour.

1957

The Thirties: Painting in New York, Poindexter Gallery, New York, June 3–29.

American Paintings: 1945–1953, Minneapolis Institute of Arts, June 18–September 1.

1958

Nature in Abstraction, Whitney Museum of American Art, January 14–March 16, and tour.

1959

The Museum and Its Friends: Eighteen Living American Artists, Whitney Museum of American Art, March 5–April 12.

Documenta II, Museum Fridericianum, Kassel, West Germany, July 11–October 11. Also included in 1964 and 1977.

New Images of Man, Museum of Modern Art, September 30–November 29.

1961

Art of Assemblage, Museum of Modern Art, October 2–November 12, and tour.

American Abstract Expressionists and Imagists, Solomon R. Guggenheim Museum, October 13–December.

1962

Continuity and Change, Wadsworth Atheneum, Hartford, Connecticut, April 12–May 27.

Art since 1950, Seattle World's Fair, April 21–October 21, and tour (of United States section only).

Nederlands bijdrage: Tot de internationale ontwikkeling sedert 1945, Stedelijk Museum, Amsterdam, June 29–September 17.

Willem de Kooning/Barnett Newman, Allan Stone Gallery, New York, October 23–November 7.

1963

Twenty-eighth Biennial Exhibition of Contemporary American Painting, Corcoran Gallery of Art, Washington, D.C., January 18–March 3. Also included in 1974 and 1979.

Eleven Abstract Expressionist Painters, Sidney Janis Gallery, New York, October 7–November 2.

Black and White, Jewish Museum, New York, December 12–February 5, 1964.

1964

Guggenheim International Award 1964, Solomon R. Guggenheim Museum, January–March, and tour.

Painting and Sculpture of a Decade: 1954–1964, Tate Gallery, London, April 22–June 28.

Within the Easel Convention: Sources of Abstract Expressionism, Fogg Museum, Harvard University, Cambridge, Massachusetts, May 7–June 7.

Van Gogh and Expressionism, Solomon R. Guggenheim Museum, July 1–September 13.

American Drawings, Solomon R. Guggenheim Museum, September 17–October 22, and tour.

1965

De Kooning/Cornell, Allan Stone Gallery, February 13–March 13.

Contemporary Painting and Sculpture 1967, University of Illinois, Urbana, March 5–April 9.

New York School: The First Generation, Paintings of the 1940's and 1950's, Los Angeles County Museum of Art, July 16–August 1.

1968

The Obsessive Image: 1960–1968, Institute of Contemporary Arts, London, April 10–May 29.

The 1930's Painting and Sculpture in America, Whitney Museum of American Art, October 15–December 1.

1969

New York Painting and Sculpture: 1940–1970, Metropolitan Museum of Art, New York, October 16–February 1, 1970.

Painting in New York: 1944–69, Pasadena Art Museum, November 24–January 11, 1970.

1973

American Art: Third Quarter-Century, Seattle Art Museum Pavilion, August 22–October 14.

1974

Painting and Sculpture Today 1974, Indianapolis Museum of Art, May 22–July 14, and tour. Also included in 1976.

1976

Twentieth Century American Drawing: Three Avant-Garde Generations, Solomon R. Guggenheim Museum, January 23–March 28, and tour.

The Golden Door: Artist-Immigrants of America 1876–1976, Hirshhorn Museum and Sculpture Garden, Smithsonian Institution, Washington, D.C., May 20–October 20.

Zweihundert Jahre Amerikanische Malerei 1776–1976, Rheinischen Landesmuseum, Bonn, June 6–August 1.

Acquisition Priorities: Aspects of Postwar Painting in America, Solomon R. Guggenheim Museum, October 15–January 16, 1977.

1977

Perceptions of the Spirit in Twentieth Century American Art, Indianapolis Museum of Art, September 20–November 21, and tour.

1978

Abstract Expressionism: The Formative Years, Herbert F. Johnson Museum of Art, Cornell University, Ithaca, New York, March 30–May 14, and tour.

American Art at Mid-Century: The Subjects of the Artist, National Gallery of Art, Washington, D.C., June 1–January 14, 1979.

1979

Zwei Jahrzehnte amerikanische Malerei 1920–1940, Städtische Kunsthalle, Düsseldorf, June 10–August 12, and tour.

1980

Pop Art: Evoluzione di una generazione, Palazzo Grassi, Venice, March–July.

L'Amérique aux Indépendants, Grand Palais, Paris, March 13–April 13.

1981

A New Spirit in Painting, Royal Academy, London, January 13–March 18.

Amerikanische Malerei 1930–1980, Haus der Kunst, Munich, November 14–January 31, 1982.

Five Distinguished Alumni: The W.P.A. Federal Project, Hirshhorn Museum and Sculpture Garden, January 21–February 22, and tour.

'60–'80, Stedelijk Museum, April 9–July 11.

Focus on the Figure: Twenty Years, Whitney Museum of American Art, April 14–June 13.

The New York School: Four Decades, Solomon R. Guggenheim Museum, July 1–August 29.

112. *Woman Seated in the Water*, 1967
Oil on paper, mounted on canvas,
23 × 18¼ in.
Judy and Ken Robins, Denver

Public Collections

Amsterdam, The Netherlands, Stedelijk
Museum
Baltimore, Maryland, Baltimore Museum of Art
Berkeley, California, University Art Museum,
University of California
Buffalo, New York, Albright-Knox Art
Gallery
Chicago, Illinois, Art Institute of Chicago
Chicago, Illinois, Inland Steel Corporation
Cleveland, Ohio, Cleveland Museum of Art
Greensboro, North Carolina, Weatherspoon
Art Gallery, University of North Carolina
Hartford, Connecticut, Wadsworth Atheneum
Kansas City, Missouri, William Rockhill
Nelson Gallery of Art and Mary Atkins
Museum of Fine Arts
Lincoln, Nebraska, Sheldon Memorial Art
Gallery, University of Nebraska Art
Galleries
London, England, Tate Gallery
Los Angeles, California, Los Angeles County
Museum of Art
New Haven, Connecticut, Yale University Art
Gallery
New York City, New York, American
Broadcasting Company
New York City, New York, Metropolitan
Museum of Art
New York City, New York, Museum of
Modern Art
New York City, New York, Solomon R.
Guggenheim Museum
New York City, New York, Whitney Museum
of American Art
Oberlin, Ohio, Allen Memorial Art Museum,
Oberlin College
Ottawa, Canada, National Gallery of Canada
Paris, France, Musée National d'Art Moderne
Philadelphia, Pennsylvania, Philadelphia
Museum of Art
Pittsburgh, Pennsylvania, Museum of Art,
Carnegie Institute
Poughkeepsie, New York, Vassar College Art
Gallery
Providence, Rhode Island, Museum of Art,
Rhode Island School of Design
Saint Louis, Missouri, Saint Louis Art
Museum
Saint Louis, Missouri, Washington University
Gallery of Art
San Francisco, California, San Francisco

Museum of Modern Art
Tehran, Iran, Tehran Museum of
Contemporary Art
Toledo, Ohio, Toledo Museum of Art
Tucson, Arizona, University of Arizona
Museum of Art
Utica, New York, Munson-Williams-Proctor
Institute

Waltham, Massachusetts, Rose Art Museum,
Brandeis University
Washington, D.C., Hirshhorn Museum and
Sculpture Garden, Smithsonian Institution
Washington, D.C., National Gallery of Art
Washington, D.C., National Museum of
American Art, Smithsonian Institution
Washington, D.C., Phillips Collection

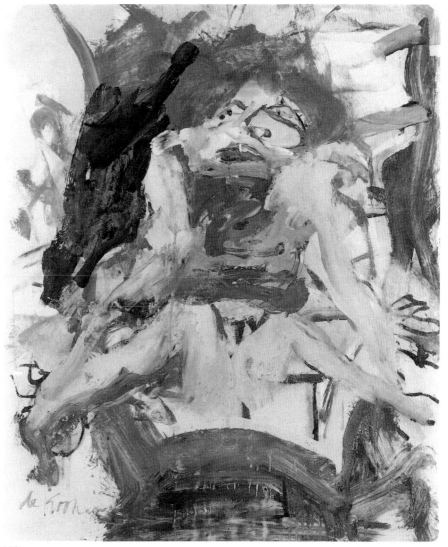

112

Selected Bibliography

Interviews and Statements

Boudrez, Martha. "De Kooning: Painter of Promise." *The Knickerbocker* 12 (May 1950): 8–9. Interview.

De Kooning, Willem. Letter to the Editor. *Artnews* 47 (January 1949): 6. On the subject of Arshile Gorky.

_____. "What Abstract Art Means to Me." *Bulletin of the Museum of Modern Art* 18 (Spring 1951): 4–8. Read at a symposium at the Museum of Modern Art, New York City, February 5, 1951, in connection with the exhibition *Abstract Painting and Sculpture in America*. Excerpt reprinted in Barbara Rose, ed. *Readings in American Art since 1900*. New York: Frederick A. Praeger, 1968, pp. 153–54.

_____. "The Renaissance and Order." *Transformation* 1, no. 2 (1951): 85–87. Written in 1950 for a series of lectures at Studio 35 on Eighth Street.

_____. "Om Abstrakt Kunst." *Aarstiderne Tidsskrift for Kunst* (Copenhagen) 9, no. 1 (November 1951): 21–25.

_____. Statement in *The Museum and Its Friends*, exhibition catalog. New York: Whitney Museum of American Art, 1959. Excerpt from "What Abstract Art Means to Me."

_____ et al. "In Support of the French Intellectuals." *Partisan Review* 28 (January–February 1961): 144–45. Letter signed by several artists.

_____ et al. "A Letter to the New York Times." *New York Times*, February 26, 1961, sec. 2, p. 19. Criticism of John Canaday signed by various critics, writers, and artists.

_____. Statement in *De Kooning Drawings*. New York: Walker and Company, 1967.

_____. Statement in *Art Now: New York* 1, no. 3 (March 1969): n.p.

Goodnough, Robert, ed. "Artists' Sessions at Studio 35 (1950)." In Robert Motherwell, Ad Reinhardt, and Bernard Karpel, eds. *Modern Artists in America*. New York: Wittenborn, Schultz, 1951, pp. 12–22, 69. Statements.

Hess, Thomas B. "Is Today's Artist with or against the Past?" *Artnews* 57 (Summer 1958): 27, 56. Interview.

Hunter, Sam. "Je dessine les yeux fermés." Interview in *Galerie Jardin des Arts* (Paris) 152 (November 1975): 68–70.

Liss, Joseph. "Willem de Kooning Remembers Mark Rothko: 'His House Had Many Mansions.'" *Artnews* 78 (January 1979): 41–44. Interview.

Mooradian, Karlen. "Remembrances of Gorky." *Ararat* 12 (Fall 1971): 48–52. Interview.

Rodman, Selden. *Conversations with Artists*. New York: Devin-Adair, 1957, and New York: Capricorn Books, 1961, pp. 100–105. Statements.

Rosenberg, Harold. "Interview with Willem de Kooning." *Artnews* 71 (September 1972): 54–59. Reprinted in *De Kooning*. New York: Harry N. Abrams, 1974, pp. 38–51.

Sandler, Irving. "Willem de Kooning: Gesprek de Kooning's atelier, 16, juni 1959." *Museumjournaal*, s. 13, no. 6, 1968, pp. 285–90. English summary, p. 336. Interview.

Schierbeek, Bert. Interview in *Willem de Kooning*, exhibition catalog. Amsterdam: Stedelijk Museum, 1968, n.p.

Sketchbook No. 1: Three Americans. New York: Time, 1960. Includes statements.

Staats, Margaret, and Matthiessen, Lucas. "The Genetics of Art." *Quest* 77 1 (March–April 1977): 70–71. Statement.

Sylvester, David. "Painting as Self-Discovery." B.B.C. broadcast, December 30, 1960. Transcript edited and published as "Content Is a Glimpse. . . ." *Location* (New York) 1 (Spring 1963): 45–53, and as "De Kooning's Women." *Sunday Times Magazine* (London), December 8, 1968, pp. 44–57, and in *Ramparts Magazine* 7 (April 1969): 20–24. Interview.

Valliere, James T. "De Kooning on Pollock." *Partisan Review* 34 (Fall 1967): 603–5. Interview.

Monographs and Solo-Exhibition Catalogs

Agee, William G. "Willem de Kooning." Unpublished three-volume collection of photographs, commentaries, and annotations compiled in 1962. Library, Museum of Modern Art, New York.

Arkus, Leon. Preface to *Willem de Kooning*, exhibition catalog. Pittsburgh: Museum of Art, Carnegie Institute, 1979. Includes reprints of Harold Rosenberg, "Interview with Willem de Kooning"; Willem de Kooning: "What Abstract Art Means to Me," "A Desperate View," and "The Renaissance and Order"; and David Sylvester, "Content Is a Glimpse. . . ."

Ashton, Dore, and de Kooning, Willem. *Willem de Kooning*, exhibition catalog. Northampton, Mass.: Museum of Art, Smith College, 1965. Includes reprint of Willem de Kooning, "The Renaissance and Order."

Beaud, Marie-Claude, preface, and Mason, Rainer Michael, text. *Willem de Kooning: Sculptures, lithographs, peintures*, exhibition catalog. Grenoble: Musée de Peinture et de Sculpture, 1977. Includes excerpts from interviews by Harold Rosenberg and Sam Hunter.

Carandente, Giovanni. *De Kooning: Disegni*, exhibition catalog. Spoleto: Palazzo Ancaini, 1969.

Cowart, Jack, and Shaman, Sanford Sivitz. *De*

Kooning: 1969–78, exhibition catalog. Cedar Falls: Gallery of Art, University of Northern Iowa, 1978.

Cowart, Jack. "De Kooning Today." *Art International* 23 (Summer 1979): 8–17. Expanded version of catalog essay.

De Kooning, exhibition catalog. New York: Sidney Janis Gallery, 1972.

De Kooning: Drawings. New York: Walker, 1967.

De Kooning: New Paintings 1976, exhibition catalog. New York: Xavier Fourcade, 1976.

De Kooning: New Works, Paintings and Sculpture, exhibition catalog. New York: Fourcade, Droll, 1975.

De Kooning's Women, exhibition catalog. New York: Allan Stone Gallery, 1966.

Drudi, Gabriella. *Willem de Kooning*. Milan: Fratelli Fabbri Editori, 1972.

Garson, Inez. *Willem de Kooning at the Hirshhorn Museum and Sculpture Garden*. Washington, D.C.: Smithsonian Institution, 1974.

Goodman, Merle. *"Woman" Drawings by Willem de Kooning*, exhibition catalog. Buffalo: James Goodman Gallery, 1964.

Greenberg, Clement. Foreword to *De Kooning 1935–1953*, exhibition catalog. Boston: Museum School, Museum of Fine Arts, 1953.

Hess, Thomas B. *Willem de Kooning*. New York: Braziller, 1959.

——— . *Recent Paintings by Willem de Kooning*, exhibition catalog. New York: Sidney Janis Gallery, 1962.

——— . *De Kooning: Recent Paintings*, exhibition catalog. New York: Walker and Company for M. Knoedler and Company, 1967.

——— . *De Kooning: Peintures récentes*, exhibition catalog. Paris: M. Knoedler and Company, 1968. Includes French translations of Willem de Kooning, "The Renaissance and Order," and "What Abstract Art Means to Me."

——— . *Willem de Kooning*, exhibition catalog. New York: Museum of Modern Art for the Arts Council of Great Britain, 1968.

——— . *Willem de Kooning*, exhibition catalog. New York: Museum of Modern Art, 1968. Distributed by New York Graphic Society, Greenwich. Includes Willem de Kooning, "The Renaissance and Order," "What Abstract Art Means to Me," and text of talk on desperation delivered February 18, 1949, at "The Subjects of the Artist: A New School," New York City; and David Sylvester, "Content Is a Glimpse. . . ."

——— . *De Kooning January 1968–March 1969*, exhibition catalog. New York: M. Knoedler and Company, 1969.

——— . *Willem de Kooning*, exhibition catalog. Amsterdam: Stedelijk Museum, 1969. Includes interview.

——— . *Willem de Kooning: Drawings*. Greenwich: New York Graphic Society, 1972. First published in Lausanne: Editions des Massons. Includes Kenneth Koch, "To and about Willem de Kooning."

Hunter, Sam. *De Kooning*. Paris: Galerie des Arts, 1975. Revised and reprinted in *L'Oeil* 244 (November 1975): 74–75.

Inge, William. *Willem de Kooning*, exhibition catalog. Beverly Hills: Paul Kantor Gallery, 1965.

Janis, Harriet, and Blesh, Rudi. *De Kooning*. New York: Grove Press, 1960.

Keller, Andrea Miller. *De Kooning: Matrix 15*, exhibition catalog. Hartford, Conn.: Wadsworth Atheneum, 1975.

Larson, Philip, and Schjeldahl, Peter. *De Kooning: Drawings/Sculptures*, exhibition catalog. New York: E. P. Dutton and Company for Walker Art Center, 1974. Revised and reprinted as Peter Schjeldahl, "De Kooning's Sculptures: Amplified Touch," *Art in America* 62 (March–April 1974): 59–63. Reply with rejoinder, Florence Hunter, "Friendly Influence?" *Art in America* 62 (July–August 1974): 112.

Lerner, Abram. *De Kooning*, exhibition catalog. Warsaw: Muzeum Narodowe, 1978. Also translated into Finnish.

Odets, Clifford. *Willem de Kooning*, exhibition catalog. Beverly Hills, Calif.: Paul Kantor Gallery, 1961.

Rosenberg, Harold. *De Kooning*. New York: Harry N. Abrams, 1974. Includes reprint of Rosenberg's "Interview with Willem de Kooning"; Willem de Kooning, "What Abstract Art Means to Me"; and excerpts from David Sylvester, "Content Is a Glimpse. . . ."

——— . Introduction to *Willem de Kooning*, exhibition catalog. Chicago: Richard Gray, 1974.

Salzmann, Siegfried. *De Kooning: Plastik-Grafik*, exhibition catalog. Duisburg: Wilhelm-Lehmbruck Museum, 1977.

Sawyer, Kenneth. *Recent Oils by Willem De Kooning*, exhibition catalog. New York: Martha Jackson Gallery, 1955.

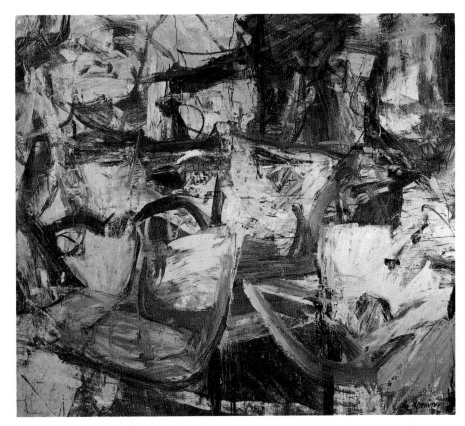

113. *Saturday Night*, 1956
Oil on canvas, 69 x 79½ in.
Washington University Gallery of Art, Saint Louis

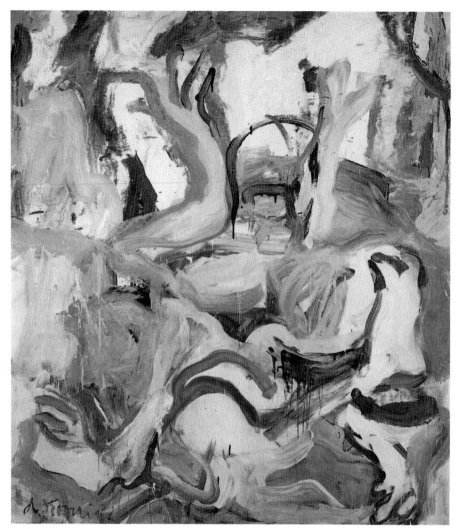

114. *Amityville*, 1971
Oil on canvas, 80 × 70 in.
Courtesy Xavier Fourcade, Inc., New York

Periodicals, Books, and Group-Exhibition Catalogs

Alloway, Lawrence. "Iconography Wreckers and Maenad Hunters." *Art International* 5 (April 1961): 32–34, 47.

_____ . "De Kooning: Criticism and Art History." *Artforum* 13 (January 1975): 46–50.

Arb, Renée. "Spotlight on de Kooning." *Artnews* 47 (April 1948): 33. Review of exhibition at Egan Gallery.

Ashbery, John. "Willem de Kooning: A Suite of New Lithographs Translates His Famous Brushstroke into Black and White." *Artnews Annual* 37 (1971): 117–28.

Ashton, Dore. "Art." *Arts and Architecture* (June 1956): 10. Review of exhibition at Sidney Janis Gallery.

_____ . "Art." *Arts and Architecture* 79 (May 1962): 6. Review of exhibition at Sidney Janis Gallery.

_____ . "Willem de Kooning: Homo Faber." *Arts Magazine* 50 (January 1976): 58–61.

Bannard, Walter Darby. "Willem de Kooning's Retrospective at the Museum of Modern Art." *Artforum* 7 (April 1969): 42–49. Reply with rejoinder, Fairfield Porter. "Letters." 7 (Summer 1969): 4.

Battcock, Gregory. "Willem de Kooning." *Arts Magazine* 42 (November 1967): 34–37.

Berman, Avis. "Willem de Kooning, 'I Am Only Half Way Through.'" *Artnews* 81 (February 1982): 68–73.

Carlson, J. T. "*Architectural Digest* Visits Willem de Kooning." *Architectural Digest* 39 (January 1982): 58–67.

Carrier, David. "Willem de Kooning at the Pittsburgh International." *Artforum* 18 (January 1980): 44–46.

Dali, Salvador. "De Kooning's 300,000,000th Birthday." *Artnews* 68 (April 1969): 56–57.

Davis, Douglas. "De Kooning on the Upswing." *Newsweek* 80 (September 4, 1972): 70–73.

Denby, Edwin. "My Friend de Kooning." *Artnews Annual* 29 (November 1963): 82–99, 156.

Dickerson, George. "The Strange Eye and Art of de Kooning." *Saturday Evening Post* 237 (November 21, 1964): 68–71.

Finkelstein, Louis. "Gotham News." *Artnews Annual* 34 (1968): 114–22.

Schjeldahl, Peter. *De Kooning: Paintings, Drawings, Sculpture 1967–1975*, exhibition catalog. West Palm Beach, Fla.: Norton Gallery of Art, 1975.

_____ . *Willem De Kooning: Beelden en lithós*, exhibition catalog. Amsterdam: Stedelijk Museum, 1976.

Sylvester, David, foreword, and Forge, Andrew, text. *The Sculptures of de Kooning with Related Paintings, Drawings, and Lithographs*, exhibition catalog. Edinburgh: Fruit Market Gallery, and London: Serpentine Gallery, 1977, and Arts Council of Great Britain. Includes reprint of Harold Rosenberg, "Interview with Willem de Kooning."

Waldman, Diane. *Willem de Kooning in East Hampton*, exhibition catalog. New York: Solomon R. Guggenheim Museum, 1978.

_____ . *Willem de Kooning: Bilder, Lithografien, Skulpturen*, exhibition catalog. East Berlin: Amerika Haus, 1978.

_____ . *Willem de Kooning: Nyere Verker*, exhibition catalog. Oslo: Nasjonalgalleriet, 1978.

_____ . *Willem de Kooning: Obras Recientes*, exhibition catalog. Madrid: Fundacion Juan March, 1978.

Welling, Dolf. *Willem de Kooning*, exhibition catalog. Amsterdam: Collection d'Art Galerie I, 1976.

Willem de Kooning Retrospective Drawings 1936–1963, exhibition catalog. New York: Allan Stone Gallery, 1964.

Wolfe, Judith. *Willem de Kooning: Works from 1951–1981*, exhibition catalog. East Hampton, N.Y.: Guild Hall Museum, 1981.

Forge, Andrew. "De Kooning in Retrospect." *Artnews* 68 (March 1969): 44–47, 61–62, 64. Review of exhibition at the Museum of Modern Art.

Forgey, Benjamin. "De Kooning's Triumphant Return: A Master Sums Up His Art." *Washington Star*, March 12, 1978, sec. H, p. 24.

Fuchs, R. H. "Willem de Kooning: The Quest for the Grand Style." *Delta* (Amsterdam) 13 (Summer 1970): 29–44.

Goldwater, Robert. "Masters of the New." *Partisan Review* (Summer 1962): 416–18.

Greenberg, Clement. "Art." *The Nation* 166 (April 24, 1948): 448. Review of exhibition at Egan Gallery.

Hartford, Huntington. "The Public Be Damned?" *New York Times*, May 16, 1955, p. 48. Full-page advertisement attacking art criticism in America and de Kooning.

Henry, Gerrit. "De Kooning: Reconfirming the Apocalypse." *Artnews* 74 (November 1975): 60–61.

Hess, Thomas B. *Abstract Painting: Background and American Phase*. New York: Viking, 1951, pp. 100–108.

_____. "De Kooning Paints a Picture." *Artnews* 52 (March 1953): 30–33, 64–67.

_____. "Six Star Shows for Spring: Willem de Kooning." *Artnews* 61 (March 1962): 40, 60–61. Review of exhibition at Sidney Janis Gallery.

_____. "Willem de Kooning and Barnett Newman." *Artnews* 61 (December 1962): 12.

_____. "De Kooning's New Women." *Artnews* 64 (March 1965): 36–38, 63–65. Review of exhibitions at Allan Stone Gallery in 1964 and Paul Kantor Gallery.

_____. "Pinup and Icon." *Artnews Annual* 38 (1972): 222–37.

_____. "Art: Water Babes." *New York Magazine* 8 (October 27, 1975): 73–75.

_____. "Art." *New York Magazine* 9 (November 1, 1976): 62.

_____. "The Flying Hollander of Easthampton, L.I." *New York Magazine* 11 (February 20, 1978): 68, 72–73.

_____. "In de Kooning's Studio." *Vogue* 168 (April 1978): 234–37, 335.

Hughes, Robert. "Slap and Twist." *Time* 100 (October 23, 1972): 71. Review of exhibition at Sidney Janis Gallery.

_____. "Landscapes and the Bodies of Women." *Horizon* 21 (February 1978): 14–21. Review of exhibition at the Guggenheim Museum.

Hutchinson, Peter. "De Kooning's Reasoned Abstracts." *Art and Artists* 3 (May 1968): 24–27. Review of exhibition at M. Knoedler, Paris.

Kozloff, Max. "The Impact of de Kooning." *Arts Yearbook* 7 (1964): 76–88.

Kramer, Hilton. "De Kooning's Pompier Expressionism." *New York Times*, November 19, 1967, sec. D, p. 31. Review of exhibition at M. Knoedler, New York. Reprinted in *The Age of the Avant-Garde*. New York: Farrar, Straus and Giroux, 1973, pp. 347–50.

_____. "A Career Divided." *New York Times*, March 9, 1969, sec. D, p. 25. Review of exhibition at the Museum of Modern Art. Reprinted in *The Age of the Avant-Garde*, pp. 350–53.

_____. "Art: The Sculptures of Willem de Kooning Shown." *New York Times*, October 13, 1972, p. 32. Review of exhibition at Sidney Janis Gallery.

_____. "Painting at the Limits of Disorder." *New York Times*, October 26, 1975, sec. 2, p. 31.

_____. "Art—de Kooning of East Hampton." *New York Times*, February 10, 1978. Review of Guggenheim Museum exhibition.

Krauss, Rosalind. "The New de Koonings." *Artforum* 6 (January 1968): 44–47. Review of exhibition at M. Knoedler, New York.

Kuh, Katharine. "The Story of a Picture." *Saturday Review* 52 (March 29, 1969): 38–39. Discussion of *Excavation*.

Larson, Kay. "Art—De Kooning Adrift." *New York Magazine* 15 (April 12, 1982): 58–59.

Lippard, Lucy. "Three Generations of Women: De Kooning's First Retrospective." *Art International* 9 (November 20, 1965): 29–31. Review of exhibition at Smith College.

Namuth, Hans. "Willem de Kooning, East Hampton, Spring, 1964." *Location* 1 (Summer 1964): 27–34. Photographic essay.

O'Doherty, Brian. "De Kooning: Grand Style." *Newsweek* 65 (January 4, 1965): 56–57. Reprinted in *Object and Idea*. New York: Simon and Schuster, 1967, pp. 87–91.

_____. "Willem de Kooning: Fragmentary Notes towards a Figure." *Art International* 12 (December 20, 1968): 21–29. Revised and reprinted in *American Master: The Voice and the Myth*. New York: Random House, 1974, pp.

112–49; E. P. Dutton, 1982, pp. 138–86.

Perreault, John. "The New de Koonings." *Artnews* 68 (March 1969): 68ff.

Ratcliff, Carter. "Willem de Kooning." *Art International* 19 (December 20, 1975): 14–19, 73. Review of exhibition at Fourcade, Droll.

Rose, Barbara. "De Kooning and the Old Masters." *Vogue* 153 (May 1, 1969): 134. Review of exhibition at the Museum of Modern Art.

Rosenberg, Harold. "The Art Galleries: 'Painting Is a Way of Living.' " *New Yorker* 38 (February 16, 1963): 126–37. Reprinted in *The Anxious Object*. New York: Horizon Press, 1964, pp. 108–20.

_____. "De Kooning." *Vogue* 144 (September 15, 1964): 146–48, 186–87. Reprinted as "De Kooning: On the Borders of the Act," in *The Anxious Object*, pp. 122–29.

Rosemarch, Stella. "De Kooning in Clay." *Craft Horizons* 32 (December 1972): 34–35.

Rosenblum, Robert. "Willem de Kooning." *Arts Magazine* 30 (May 1956): 50. Review of exhibition at Sidney Janis Gallery.

Russell, John. "De Kooning: 'I See the Canvas and I Begin.' " *New York Times*, February 5, 1978, sec. B. pp. 1, 25. Review of exhibition at the Guggenheim Museum.

Sandler, Irving. "Willem de Kooning." In *The Triumph of American Painting: A History of Abstract Expressionism*. New York: Praeger, 1970, pp. 122–37.

Sawyer, Kenneth B. "Three Phases of Willem de Kooning." *Art News and Review* (London) 10 (November 22, 1958): 4, 16.

Schjeldahl, Peter. "Willem de Kooning: Even His 'Wrong' Is Beautiful." *New York Times*, January 9, 1972, sec. B, p. 23.

_____. "De Kooning's Sculptures: Amplified Touch." *Art in America* 62 (March–April 1974): 59–63.

_____. "De Kooning: Subtle Renewals." *Artnews* 71 (November 1972): 21–22.

_____. "Delights by De Kooning." *Village Voice*, April 13, 1982, p. 79.

Shirey, David L. "Don Quixote in Springs." *Newsweek*, November 20, 1967, pp. 80–81.

Steinberg, Leo. "Month in Review: De Kooning Shows Recent Painting in 'Woman' Series at Janis Gallery." *Arts Magazine* 30 (November 1955): 46. Review of exhibition at Martha Jackson Gallery. Reprinted in *Other Criteria*.

New York: Oxford University Press, 1972, pp. 259–62.

Stevens, Mark. "De Kooning in Bloom." *Newsweek* 91 (February 20, 1978): 92–93. Review of exhibition at the Guggenheim Museum.

Stuckey, Charles F. "Bill de Kooning and Joe Christmas." *Art in America* 68 (March 1980): 66–79.

Yard, Sally E. "De Kooning's Women." *Arts Magazine* 53 (November 1978): 96–101.

_____ . "Willem de Kooning: The First Twenty-six Years in New York, 1927–1952." Ph.D. Dissertation, Princeton University, 1980.

_____ . "Willem de Kooning's Men." *Arts Magazine* 56 (December 1981): 134–43.

"Willem de Kooning." *Magazine of Art* 41 (February 1948): 54. Announcement of first solo exhibition at Egan Gallery.

Films

Willem de Kooning. Produced by Hans Namuth and Paul Falkenberg. New York: National Educational Television, 1966. 29 minutes, black and white, 16 mm.

De Kooning on de Kooning. Produced by Courtney Sale; directed by Charlotte Zwerin. New York: Cort Production financed by the Masco Corp. and Atlantic Richfield Co., 1982. 58 minutes, color, 16 mm.

115. *Untitled No. 6,* 1969
Bronze, height: 9 in.
Courtesy Xavier Fourcade, Inc., New York

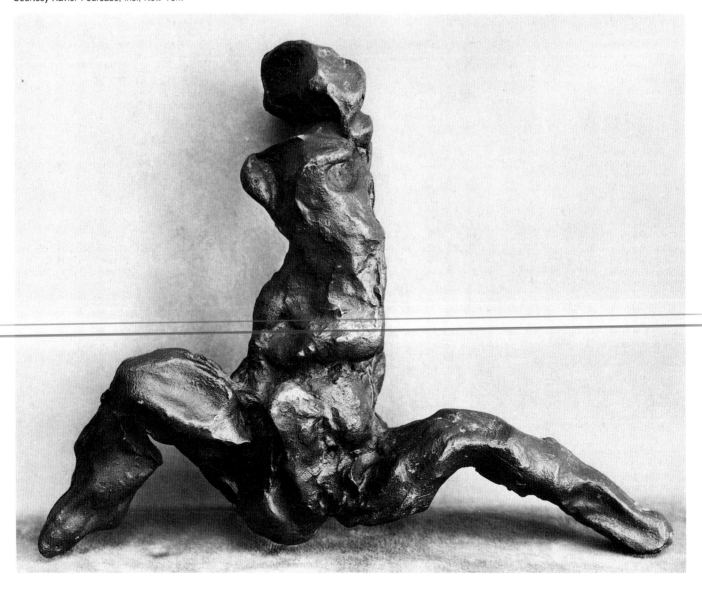

Index

Abstract Expressionists, 8, 9, 104, 109
 de Kooning as, 25, 37, 52, 56, 59, 64, 109–10, 119
 European response to, 38
 sculpture, 95
action painting, 59
American artists
 battle for abstract art, 8
 Cubism and, 64
 post-World War II, 20–21
Amityville, 132
Antigracioso (Boccioni), 101
Armory Show of 1913, 9
art
 American vs. European, 67
 woman and landscape in, 55
art history, 70, 110
Ashville, 38
Attic, 31, 32–33, 36
 detail, 31
Attic Study, 30

Bacon, Francis, 84
Barnes Hole Bridge, 85
Bartholdi, Frédéric Auguste, 52
Bernini, Giovanni Lorenzo, 101
Bethlehem (Kline), 67
Black Friday, 28
Black and White Rome (Two-Sided Single L), 66, 67
Blesh, Rudi, 49
Boccioni, Umberto, 101
Bolton Landing, 62
Bosch, Hieronymous
 Garden of Earthly Delights, The, 81, 85
Bourdelle, Emile, 95
Brainard, Joe, 52
Brancusi, 120
Brancusi, Constantin, 120
Braque, Georges, 20
Breughel, Pieter, 88
Brooks, James, 25
brushwork, *see* de Kooning: technique
Burckhardt, Rudolph, 7–8, 14, 26

Calder, Alexander, 85
Cézanne, Paul, 14, 61, 93
Christian, David, 98
Clam Digger, 94, 95–97, 98
color, 55–56, 64, 85
Constructivism, 116
critics and criticism, 41, 49, 51, 52
Cross-Legged Figure, 100
Crucifixion (Picasso), 88
Cube Totem (Smith), 71
Cubi XXVI (Smith), 71
Cubism, 84, 116
 de Kooning and, 60, 61–64
 Synthetic, 13

Davis, Stuart, 20
Day (Michelangelo), 97, 98
Death's Head (Picasso), 100
de Kooning (Hess), 115, 116
de Kooning, Elaine Fried, 14–16, 22, 41, *114*, 119
 de Kooning's portrait of, *16*
de Kooning, Willem
 biography, 7–8
 black and white abstractions, 25–39
 commercial success, 8, 74
 and Cubism, 60–64
 Door series, 77
 early exhibitions, 20, 25
 early work, 11–23
 humor of, 42

imagery, 11, 22, 49, 51
influence of, 9, 25, 37, 52, 56, 59, 64, 109–10, 119
influences on, 8, 16
interviews with, 56, 77–78, 117
and Kline, 66–68
landscapes, *54–75*, 88, 93, 102–5, 119
late paintings, 102–11
media, 119
Men series, 14, 21
Michelangelo and, 97–98
mother of, 52
New York as source for, 26–27, 37, 42, 56
non-Women paintings of late 1960s, 87–88
paints and paint pots, 27, *118*
photographs of, *16, 37, 40, 114*
Pollock and, 8
Rome drawings, 66, 121
sculpture, 77, 85, 94–101, 104, 105
small oils, 68–71
studios, 74, 119
and Surrealism, 20–22
technique, 30, 119–22
 abstract landscape, 71
 brushwork, 11, 20, 56, 64, 119
 drawing, 91–93
 painting with letters, 30
 sculpture, 98
 variety of, 9
themes, 93
Woman on a Sign series, 78, 80
Women series, *see* Women series
Demoiselles d'Avignon, Les (Picasso), 84, 93, 122
Denby, Edwin, 14, 16, 26
Dine, Jim, 9
Dish with Jugs, 11
Door to the River, 37, 64, 66, *75*, 110
Duchamp, Marcel, 9

Easter Monday, 56, *58*, 59, 60–61, 64, 74
 detail, *61*
East Hampton, 8, 9, 74, 104
East Hampton I, 104
Egan, Charles, Gallery, 25
Elegy, 13, *15*
El Greco, 8
"Epitaph for an Avant-Garde" (Ferren), 64
European art, 20
Excavation, 31, *34–35*, 36–38, 41, 56, 64, 71, 109

Farmhouse, The, 10
Foutrier, Jean, 38
February, *59*, 64
Federal Arts Project, 7
Ferren, John, 8, 22, 64

Flowers, Mary's Table, 85, 87
Forgeries (Williams), 52, *53*
Fourcade, Droll Gallery, 109

Gansevoort Street, 39
Garden of Earthly Delights, The (Bosch), *81*, 85
Gardens in Sochi (Gorky), 104
Geist, Sidney, 52
Giacometti, Alberto, 84, 119
Giorgione, 55, 93
Glazier, 14, *18*
Gorky, Arshile, 11, 20, 25, 36, 104
Gotham News, 56, 60, 104
Graham, John, 20
Greenberg, Clement, 109
Guston, Philip, 41, 85, 105
Guernica (Picasso), 36
 study for, *31*
Guardians of the Secret (Pollock), 88

Head No. 3, 101
Head No. 4, 100, *101*
Head of a Warrior (Picasso), *31*, 36
Hess, Thomas B., 7, 11–13, 14, 27, 51, 52, 74, 109
 de Kooning, 115, 116

imagery, 11, 22, 49, 51
Impressionism, 73–74, 105
Ingres, Jean Auguste Dominique, 16, 55
Irises by the Pond (Monet), 105, *107*
I Still Get a Thrill When I See Bill (Ramos), 52

Janis, Harriet, 49
Janis, Sidney, 59
Janis Gallery, 8, 41, 66, 85

Kline, Franz, 21, 25, 36, 38, 52, 55
 de Kooning and, 66–68
 Mahoning, 67
Kokoshka, Oskar, 70
Kramer, Hilton, 109
Krasner, Lee, 20

La Guardia in a Paper Hat, 84
landscapes, *54–75*, 88, 93
 abstract, 64–68, 71–75, 119
 late, 102–5
 urban, 54–61, 119
Large Torso, 100, *101*
Leda (Brancusi), 120
lettering, 30
Lewitin, Landès, 61
Liberty (Bartholdi), 52
light, 64, 119

135

Light in August, 24, 25, 27, 30, 104
Lisbeth's Painting, 68
lithographs, 96
Liver Is the Cock's Comb, The (Gorky), 36

Mae West, 48, 121
Mahoning (Kline), 67
Mailbox, 29, 30–31, 85
Man (c. 1939), 14–16, 17, 20
Man (1967), 80, 84–85
Man (1974), 96
Man on the Dunes, 95
Manet, Edouard, 9, 93, 109
Marilyn Monroe, 47
Matisse, Henri, 20, 38, 85, 95, 116
McCartney, Linda, 118
McMillen, Inc., 20
Men series, 14–16
Merritt Parkway, 64
Michelangelo, 8
 Day, 97, 98
 de Kooning and, 97–98
Monet, Claude, 74, 105
 Irises by the Pond, 105, 107
Monroe, Marilyn, 48–49
Montauk I, 85, 86, 88
Montauk Highway, 63
Monumental Woman, 53
Moore, Henry, 55, 95
Museum of Modern Art, 87, 115

Nakian, Reuben, 97
Namuth, Hans, 109, 114
Nancy (Brainard), 52
Newman, Barnett, 95, 110
New York
 de Kooning shows, 74, 85
 de Kooning's life in, 8
 galleries, 20
 post-World War II battle for abstract art in, 8
 as source for de Kooning, 26–27, 37, 42, 56
New York (Kline), 67
New Yorker, 41
New York School, 20–22, 25, 67
Night (Michelangelo), 98
Nighttime, Enigma, and Nostalgia (Gorky), 13
Nose (Giacometti), 84
Nude Descending a Staircase (Duchamp), 9

oils, 68–70
Olympia (Manet), 9
Orestes, 27, 30

Palisade, 64
Parc Rosenberg, 64
Pasiphaë (Pollock), 88
Pasolini, Pier Paolo, 81
pastels, 70–71
Pastorale, 64, 73, 74
Picasso, Pablo, 9, 20, 36, 74, 84, 88, 93, 95, 97, 100, 122
 Head of a Warrior (study for *Guernica*), 31, 36
Pink Angels, 22, 23, 56, 73
Pissarro, Camille, 74
Police Gazette, 56
Pollock, Jackson, 20, 25, 36, 52, 59, 64, 74, 88, 109, 110, 119
 de Kooning and, 8
Provincetown II (Kline), 67

Queen of Hearts, 116

Ramos, Mel, 52
Rauschenberg, Robert, 38
Reclining Nude, 12
Red Man with Moustache, 85, 87, 95, 97
Reinhardt, Ad, 25
Rodin, Auguste, 95, 97
Rosenberg, Harold, 36, 56, 77–78, 109, 117
Rosy-Fingered Dawn at Louse Point, 71, 72
Rothko, Mark, 20, 64, 85, 110, 119
Rubens, Peter Paul, 88, 116
Ruth's Zowie, 62, 64, 66

Sander, Ludwig, 55
Saturday Night, 56, *131*
Saul, Peter, 52
Schapiro, Meyer, 8–9, 37, 41
Scudera (Kline), 67–68
sculpture, 77, 85, 94–101, 104, 105
Seated Clowness, The (Lautrec), 88
Seated Figure (Classic Male), 19
Seated Figure on a Bench, 98, 99, 100
Secretary, 85
sexuality, 49, 77
Small Painting I, 70
Small Painting III, 71
Smith, David, 71
Source, La (Ingres), 55
Soutine, Chaim, 16
Sphinx, 121, *122*
Stedelijk Museum, 88
Suburb in Havana, 64, 65–66, 110
Summer Couch, 21–22
Surrealism, 84, 85
 de Kooning and, 20–22
Sylvester, David, 116
Synthetic Cubism, 13

Thirteen Little Sculptures, 95, 98
Time, 41
Time of the Fire, The, 56–57, 64
Toulouse-Lautrec, Henri de, 88
Town Square, 28, 30–31, 36
Tree (Grows) in Naples, A, 67–68, 69
Two Figures, 93
Two Figures in a Landscape, 83, 87, 88
Tworkov, Jack, 25
Two Trees on Mary Street . . . Amen!, 104

Untitled, after Breughel (Spoleto), 92
Untitled (c. 1931), 14
Untitled (c. 1934), 12
Untitled (1947), 26
Untitled (c. 1956–57), 70
Untitled (1959), 120, 121
Untitled (1966–67), 90
Untitled (1968), 90
Untitled (Crucifixion), 89
Untitled (Figures in Landscape), 91
Untitled I (1982), 111
Untitled No. 2 (1969), 98
Untitled III (1981), 2
Untitled III (1982), 111
Untitled No. 4 (1969), 97
Untitled IV (1981), 104, *108*
Untitled V (1976), *103*
Untitled V (1980), 104, *106*
Untitled No. 6, *134*
Untitled XI (1975), *105*
Untitled XI (1981), 102, *110*
Untitled No. 13 (1969), 100
Untitled XIII (1975), *105*
Untitled XIV (1977), 102, *103*

van Gogh, Vincent, 66
Venice Biennale, 38
Venus (Giorgione), 55

Venus of Laussel (paleolithic), 49, 52
Visit, The, 82, 85, 87–88

Walking Figure, 96
Ward, Nancy, 55
Water of the Flowery Mill (Gorky), 104
Water . . . Soft Banks, and a Window, 104
West, Mae, 48
Whose Name Was Writ in Water, 102, 104
Williams, Larry, 52
 Forgeries, 52
Woman, Sag Harbor, 76, 77–78
Woman (1942), 20
Woman (c. 1944), 42, 49
Woman (c. 1952), 46
Woman (1953), 51
Woman I, 9, 36, 38, 42, *43*, 49, 52, 77–78, 119, 121–22
 creation of, 41
 early version, 40
Woman II, 44
Woman III, 45, 49
Woman IV, 49, 50, 51
Woman V, 6, 8, 55, 56
Woman VI, 51, 56
Woman Acabonic, 117
Woman and Bicycle (de Kooning), 42, 47, 48
Woman with Bicycle (Saul), 52
Woman as Landscape, 54, 55–56, 88
Woman in a Red Blouse (Matisse), 116
Woman on a Sign I, 79
Woman on a Sign series, 88
Woman Seated in the Water, 129
Women series, 59, 74, 101, 102, 109, 121
 color in, 55–56
 critics on, 41, 49, 51, 52
 de Kooning on, 115–16
 imagery, 56
 post-1964, 77–81
 sexuality of, 49
Women Singing, 78
World's Fair of 1935, 7
World War II imagery, 22

Photography Credits

The photographers and the sources of photographs other than those indicated in the captions are as follows: Rudolph Burckhardt, New York: plates 19, 21, 23; Geoffrey Clements, New York: plates 34, 35, 46, 47, 65; Defense Audiovisual Agency, Washington, D.C.: plate 15; A. D. Dolinski, San Gabriel, California: plates 7, 54; Courtesy Xavier Fourcade, Inc., New York: plates 3, 49, 55, 81, 84, 94, 95; Bruce C. Jones, Rocky Point, New York: plates 17, 82, 90, 91, 96, 99; M. Knoedler & Co., New York—Paulus Leeser: plates 2, 13, 60, 61, 67, 68, 73, 77, 78, 80, 85, 115; Wyatt McSpadden, Amarillo, Texas: plate 12; Cliché Musée d'Aquitaine, Bordeaux, France—tout droits réservés: plate 40; O. E. Nelson, New York: plate 6; Douglas M. Parker, Los Angeles, California: plate 16; Eric Pollitzer, New York: plates 9, 62; Glenn Steigelman, New York: plates 10, 11, 18, 32, 52, 64; Courtesy Allan Stone Gallery, New York: plate 58; John Tennant, Mount Airy, Maryland: plate 14; John Webb/Tate Gallery Publications Department, London: plate 71; Bob Wharton, Fort Worth, Texas: plate 22; Courtesy Larry E. Williams, New York: plate 44.

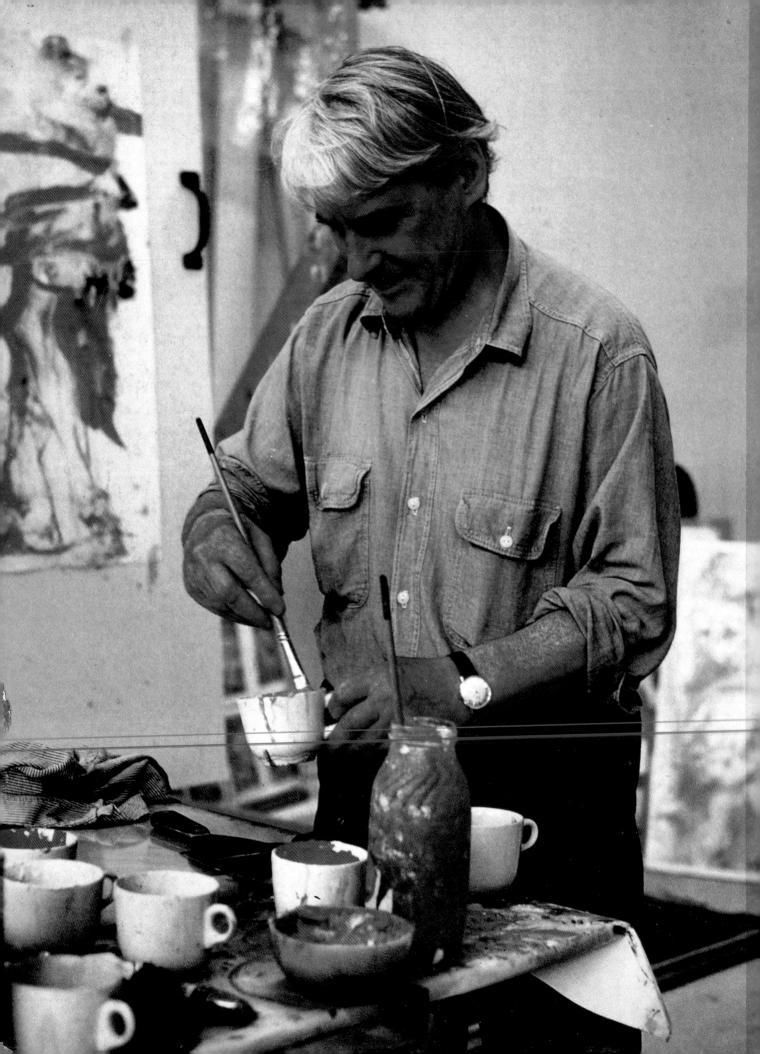